W9-BFF-606

1130 HIGHLAND AVENUE
NEEDHAM, MA 02494

WASHINGTON D.C.

A VISUAL PORTRAIT

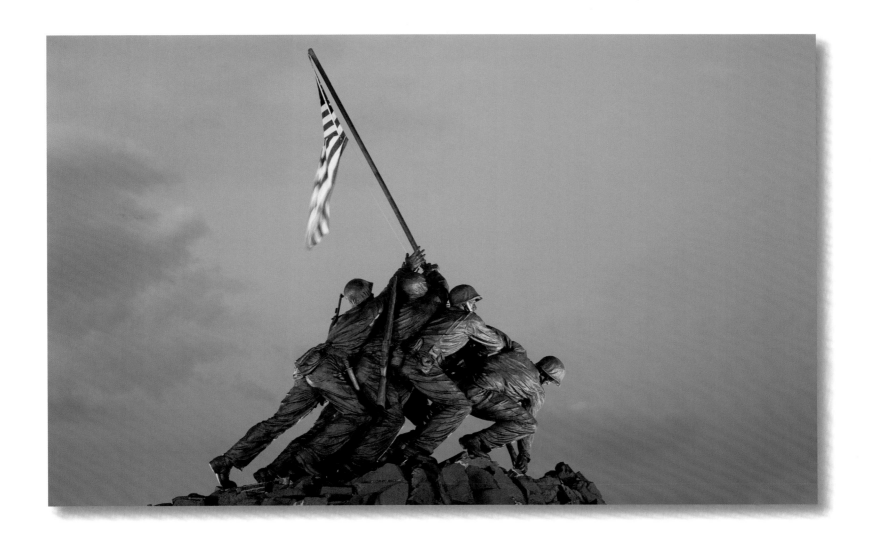

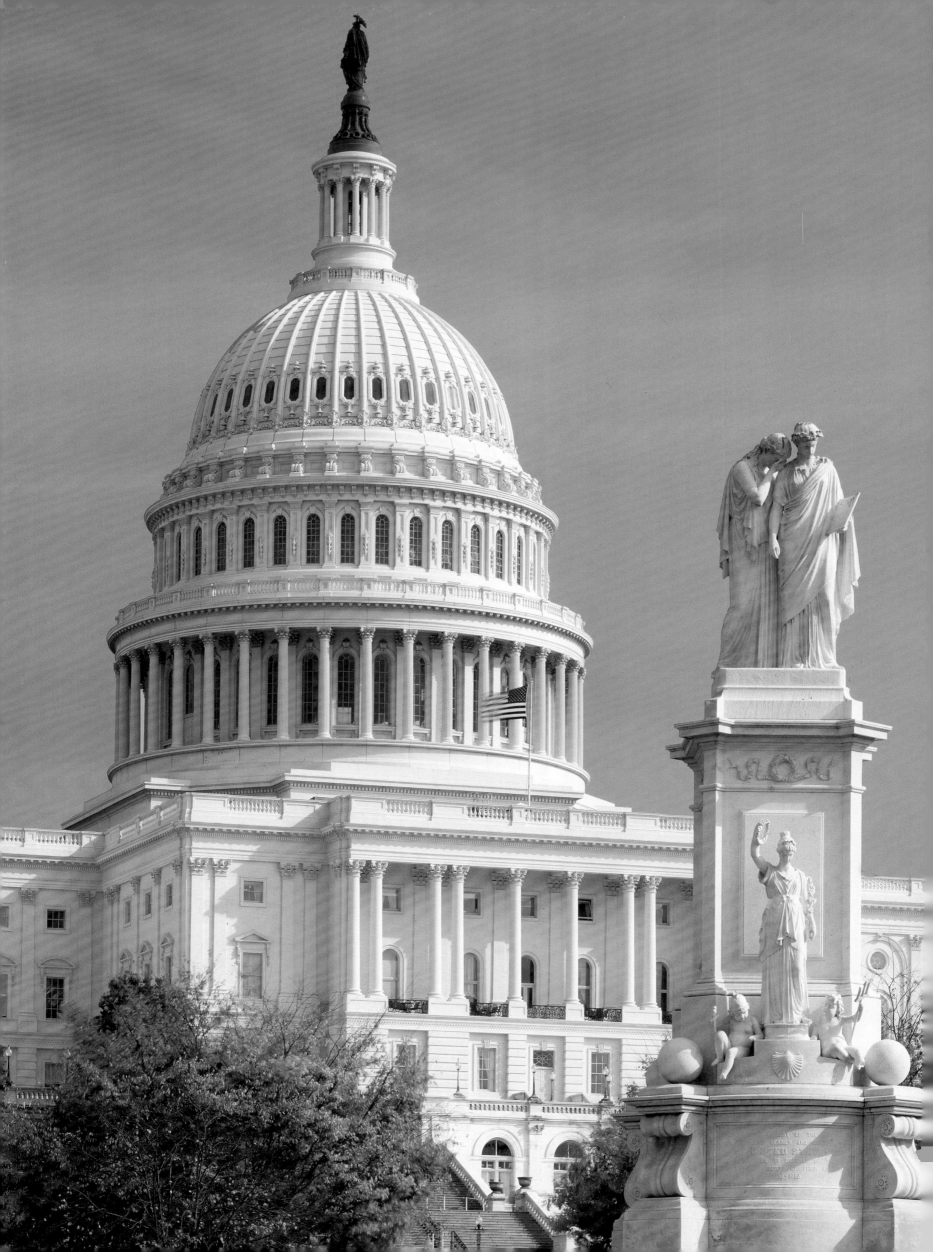

WASHINGTON D.C.

A VISUAL PORTRAIT

whitecap

Copyright © 2007 by Whitecap Books

All rights reserved. No part of this publication may be reproduced, stored in a retrieval system, or transmitted in any form or by any means, electronic, mechanical, photocopying, recording or otherwise, without prior written permission from the publisher.

The information in this book is true and complete to the best of our knowledge. All recommendations are made without guarantee on the part of the author or Whitecap Books Ltd. The author and publisher disclaim any liability in connection with the use of this information. For additional information please contact Whitecap Books Ltd., 351 Lynn Avenue, North Vancouver, BC V7J 2C4.

Written by Claire Leila Philipson
Photo selection by Claire Leila Philipson
Edited by Ben D'Andrea
Interior and cover design by Claire Leila Philipson

Printed and bound in Canada

Library and Archives Canada Cataloguing in Publication

Philipson, Claire Leila, 1980-
 Washington, D.C. : a visual portrait / Claire Leila Philipson.

ISBN 978-1-55285-907-0
ISBN 1-55285-907-X

 1. Washington (D.C.)--Pictorial works. 2. Washington (D.C.)--History.
I. Title.

F195.P54 2007 975.3'0420222 C2007-901777-0

The publisher acknowledges the financial support of the Government of Canada through the Book Publishing Industry Development Program (BPIDP) and the Province of British Columbia through the Book Publishing Tax Credit.

For more information on other Whitecap Books titles,
please visit our website at www.whitecap.ca.

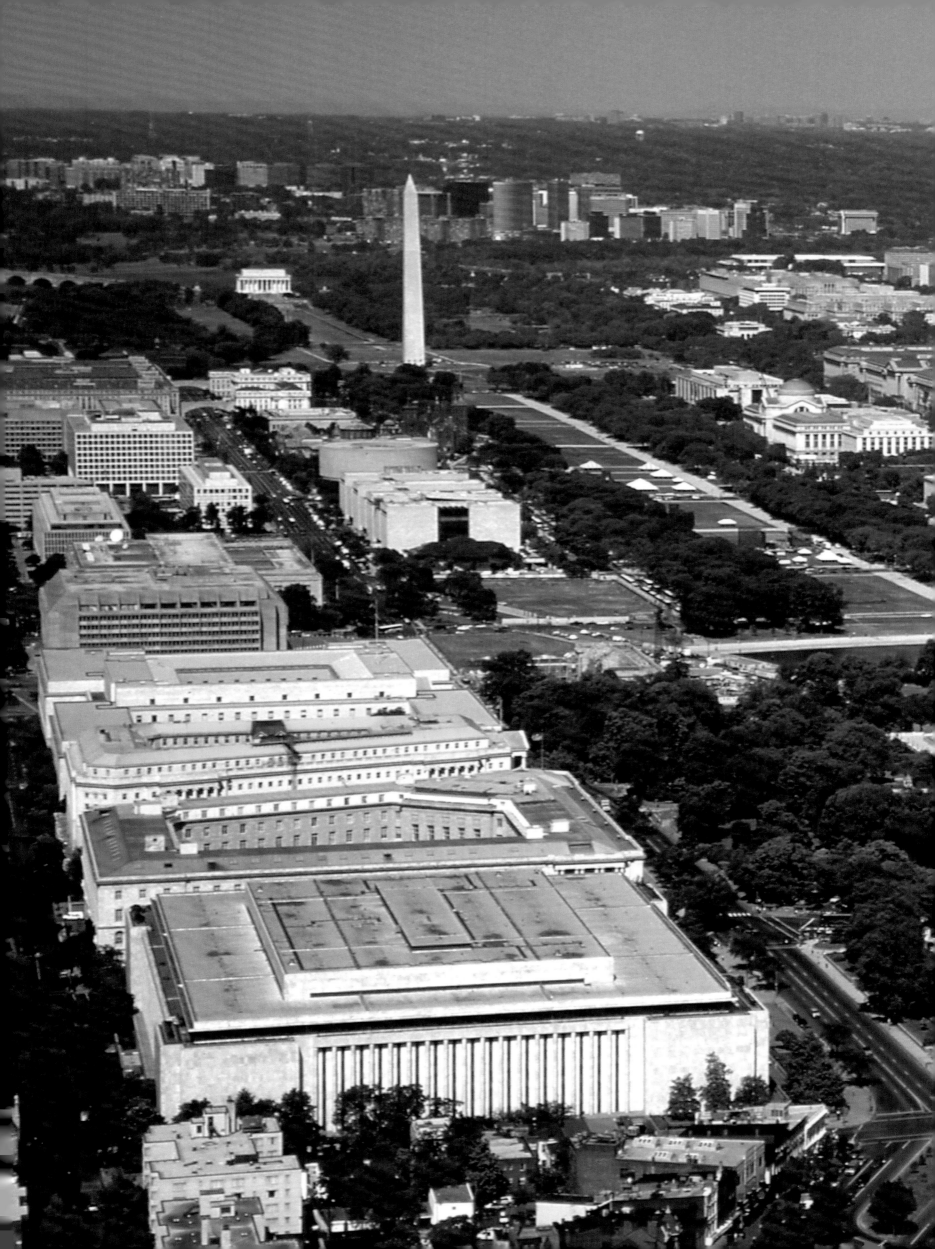

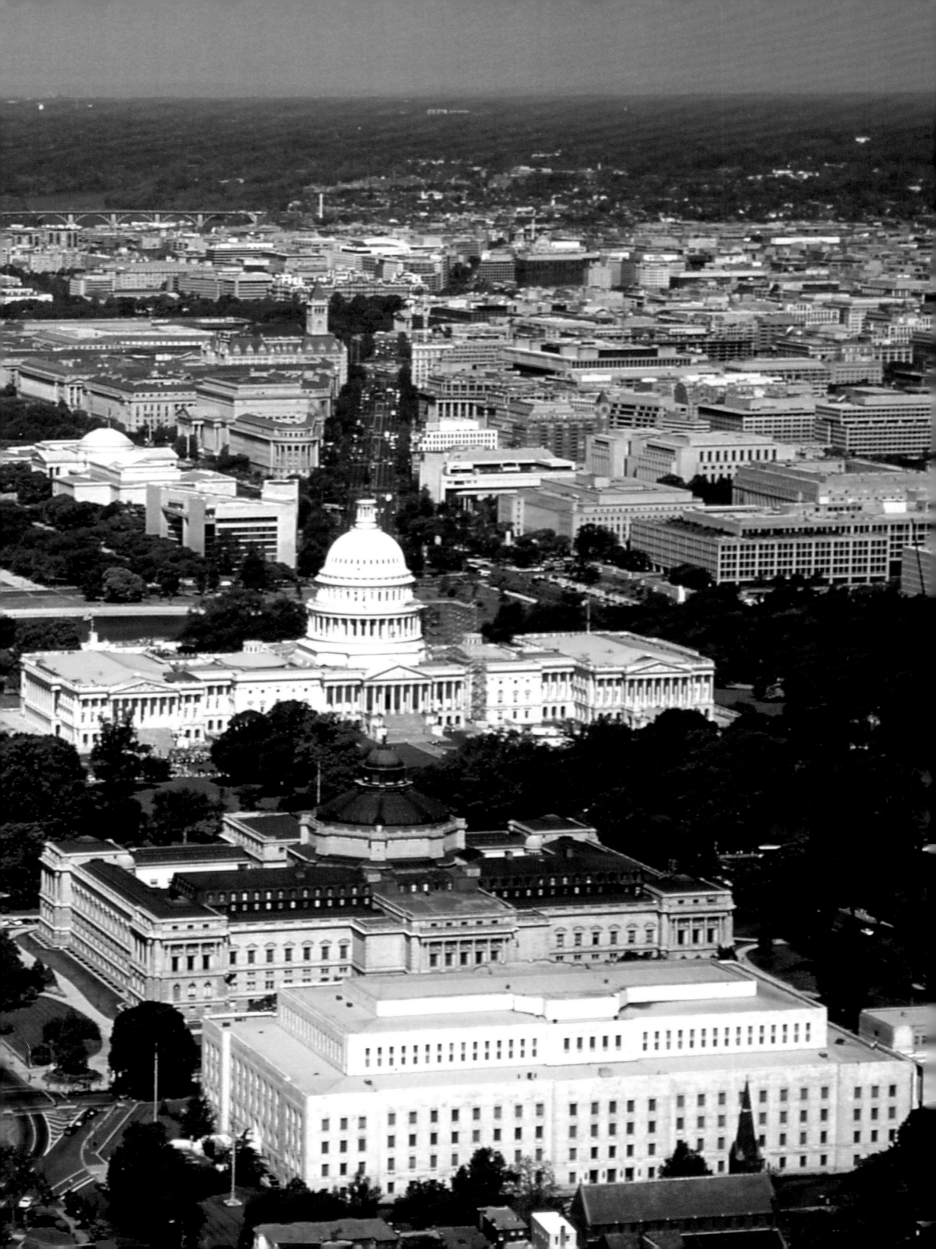

—Introduction—

Only a tiny slice of America's sprawling land mass — yet brimming with legend, history, and power — Washington, District of Columbia is the political heart of the country. Named after George Washington and Christopher Columbus, the enclave on the shores of the Potomac River reflects the influence of the nation's first president and the spirit of adventure of its most famous explorer. Anchored by three neoclassical buildings representing America's levels of government — the U.S. Capitol building, the White House, and the Supreme Court — some of the country's finest museums and galleries, and a stunning collection of monuments that pay tribute to the country's past, Washington, D.C. is a remarkable capital city. Its rise to prominence exhibits the strength and potential of a young, emerging nation.

A newly independent America inaugurated George Washington as her first president in 1789. With a leader in place, the next order of business was to decide on a permanent capital and appoint a city planner with a vision for a majestic city capable of reflecting the new nation's ideals.

Congress decided to situate the capital in what was then America's upper South, and George Washington himself selected the federal city's site on the shores of the Potomac River. The Founding Father also appointed French architect and freemason Pierre Charles L'Enfant as the primary city planner. Taking his cue from the grand avenues and parks of Paris, L'Enfant created blueprints to transform the marshland into a city with sculptures, fountains, parks, and majestic buildings dotted around a central boulevard. L'Enfant and the District commissioners overseeing the process, however, disagreed on how to allocate the project's meager funds, and L'Enfant was let go before many of his ideas could be realized.

L'Enfant's vision came to life later when surveyor Major Andrew Ellicott, city planner and scientist Benjamin Banneker, and the McMillan Commission revised his plans and saw them through to development. L'Enfant's vision of a central avenue resulted in the National Mall, the city's main artery and host to many of its finest museums, monuments, and loudest demonstrations.

Washington, D.C. is a vibrant work in progress — its offerings regularly updated and enhanced to reflect the country's history. A potent fusion of politics and culture that pays homage to the country's past as it looks towards the future, Washington, D.C. is the core of American power and influence.

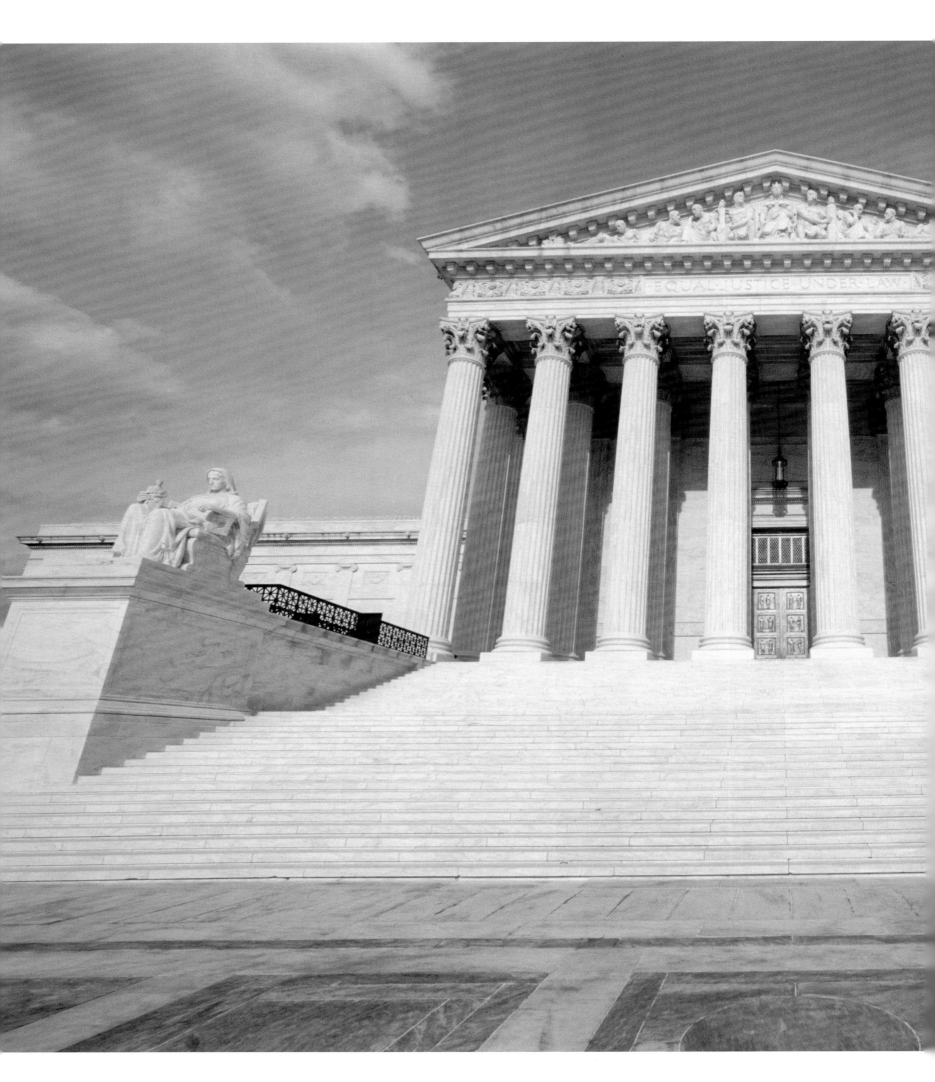

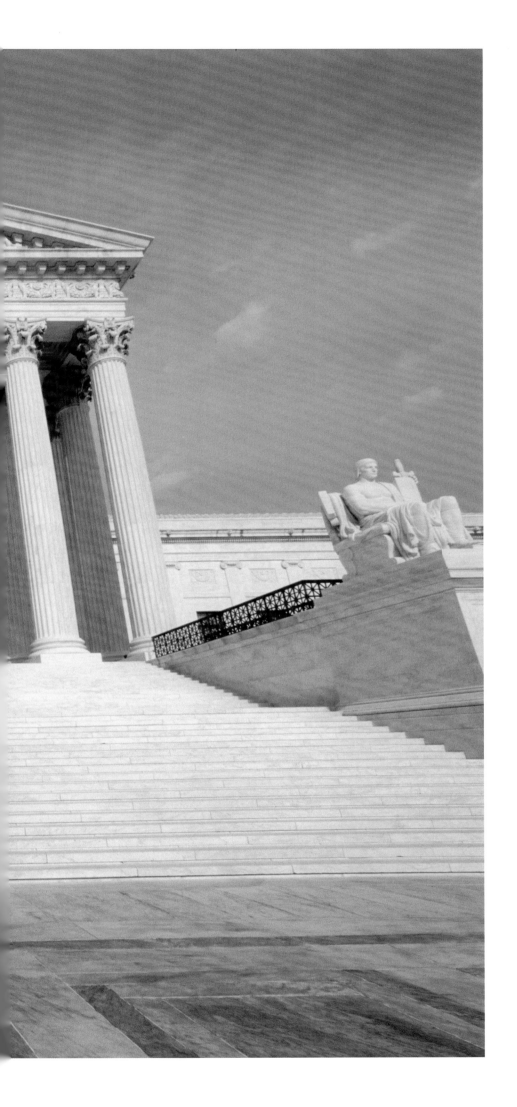

Large bronze doors make an impressive gateway into the Supreme Court. Inside the building, magnificent friezes illustrate the history of law and lawmakers throughout the ages. Representations of historical figures from Confucius and Moses to Charlemagne and King Louis IX of France grace the walls of the courtroom, alongside a frieze depicting the Ten Commandments.

The highest judicial authority in America, the Supreme Court of the United States moved out of the Capitol Building in 1935 and into this dignified building of its own. With the court's motto "Equal Justice Under Law" etched into its façade, and the imposing stone figures of the Contemplation of Justice and the Guardian of Law flanking its steps, the Supreme Court of the United States' grandiose home reflects its power. (*left*)

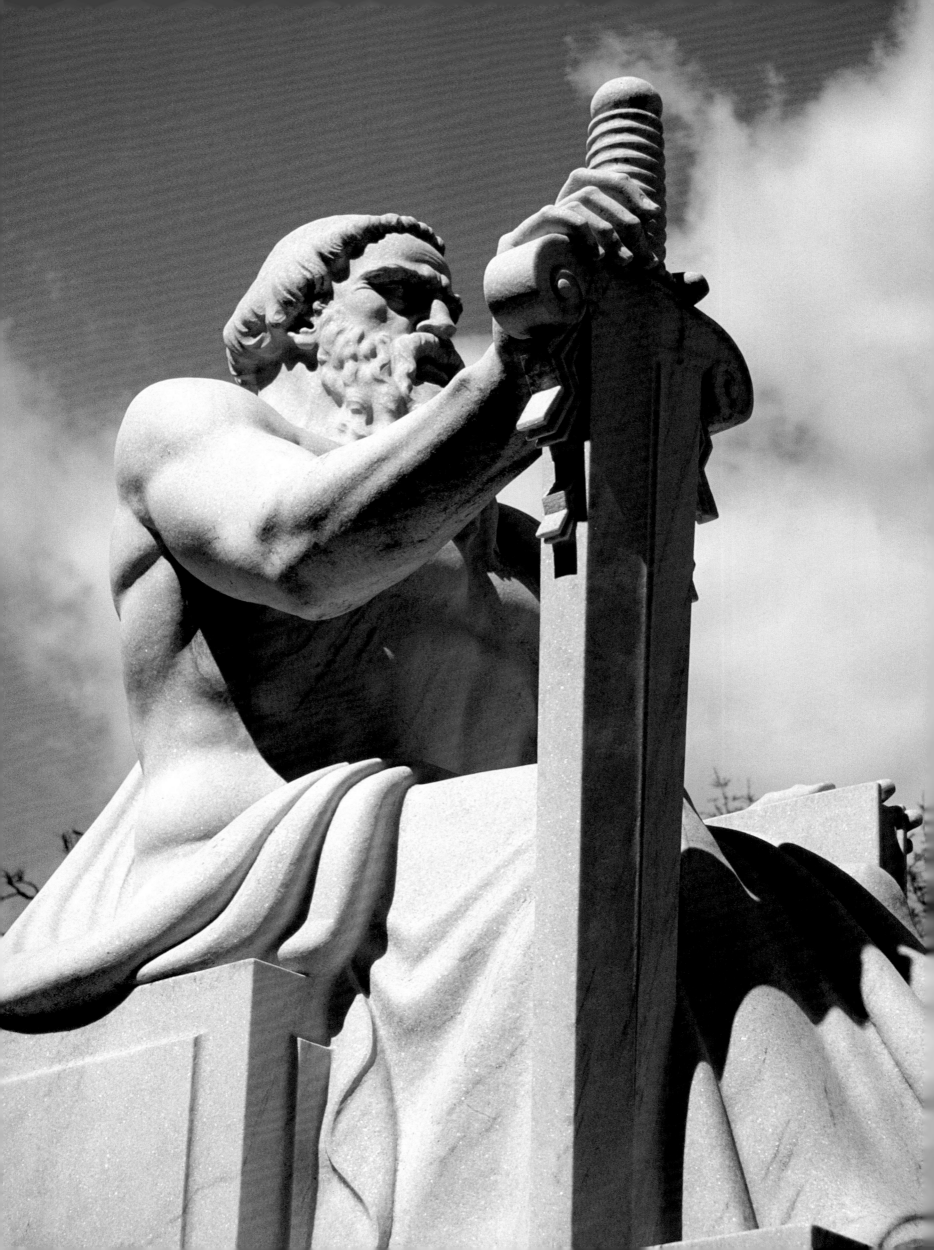

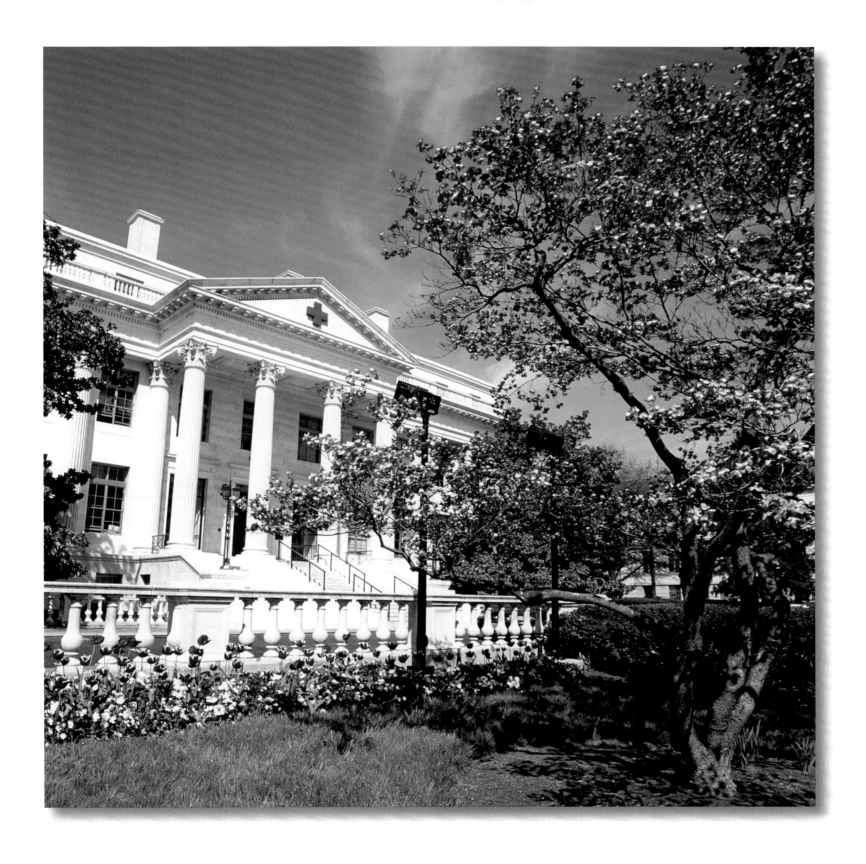

Bearing its signature emblem, this building is part of the American Red Cross Headquarters, which fill an entire city block in Washington, D.C. called Red Cross Square. The square consists of a memorial garden with commemorative sculptures and two classical buildings whose cornerstones were laid by American presidents: Woodrow Wilson in 1915 and Herbert Hoover in 1928.

This 10-foot-high representation of the Majesty of Law — holding a book of federal laws bearing the U.S. seal and a sword that symbolizes valor — presides over one side of the Rayburn House and Office Building. On the other side of the steps, the female Spirit of Justice sits holding a lamp representing truth. (*left*)

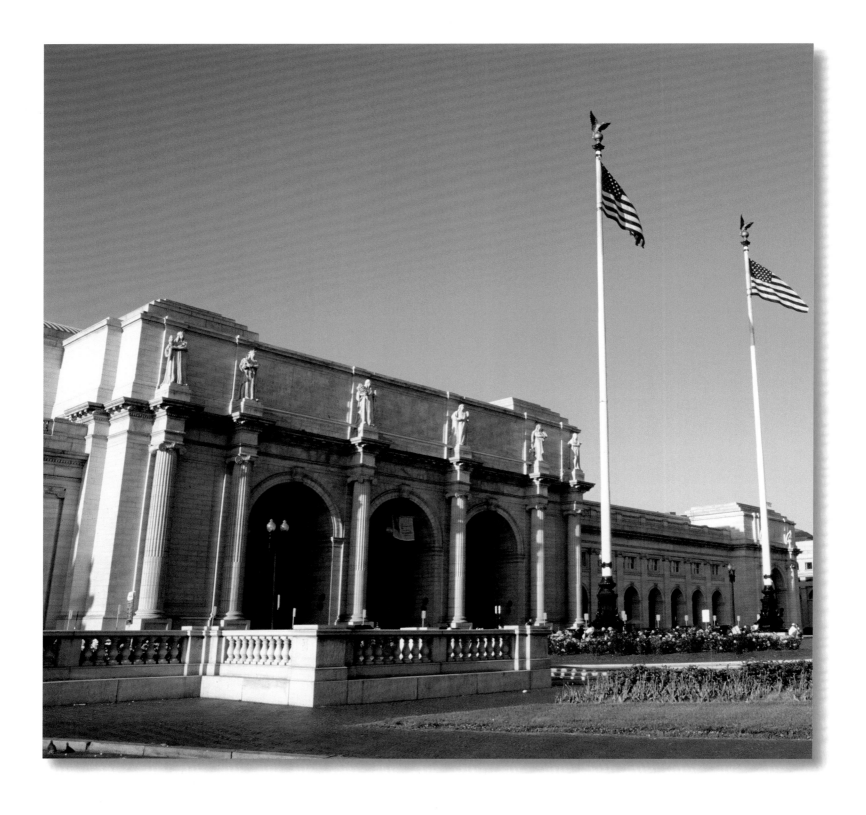

Thousands of square feet larger than New York's Grand Central Station, Union Station is an imposing masterpiece of beaux arts architecture. Built in 1908 to streamline all the train activity to and from the nation's capital, Union Station features ornate skylights, marble detailing, and statuary. A decline in train travel saw Union Station converted into a visitor's centre in 1976, but it was fully restored as a train station by 1988.

The imposing caped figure of explorer Christopher Columbus stands on a ship's prow outside Union Station. Dedicated in 1912, the Columbus Memorial Fountain fittingly symbolizes discovery and adventure: the figure crouched on Columbus' left symbolizes the new world and the winged figure in the center represents democracy. Christopher Columbus is widely regarded as the man who "discovered" America in 1492. (*right*)

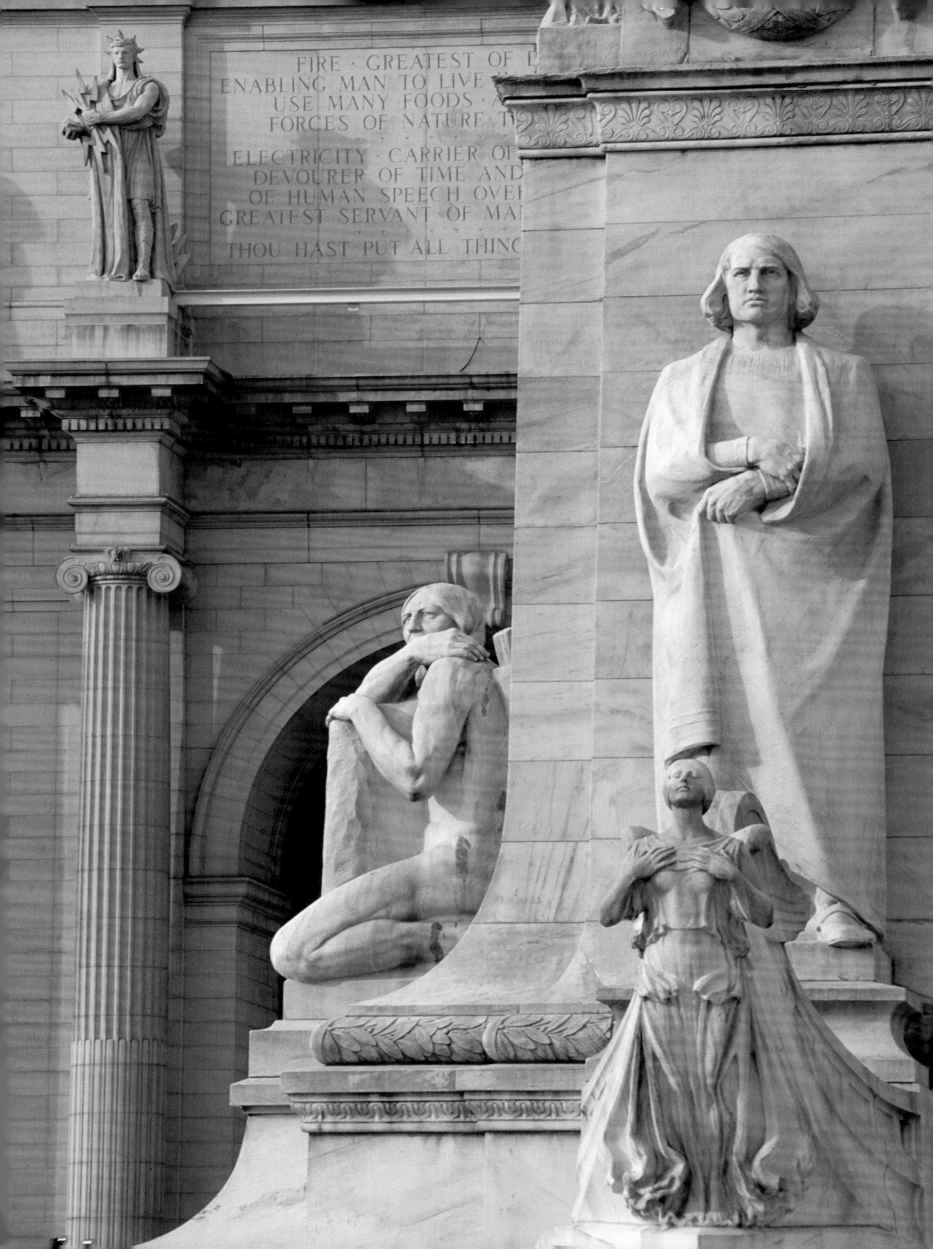

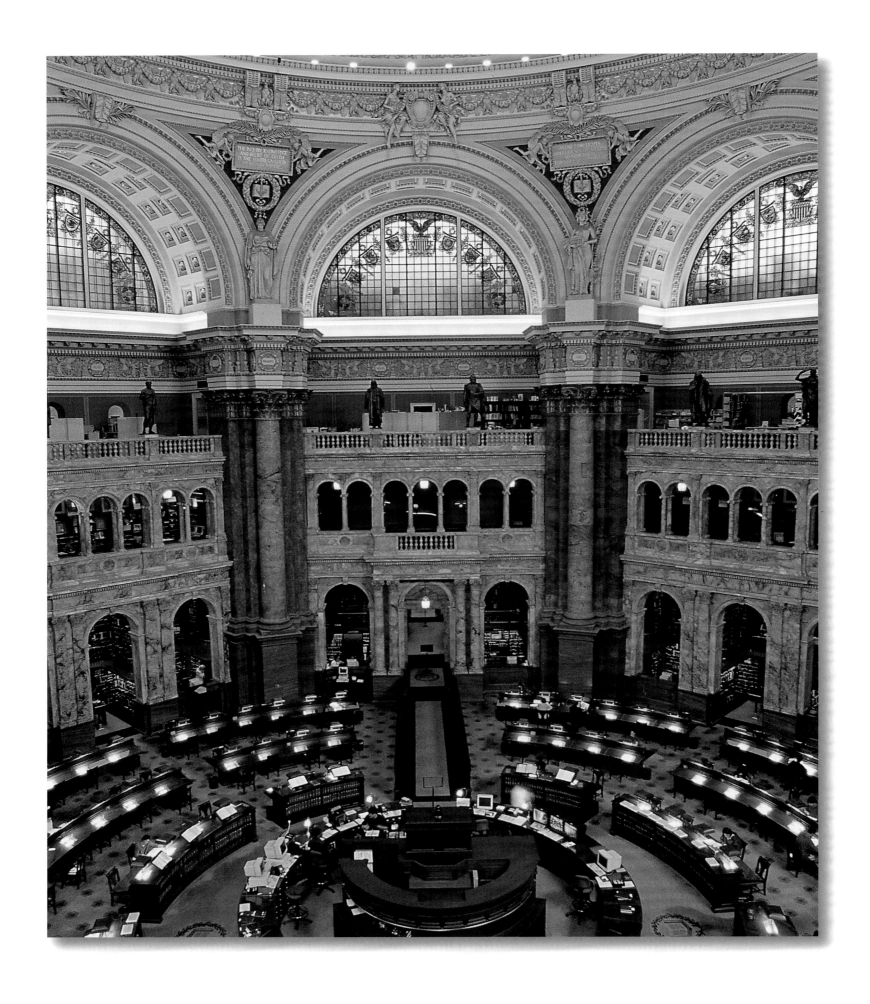

One of 22 reading rooms in the Thomas Jefferson Building, the Library of Congress' Main Reading Room is supported by eight massive marble columns. Housing a large portion of the library's catalogs, this room is the gateway to the Library of Congress' huge collection.

—THE LIBRARY OF CONGRESS—

The world's largest library, the Library of Congress contains over 30 million books and print materials in almost 500 languages. Boasting one of the most extensive rare book collections in the world, the Library of Congress owes the diversity of its collection in part to Thomas Jefferson and the founding father's belief in the importance of access to a wide range of information.

The research arm of the United States Congress and America's national copyright office, the Library of Congress was established in 1800 and was initially housed in the nation's new Capitol Building. British troops burned the Capitol, along with many other seminal buildings in Washington, during the War of 1812, destroying the library's meager collection of books. Almost immediately after the disaster, Declaration of Independence author Thomas Jefferson volunteered to sell Congress his personal library to help rebuild the Library of Congress. Acquiring Jefferson's library in 1815 doubled the library's collection to over 6,000 books and greatly increased the scope of its collection to include books on philosophy, science, and literature, providing the core for an eclectic library with an acquisition policy based on the Jeffersonian ideal that books on all subjects and languages should be readily available.

By the end of the 19th century, the library's collection grew large enough to need a building of its own. The library moved into the Italian Renaissance Thomas Jefferson Building in 1897, where today its collection and prized copy of the Gutenberg Bible are displayed among mosaics, murals, and statues. The library's main reading room features huge marble columns and statues, and a domed ceiling towering 125 feet above the floor. The building's exquisite Great Hall is an ornate display of marble, stained glass, and statuary.

The Jefferson Building was supposed to house the library until the 1970s, but with a collection that acquires an estimated 10 items per minute, the rapidly growing library was forced to expand into the John Adams Building in 1939 and the James Madison Memorial Building in 1980. The ornate Jefferson Building remains the library's core, however, and rotating exhibits feature its historical treasures — from Alexander Graham Bell's lab notebook to the original typescript of Martin Luther King Jr.'s "I Have a Dream" speech. (*overleaf*)

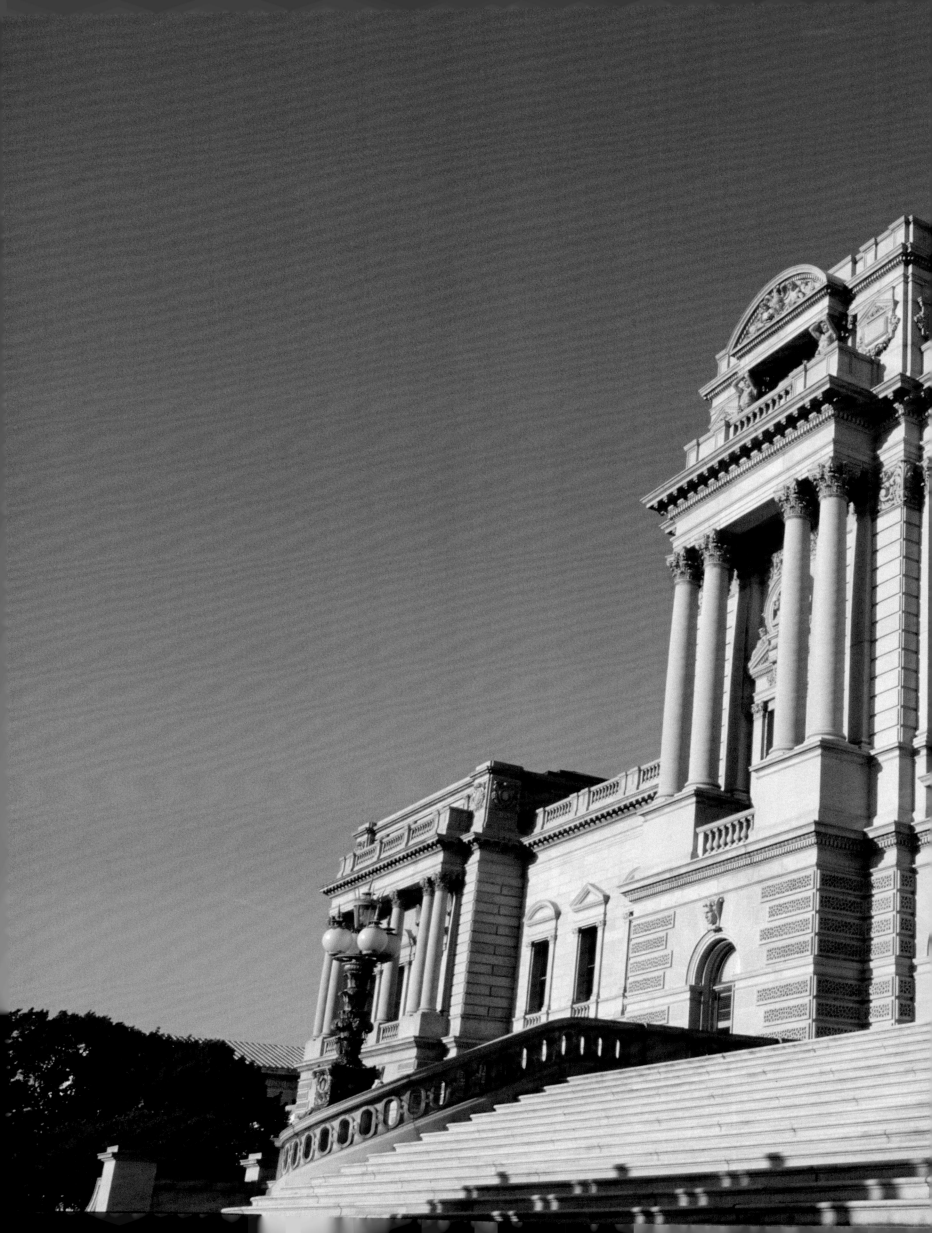

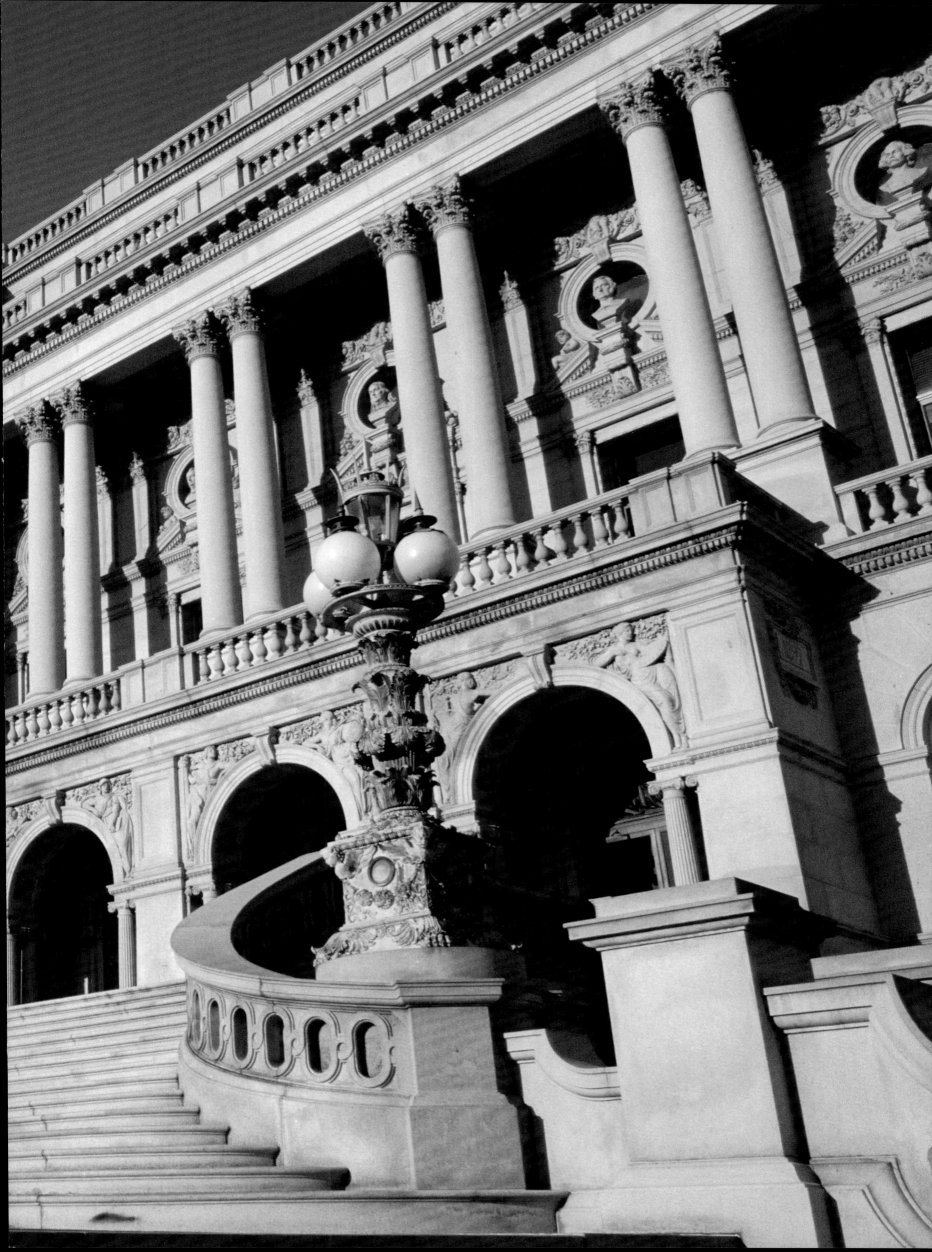

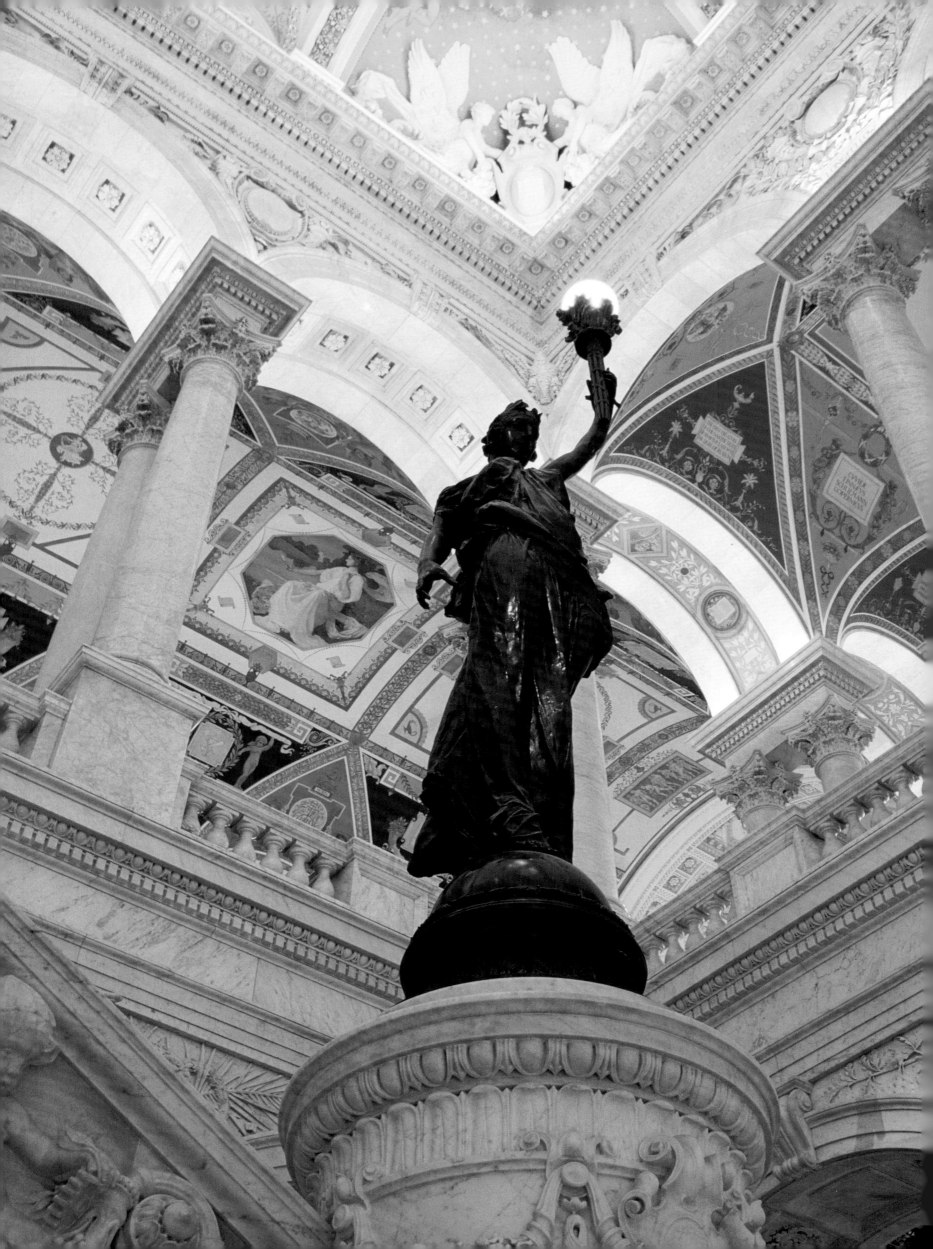

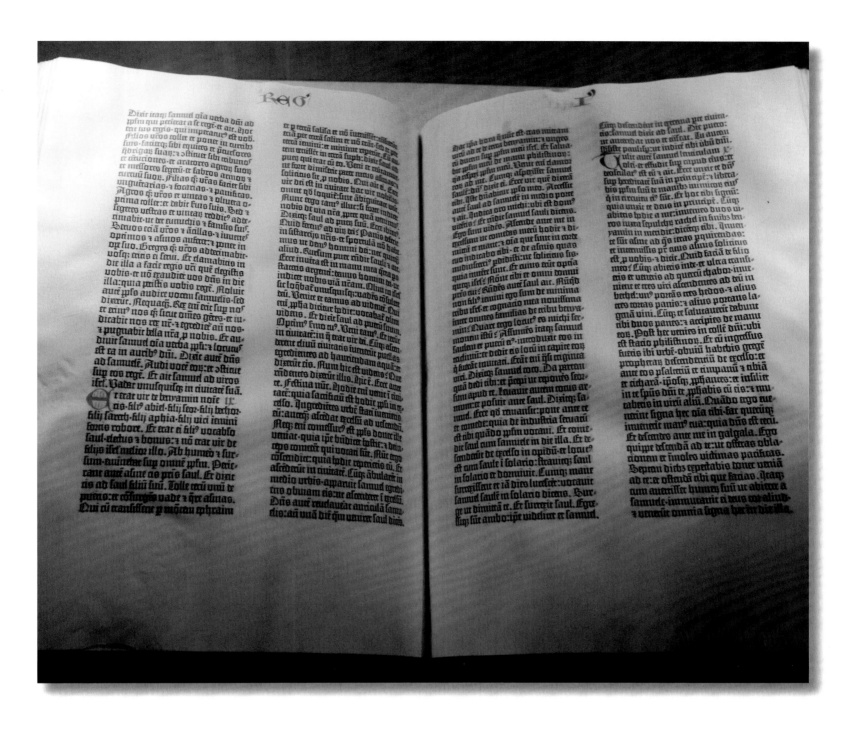

Made in the 15th century by print revolutionary Johannes Gutenberg, this Gutenberg Bible is one of the Library of Congress's most prized possessions. Produced using a printing press and movable type, the Gutenberg Bible is often credited with ushering in the "Age of the Printed Book." The Bible on display here at the Library of Congress is one of only three perfect copies printed on vellum in the world.

The elaborate Italian Renaissance façade of the Library of Congress is matched by its ornate interior. The Great Hall alone features marble walls, inscriptions, murals, and mosaics. More than 40 works of art by American painters and sculptors grace the Thomas Jefferson building's halls. (*left*)

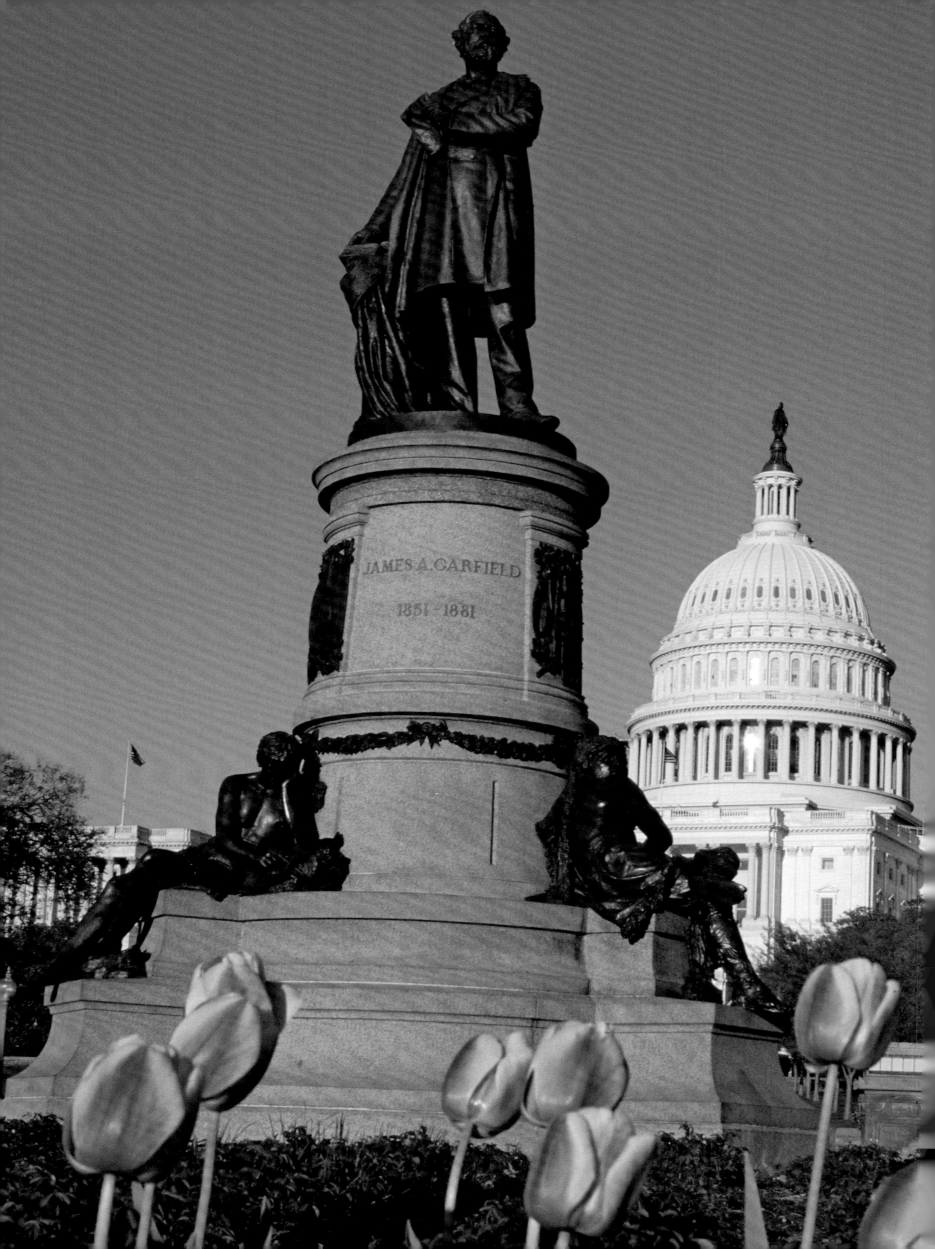

One of Washington, D.C.'s oldest residences and the former home of Alice Paul, the Sewall-Belmont House became the headquarters of the National Women's Party in 1929. Paul, who founded the National Women's Party in 1916, authored the 1923 Equal Rights Amendment to the Constitution. Exhibits throughout the historic house detail the history of the fight for suffrage and equality.

This statue on the National Mall commemorates James Garfield, the 20th President of the United States. Garfield served the second-shortest presidential term in American history. His term was cut short in 1881 when he became the second president to be assassinated after Abraham Lincoln. (*left*)

—THE UNITED STATES CAPITOL—

Sitting atop Capitol Hill is perhaps the most majestic building in all of Washington, D.C. — the neoclassical United States Capitol building. Visible from any point in the city, the lavish structure represents immense power: it houses the two legislative bodies of Congress — the Senate and the House of Representatives.

Designed to resemble the classical buildings of ancient Greece, the splendid U.S. Capitol building calls to mind the birthplace of democracy — a feature that helped architect William Thornton win the 1792 contest for the Capitol's design. A year after the contest, George Washington laid the Capitol's cornerstone, and although it was still largely unfinished by then, the building was occupied in 1800.

British troops set the Capitol building alight during the War of 1812, as the immense building was nearing completion. Consequently, Congress met in the makeshift old brick Capitol on the site of what is now the Supreme Court while restoration began on the Capitol, ushering in an era of huge additions and renovations. It was during the 1850s expansion that the signature piece of one of Washington's most glorious buildings was constructed — the capitol's huge dome and its crowning 19-foot-tall *Statue of Freedom*.

The scale of the Capitol's exterior is matched by its magnificent interior. The rotunda created by the massive dome provides the backdrop for frescoes, friezes, and paintings portraying defining moments in American history, as well as statues of distinguished citizens like Martin Luther King Jr., Abraham Lincoln, and Thomas Jefferson. Beyond the rotunda, the old House of Representatives chamber has been converted into the National Statuary Hall, which features renderings of eminent Americans from each state.

The United States Capitol building is not only the symbolic centerpiece of American politics, it also literally sits at the center of the country's capital. Washington's quadrants radiate from the Capitol Building and its grounds, which span almost 300 acres. Representing unprecedented political and historical power, the United States Capitol building is truly the center of Washington, D.C. (*right*)

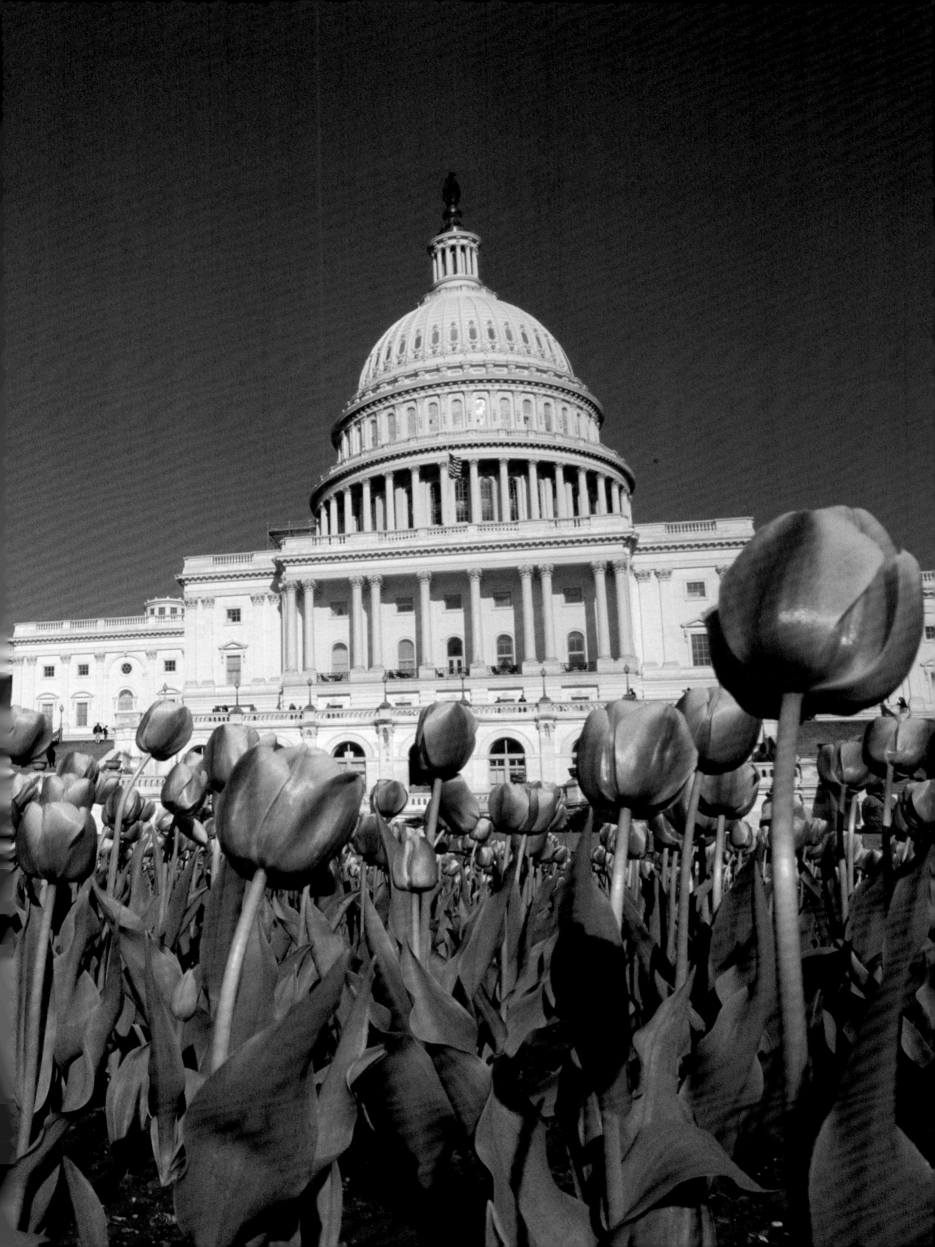

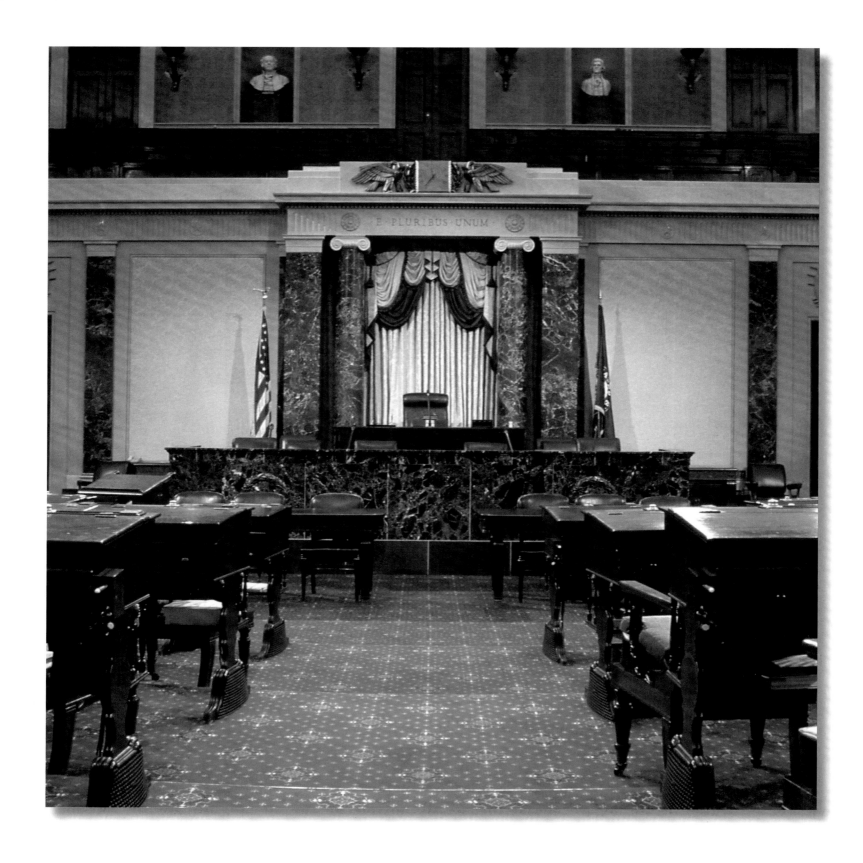

Senators debate issues and vote on legislation here in the Senate Chamber in the United States Capitol building's North Wing. In line with tradition, Republican senators sit on the right side of the chamber, while the Democrats take the left. Many of the Capitol Building's vice presidential busts are displayed here in the Senate Chamber.

Occupying the Peace Circle in front of the United States Capitol building, the Peace Monument was erected to commemorate those who lost their lives at sea during the Civil War. Standing atop the 44-foot-high monument are two robed female figures representing Grief and History. Below them are Victory and baby cherubs symbolizing the gods Mars and Neptune. (*right*)

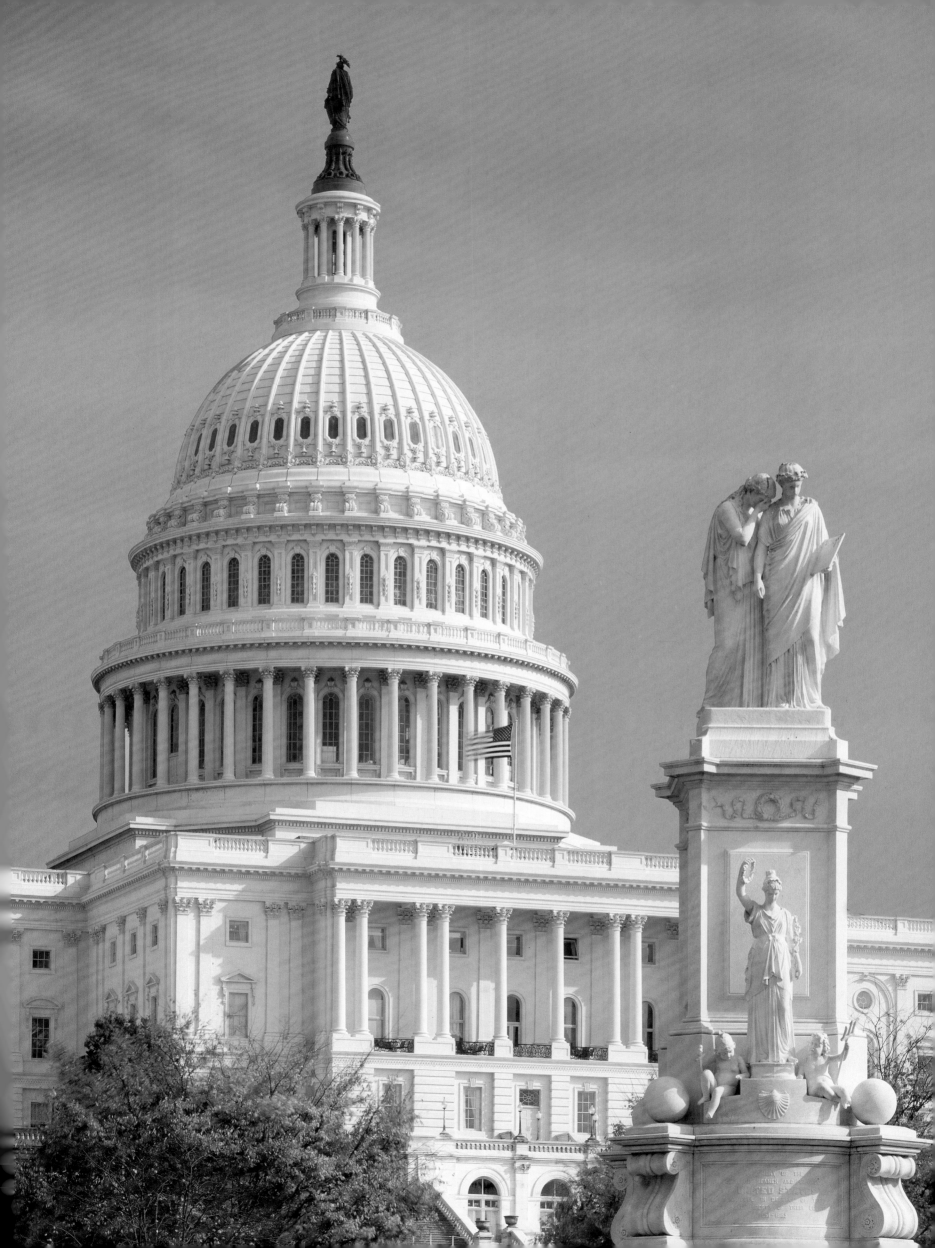

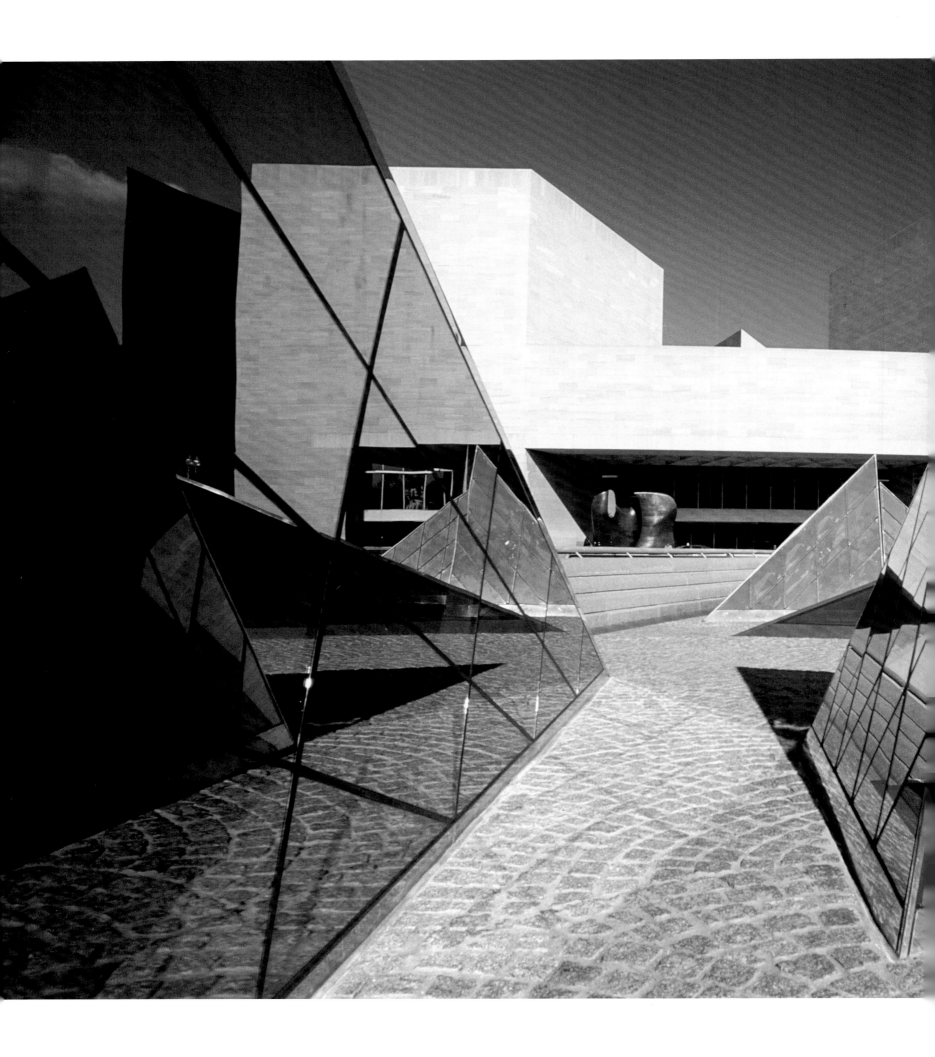

Designed by renowned architect I.M. Pei, the modern structure of Washington's National Gallery of Art's East Building houses the museum's extensive collection of modern and contemporary art. This building, with its signature pyramid skylights and triangular grid, displays works by Pablo Picasso, Henri Matisse, Jackson Pollock, and Andy Warhol.

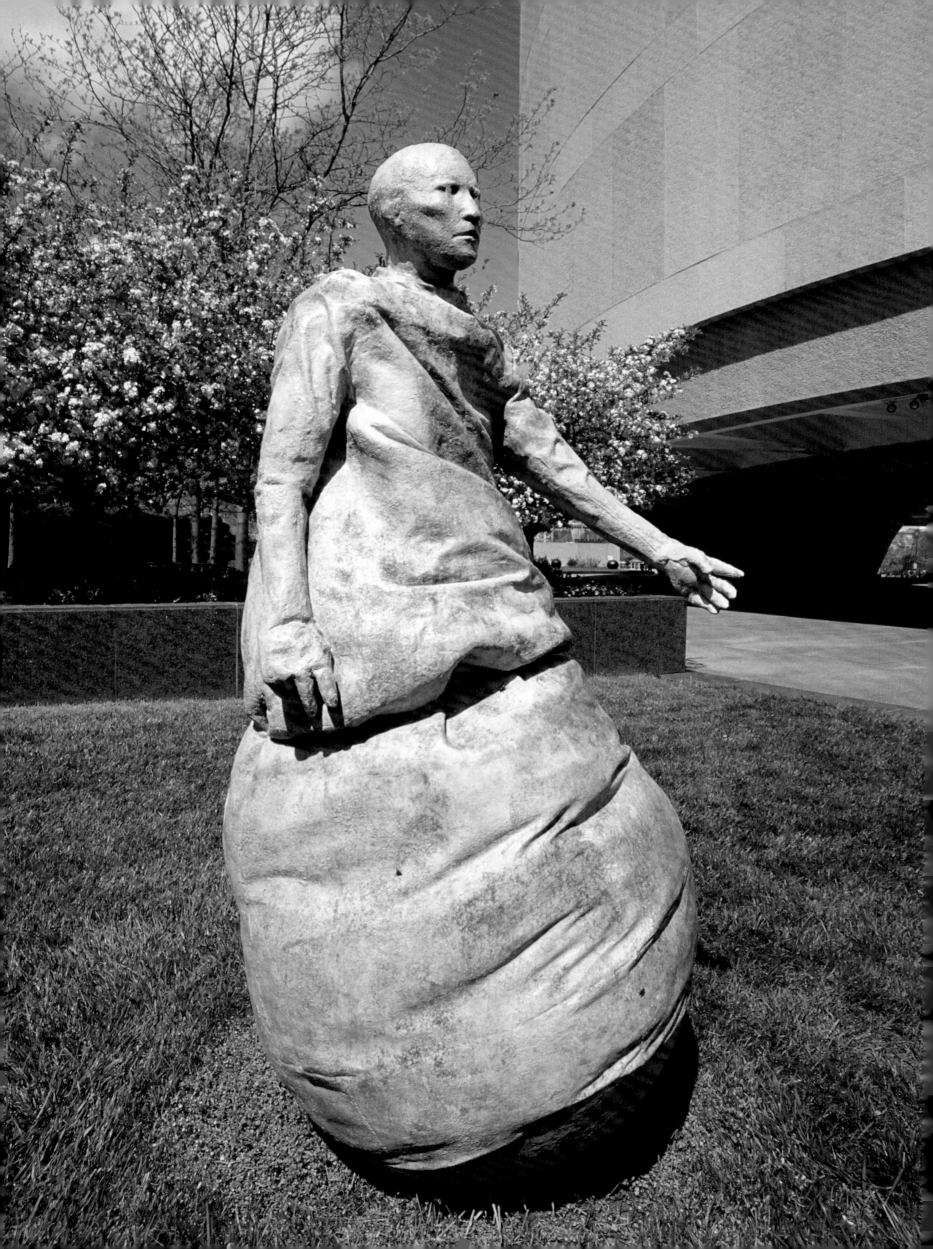

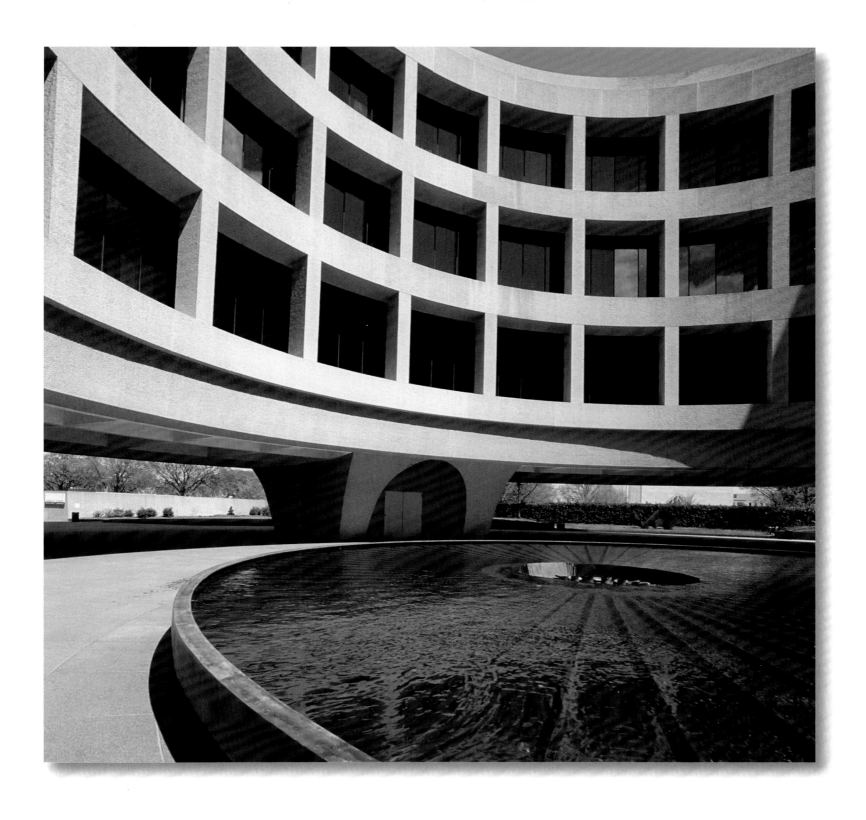

A stark contrast to the classic buildings along the National Mall, the modernist Hirshhorn Museum and Sculpture Gallery makes a fitting home for its vast collection of late 19th- and 20th-century art. An arm of the Smithsonian Institution, the Hirshhorn Museum and Sculpture Garden displays the personal collection of Latvian-born stockbroker Joseph H. Hirshhorn, whose modern art collection included more than 12,000 pieces by the time of his death in 1981.

Acclaimed Spanish artist Juan Munoz's sculpture *Last Conversation Piece* — inspired in part by a ventriloquist's dummy — is a permanent installation in the Hirshhorn Sculpture Garden. Spanish painter Diego Velázquez's signature dwarves and French artist Edgar Degas' legendary dancers also influenced the sculpture's bottom-heavy bronze figures. (*left*)

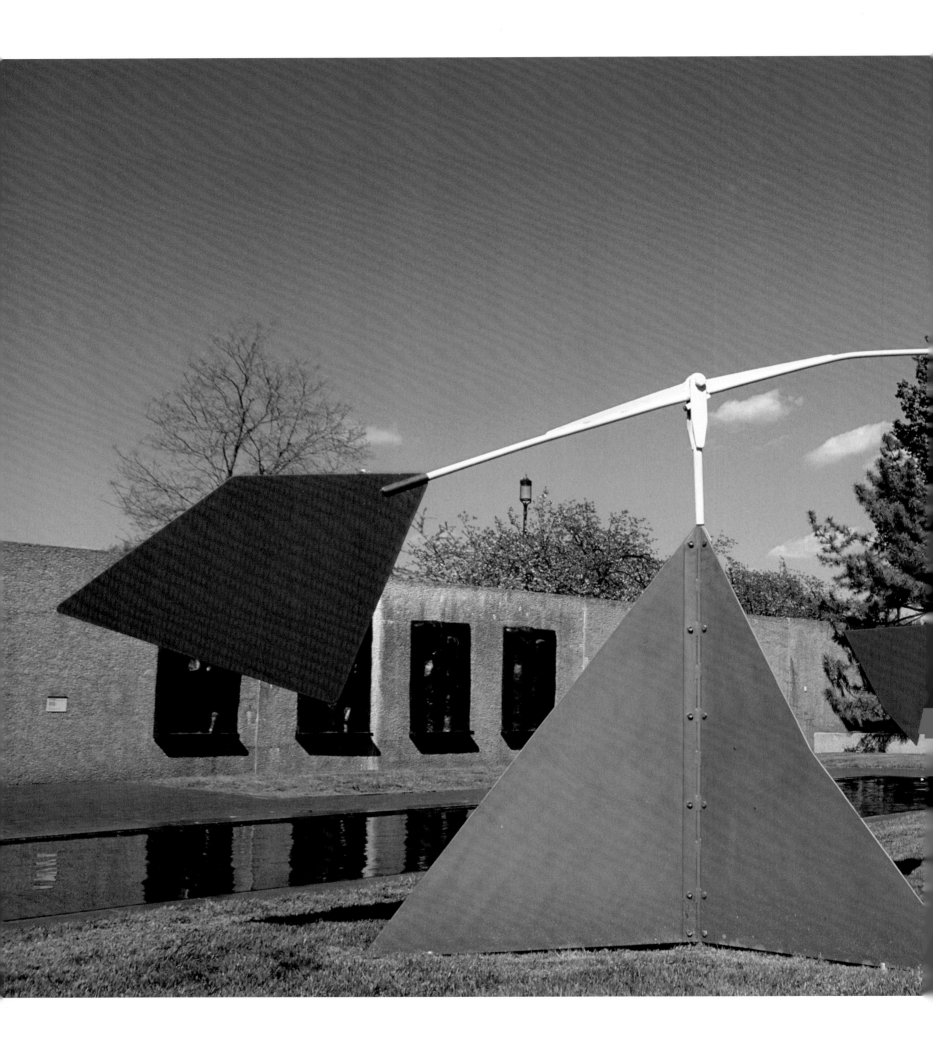

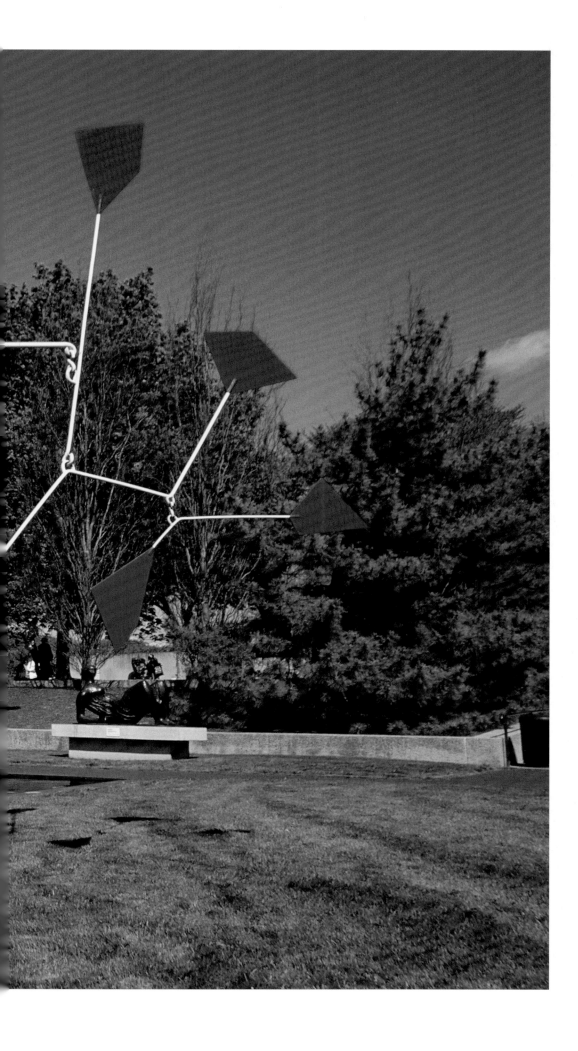

Part of the permanent collection of the Hirshhorn Museum and Sculpture Garden, *Six Dots over a Mountain* by Alexander Calder is part of the American artist's "stabiles series" — which include pieces that combine stationary sculptures and mobile features. Calder, who started making wind-activated sculptures in the 1930s, is famous for inventing the mobile.

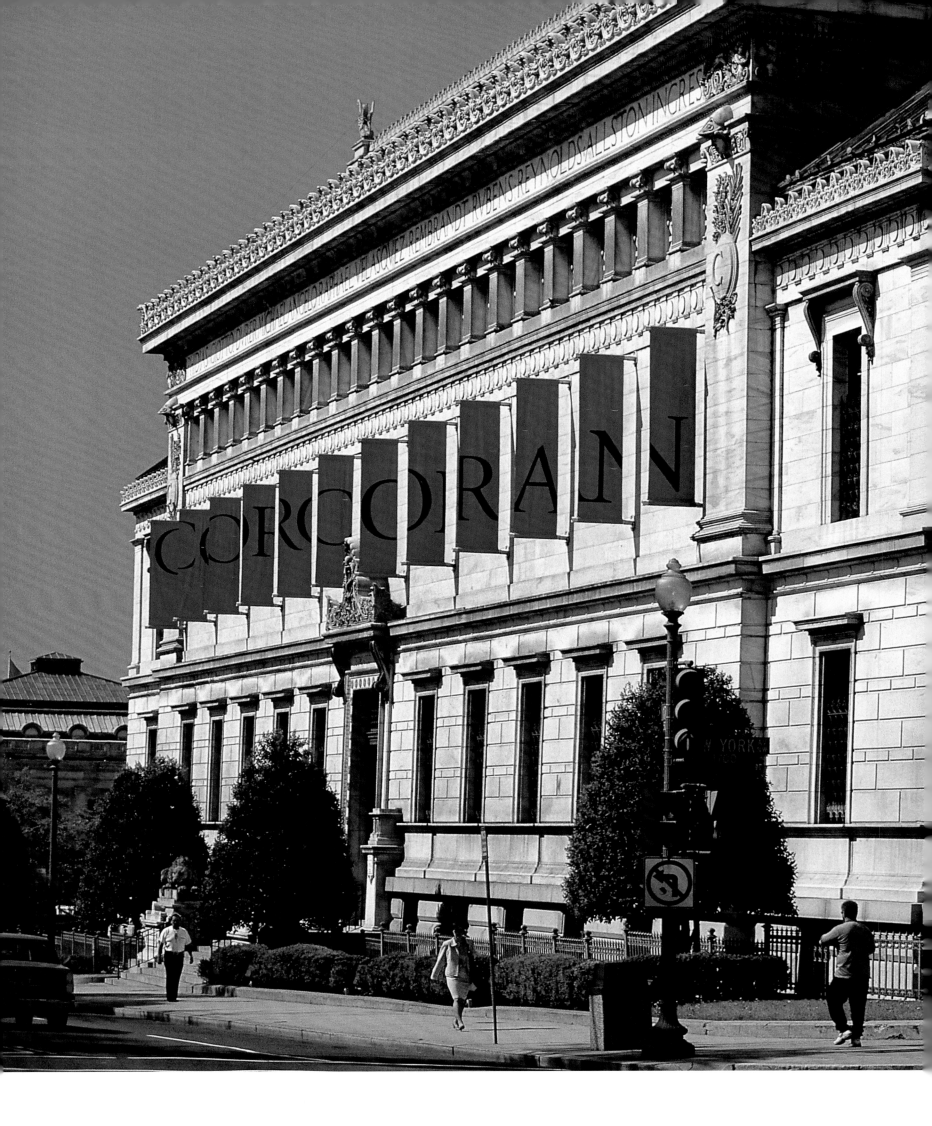

The beaux arts building of the Corcoran Art Gallery houses an extensive collection of important artworks from all over the world. Founded in 1874, the Corcoran is Washington, D.C.'s first art museum and features works by such renowned masters as Edgar Degas, Claude Monet, Pablo Picasso, and Andy Warhol among its collection of thousands of paintings, sculptures, and photographs.

The building that produces more security documents than any other in the United States, the Bureau of Engraving and Printing is fittingly large and imposing. Billions of dollars in notes are printed and engraved here every year, along with stamps, American passports, and White House invitations. Established in 1862, this Bureau started with a staff of six working out of the Treasury building, and now employs thousands both here and at its second branch in Fort Worth, Texas.

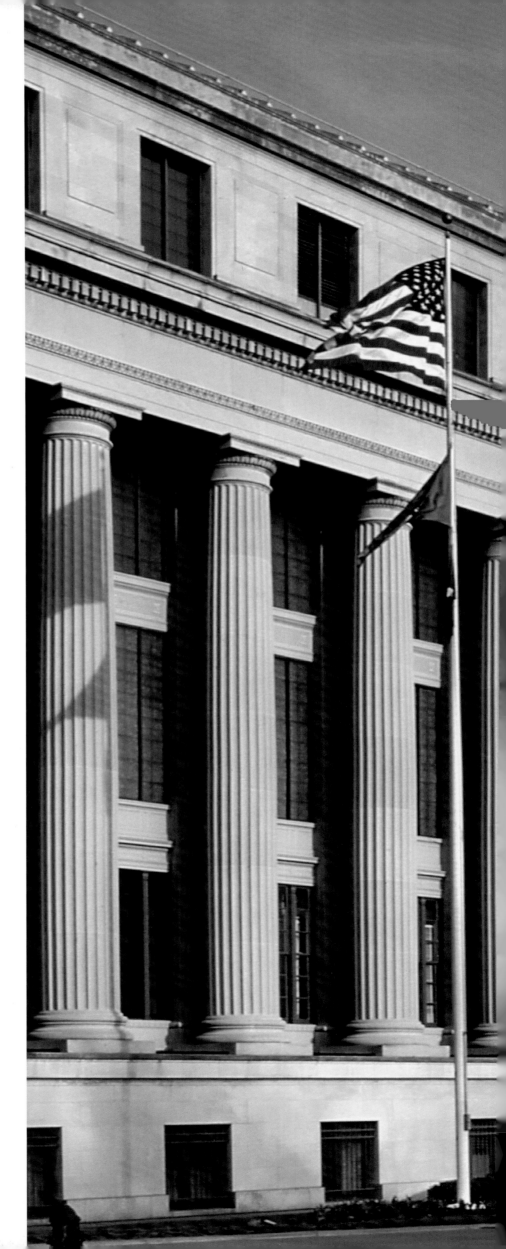

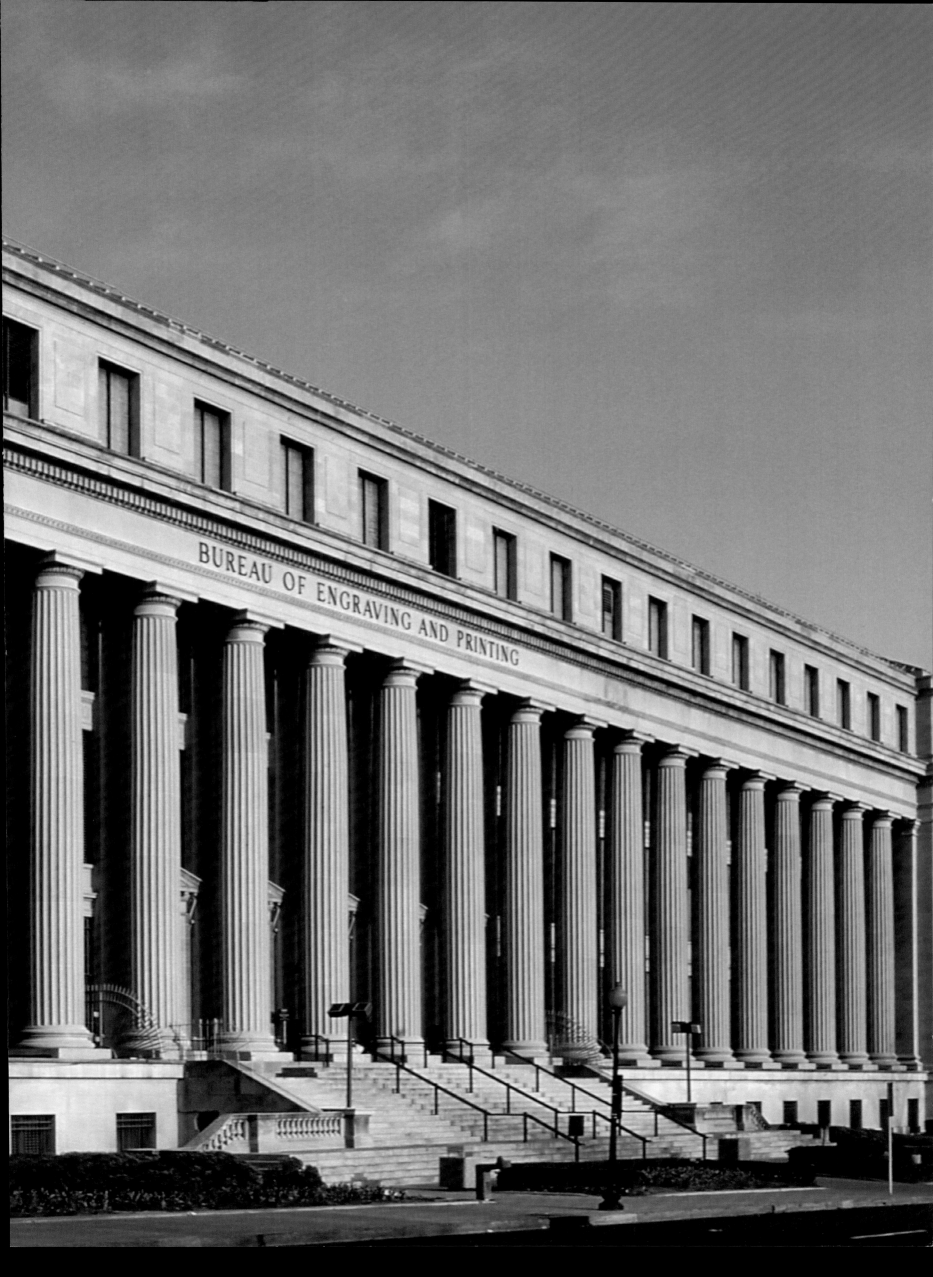

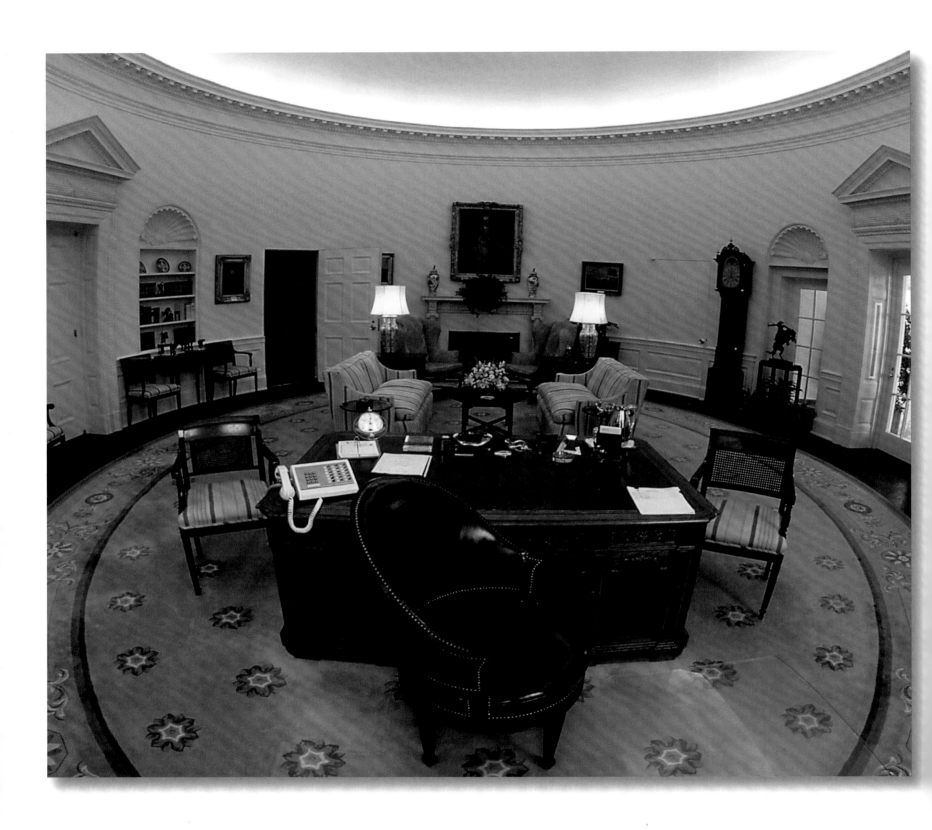

The opulent Oval Office is where the President of the United States conducts his business. It is customary for each incumbent president to re-decorate the room to his taste, traditionally outfitting it with curtains and a new rug. When a president finishes his term and moves out of the office, this rug is usually moved to his presidential library.

—THE WHITE HOUSE—

The heart and power center of Washington, D.C., the White House sits prominently among the city's most important sites — the National Mall, the Federal Triangle, the Treasury Building, and Lafayette Square. Serving as the primary office of the President of the United States and home to his family, the neoclassical mansion at 1600 Pennsylvania Avenue is undoubtedly America's most dignified address.

Architect Pierre Charles L'Enfant, who designed the capital city, originally planned for an opulent mansion to serve as the home of the nation's leader. President George Washington and then Secretary of State Thomas Jefferson found L'Enfant's vision too extravagant, however, so in 1792 the founding fathers arranged a competition for the house's design. Of the nine submissions, James Hobart's plan for a Georgian mansion like those in his native Ireland was the winner.

The White House was not completed in time to house America's first presidential family. Second President John Adams became the first Chief Executive to occupy the house when he moved in at the end of his term in 1800. Only 14 years later, when fourth President James Madison was America's leader, British troops set the White House, along with many other buildings in the capital city, alight during the War of 1812. The inside of the house was badly damaged, and though the exterior remained mostly intact, the event led to the additions and renovations that have since shaped the White House.

Each new presidential administration has left its mark on the White House. The house's famed West Wing came with Theodore Roosevelt. William Taft had the Oval Office constructed, and the French-inspired motifs throughout came with First Lady Jacqueline Kennedy. The renovations and redecorations throughout the years have turned the regal residence into a grandiose structure that is perhaps more aligned with L'Enfant's vision than Washington and Jefferson's. The six-storey home now features over 100 rooms, more than 30 bathrooms, a tennis court, a bowling alley, a movie theater, and a putting green.

In a city where history, power, and legend unite, the White House remains one of Washington, D.C.'s most enduring symbols. (*overleaf*)

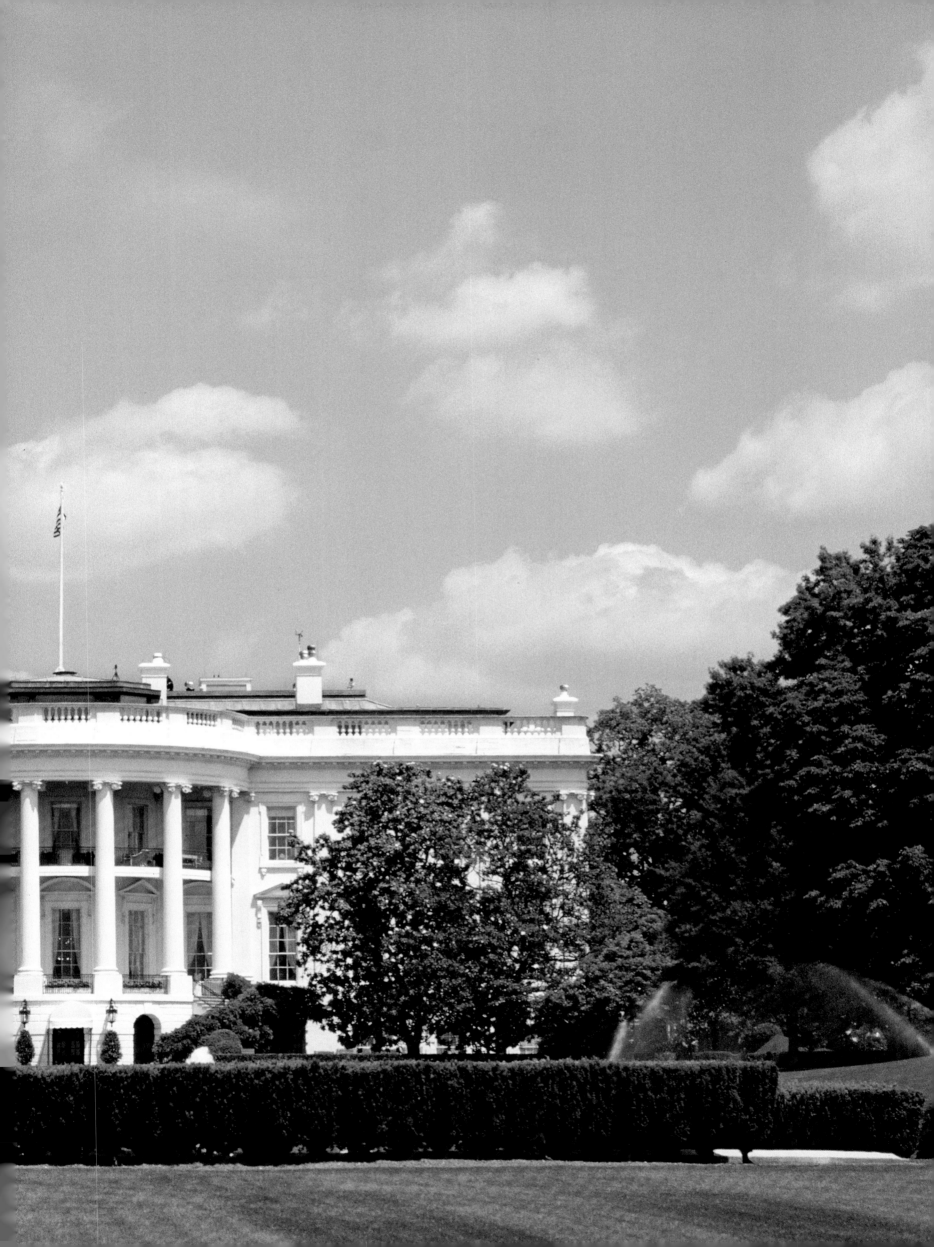

Charming 19th-century row houses line the streets in Foggy Bottom, one of Washington's oldest neighborhoods. Once a busy town on the banks of the Potomac and then the site of D.C.'s industrial zone, this distinct area is now home to several government buildings, international organizations, and historical sites — from the National Academy of Sciences to the World Bank headquarters to the infamous Watergate complex.

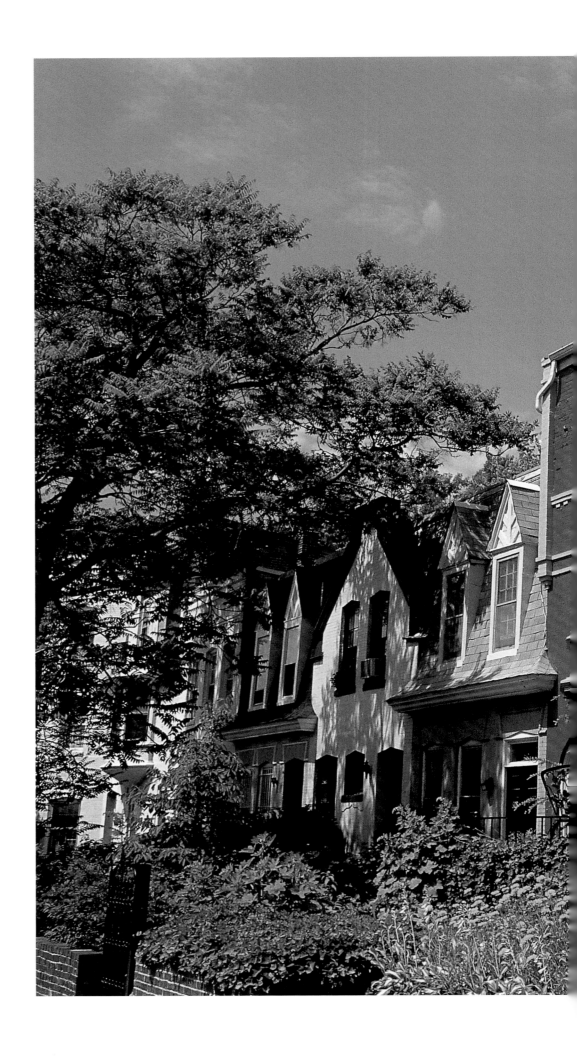

Colorful ribbons join the cherry blossoms in decorating the National Mall every year during the Smithsonian Kite Festival. Flyers from all over the world gather here with their kites for the event, which was created in 1967 by National Air and Space Museum founder Paul E. Garber.

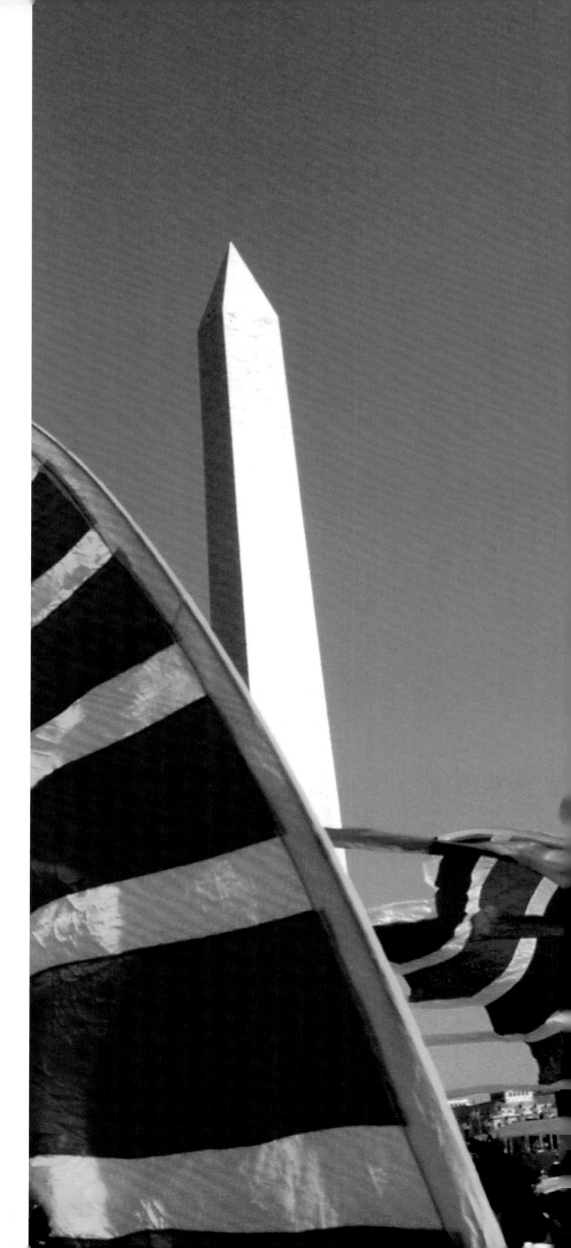

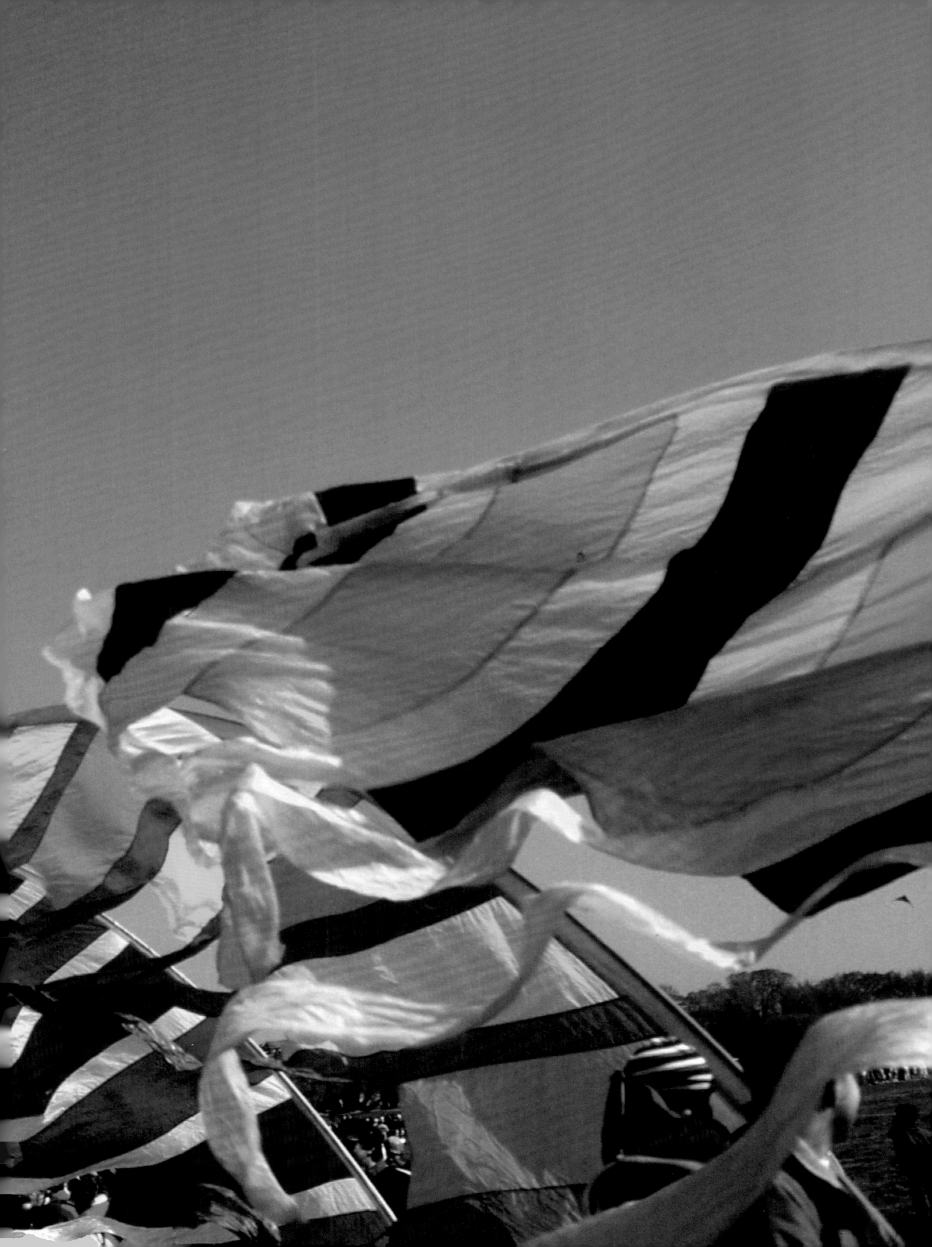

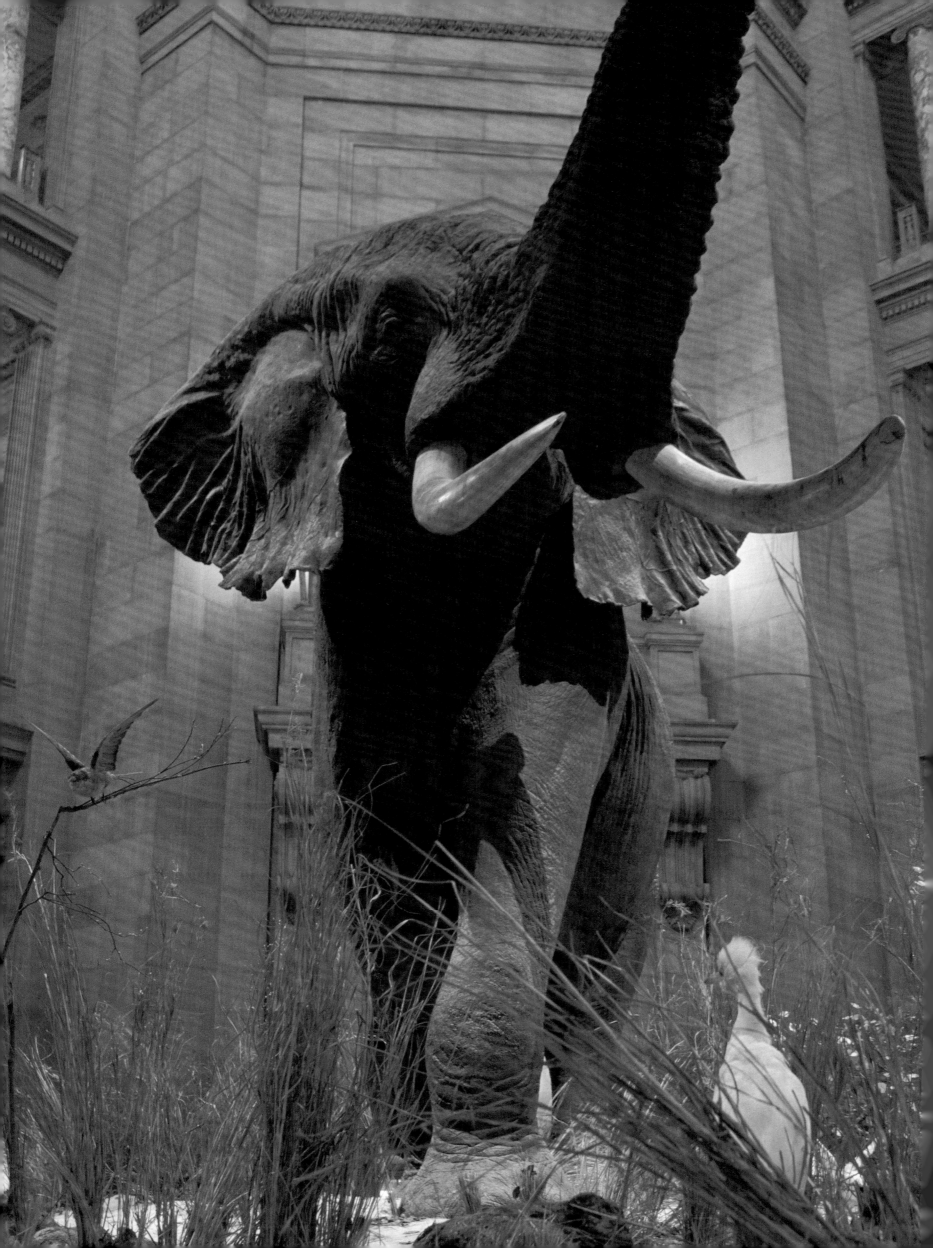

Mammals, dinosaurs, and gemstones are just a few of the many wonders preserved and exhibited at the National Museum of Natural History. Part of the Smithsonian Institution, the museum began its legacy of inspiring curiosity when it opened on the National Mall in 1911. Larger than 18 football fields, the National Museum of Natural History houses 5 million plants, 30 million insects, and 2 million cultural artifacts.

This immense African elephant guards the main floor at the National Museum of Natural History. A notable portion of the museum's early collection is comprised of specimens collected by 25th President of the United States Theodore Roosevelt. After Roosevelt had served two terms as president, he went to Africa on a hunting mission for the Smithsonian Institution and the American Museum of Natural History. Many of the animals he acquired are still on display here at one of Washington, D.C.'s oldest museums. (*left*)

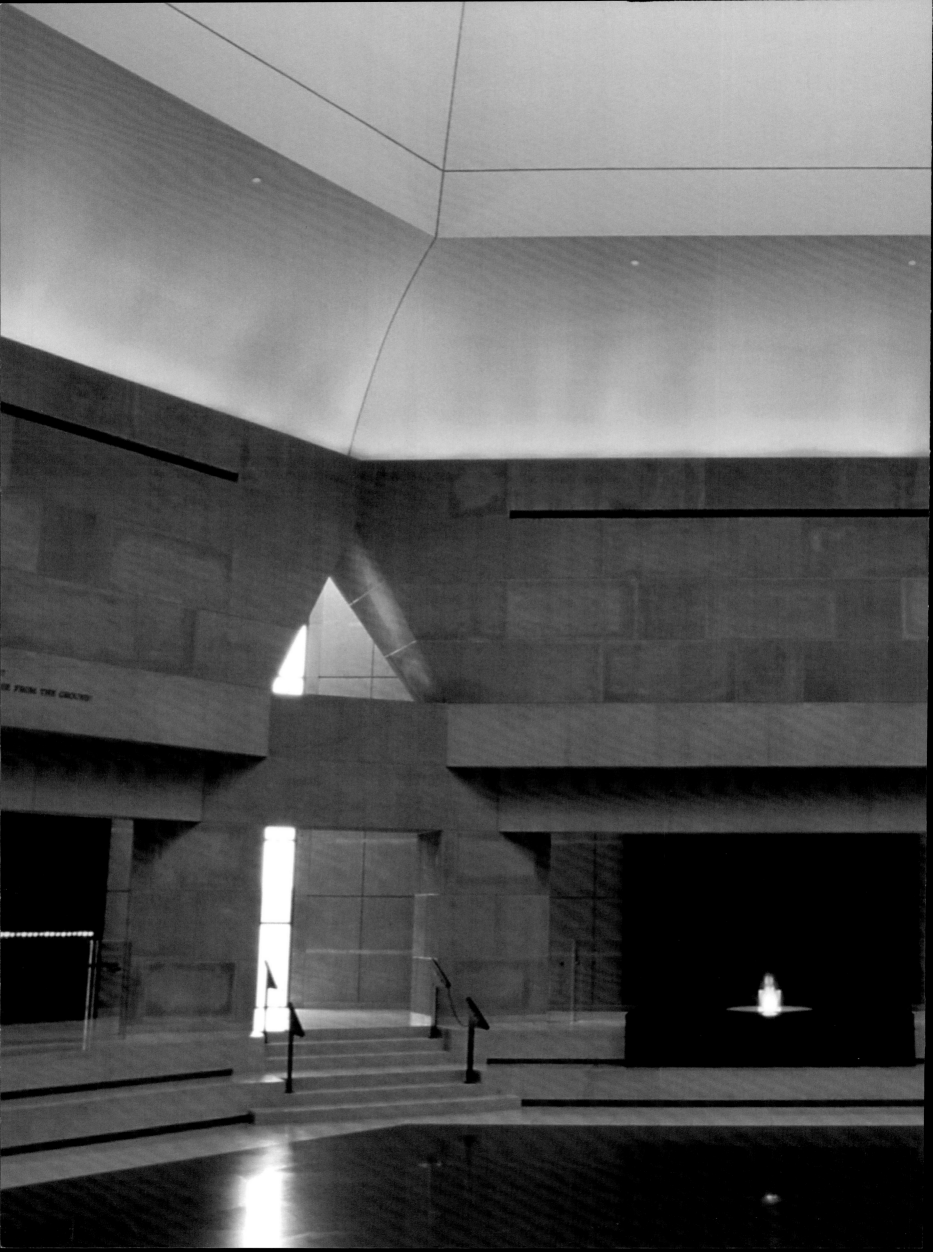

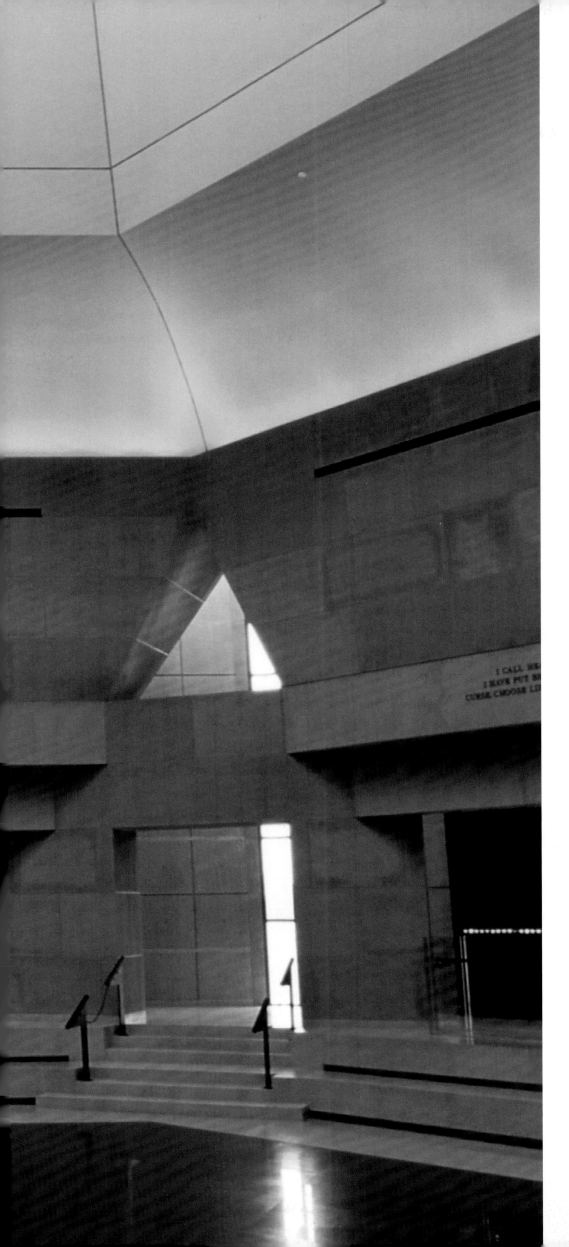

An eternal flame burns in the Hall of Remembrance of the United States Holocaust Memorial Museum to commemorate the lives of the six million Jews who died at the hands of the Nazis. Dedicated to victims of the genocide, the museum chronicles the Nazi rise to power from 1933–45 and the holocaust through pictures, multimedia presentations, and paraphernalia.

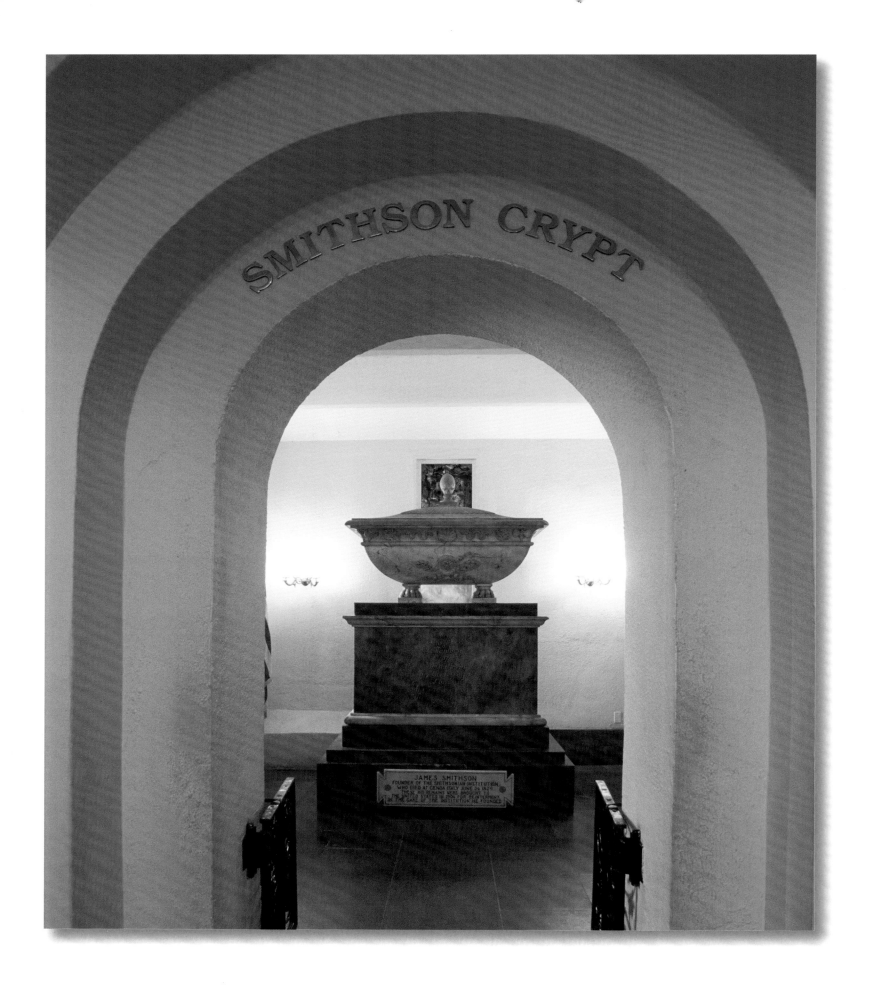

No one knows why English scientist James Smithson left his fortune to open an establishment in Washington, D.C. for "the increase and diffusion of knowledge" when he had never even visited the United States. The bones of this mysterious philanthropist, whose legacy is the Smithsonian Institution, were unearthed from a cemetery in Italy and brought here to the Smithson Crypt in the Smithsonian Castle.

—THE SMITHSONIAN INSTITUTION—

From the National Museum of Natural History to the National Air and Space Museum, the many eclectic buildings of the world's largest museum and research complex dot downtown Washington.

A quintessentially American organization, the Smithsonian Institution was actually bequeathed to the American people by British philanthropist and scientist James Smithson. The illegitimate son of the first Duke of Northumberland, Smithson left his considerable fortune to his nephew when he died in 1829. A clause in Smithson's will, however, stipulated that if his nephew died without heirs the estate should be bestowed to "the United States of America, to found at Washington, under the name of the Smithsonian Institution, an establishment for the increase and diffusion of knowledge." Smithson's nephew died childless in 1835 and over half a million dollars was left to America.

There was a great debate among politicians about whether or not to accept the staggering bequest from a man who had never set foot on U.S. soil. Believing that an institute devoted to knowledge would be positive for Americans, President Andrew Jackson asked Congress to pass legislation allowing him to accept the inheritance. His request was granted in 1836.

Finally accepted, Smithson's funds sparked another debate among the governing parties, this time about what kind of institution to found. Initial ideas centered on a university, but soon other proposals were suggested — a national library, a scientific institute, a museum, or an observatory. Before any decisions about the nature of the institution were reached, however, the Smithsonian Board of Regents authorized the construction of the institute headquarters. Architect James Renwick Jr. was hired to design the sandstone medieval revival-style Smithsonian Building on the National Mall, widely known as the "Castle."

The Smithsonian Institution has expanded into 16 museums, now housing the national collections in natural history, the fine arts, and air and space, among others. Its facilities also include four research centers, the National Zoo, a library, and a press. Except for the university, the far-reaching institute fulfills all the ideas suggested at its founding. Diverse and accessible, the Smithsonian Institution has certainly implemented its benefactor's wishes, and made incalculable contributions to the arts, sciences, history, and research in America. (*overleaf*)

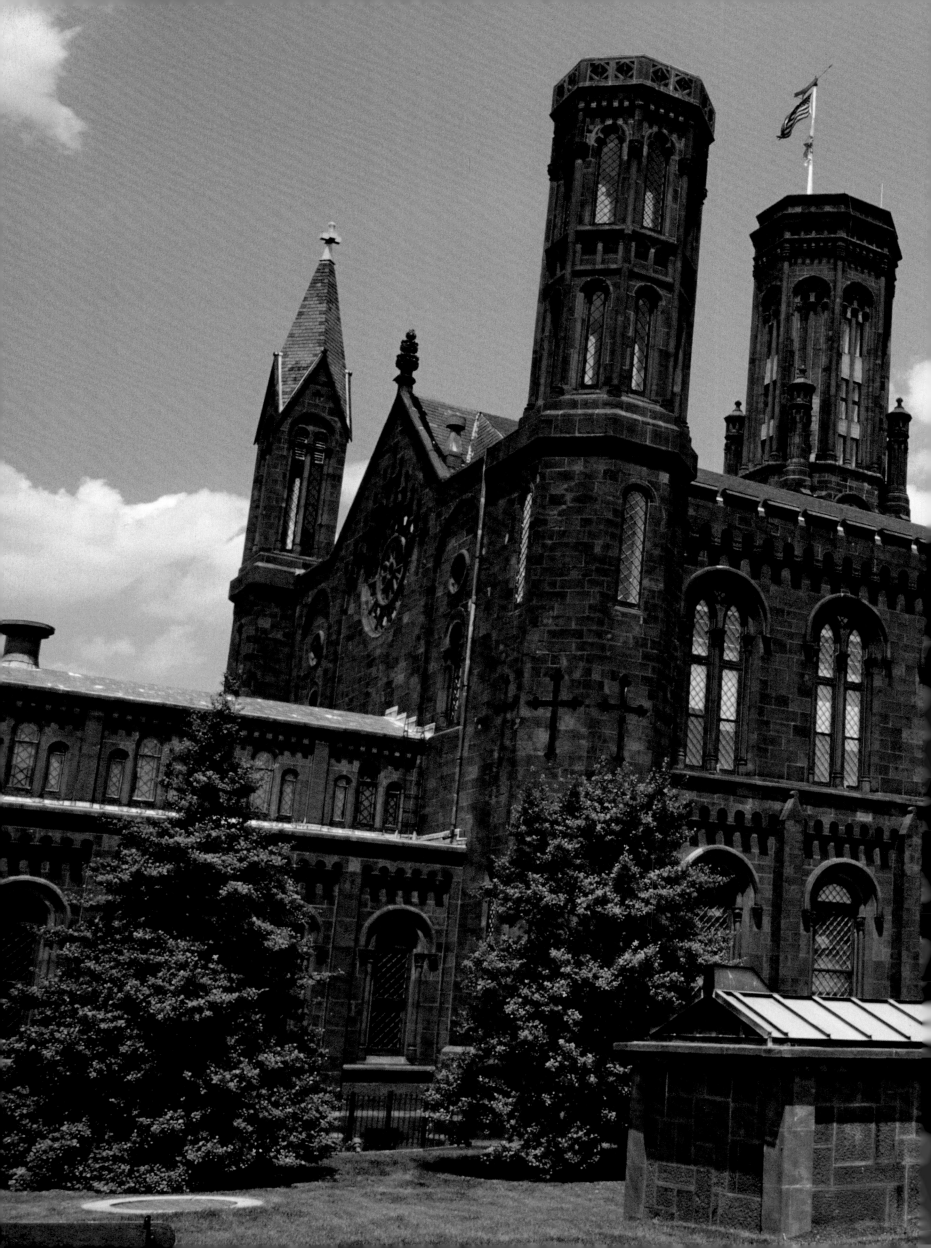

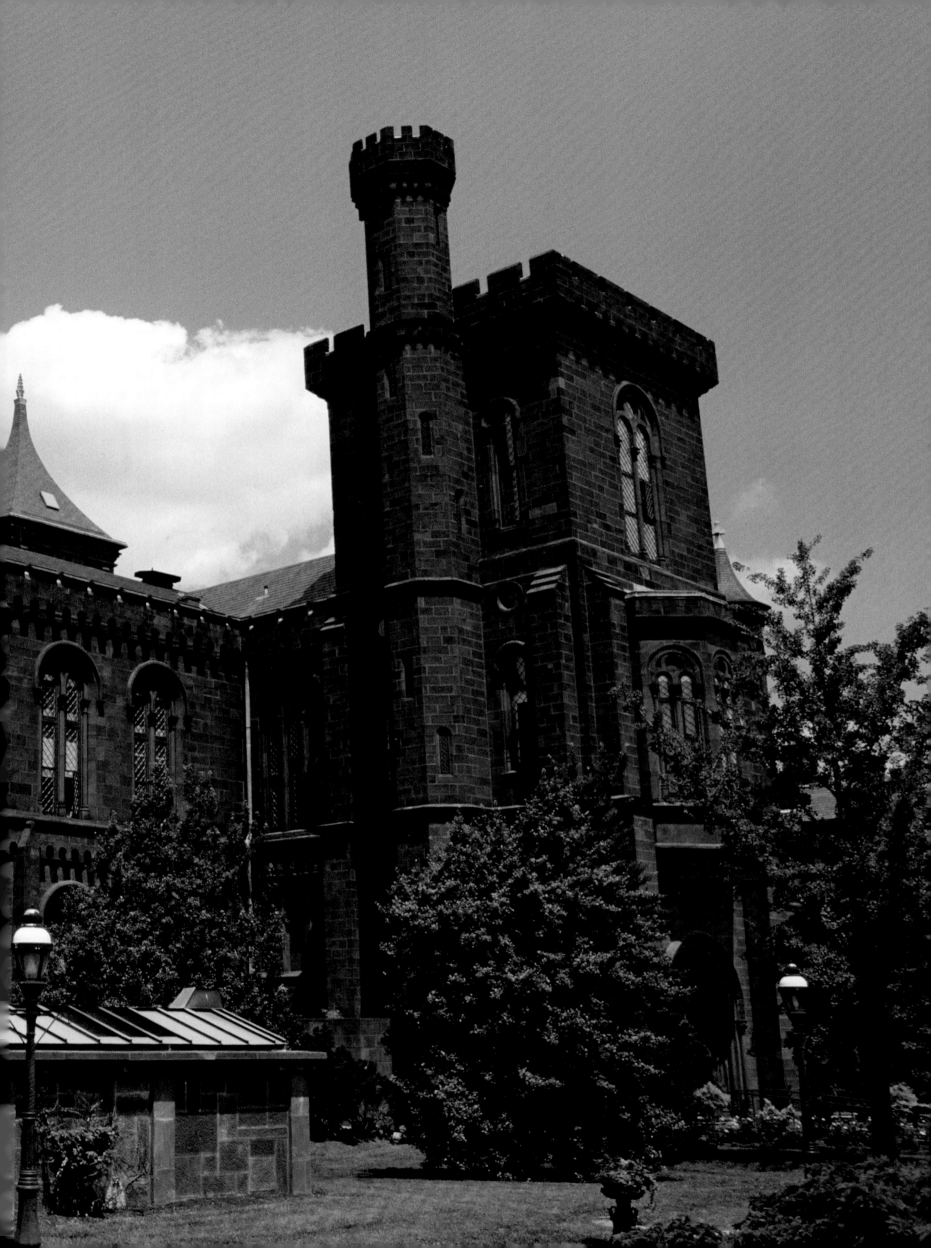

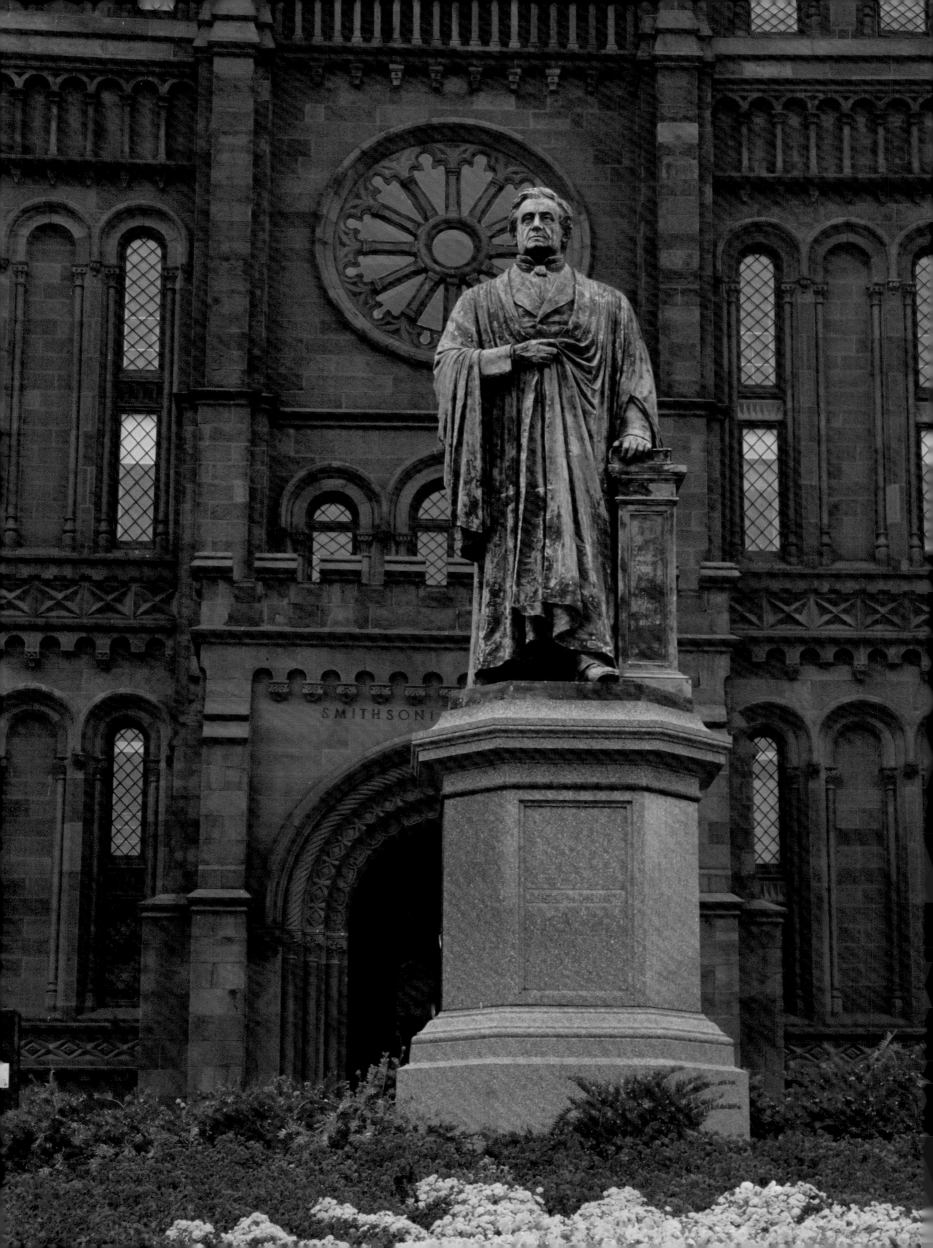

Designed by French sculptor Frédéric-Auguste Bartholdi, who would later create the Statue of Liberty, this 30-foot-high fountain is located across the street from the U.S Botanic Garden. With a mandate to examine and support the earth's ecosystems and enhance human life, the United States Botanic Garden can display more than 4,000 plants.

One of the greatest American scientists and the first secretary of the Smithsonian Institution, Joseph Henry is immortalized in bronze outside the Smithsonian Institution Building that once served as his home. The 19th-century physicist, Princeton professor, and the co-founder of the National Academy of Sciences provided the basis for the electrical telegraph with his work in electromagnetism. (*left*)

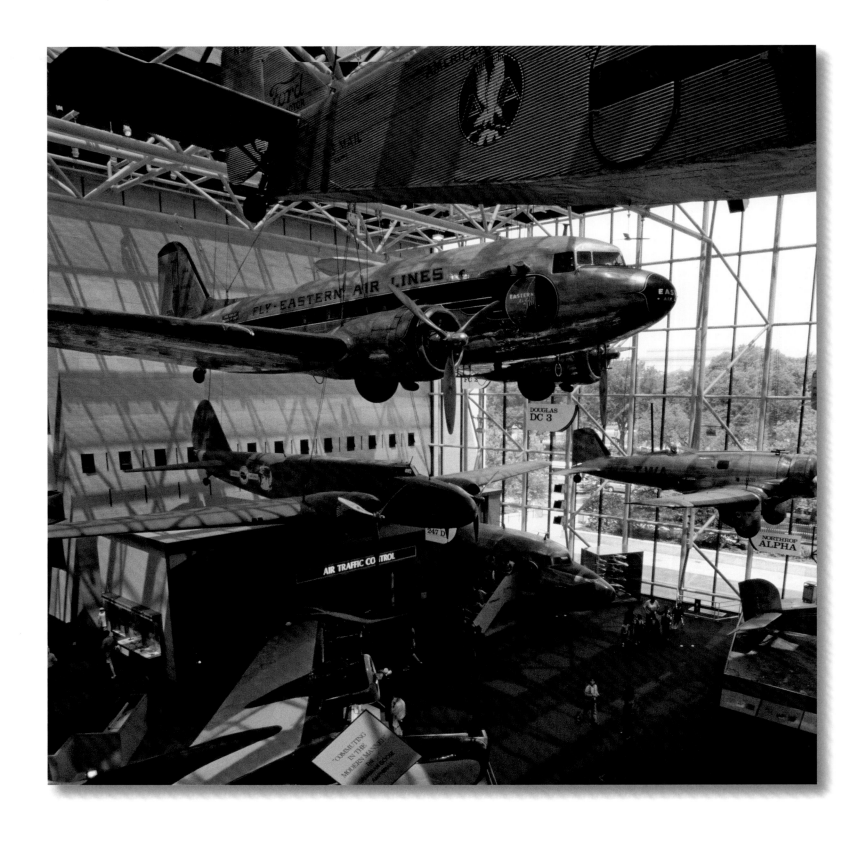

There is such an immense, impressive display of rockets, satellites, and aircraft at the National Air and Space Museum that they are literally hanging from the rafters. One of the most popular attractions in the United States, this museum features exhibitions entitled Milestones of Flight, Space Race, Explore the Universe, Early Flight, Pioneers of Flight, and Apollo to the Moon.

The suits worn by Neil Armstrong and Buzz Aldrin when they became the first people to visit the moon's Sea of Tranquility are displayed at the National Air and Space Museum. Their original Teflon-coated fiberglass outfits stand alongside the original flight deck from Apollo 17 and interactive displays of every U.S. space mission since 1962. (*right*)

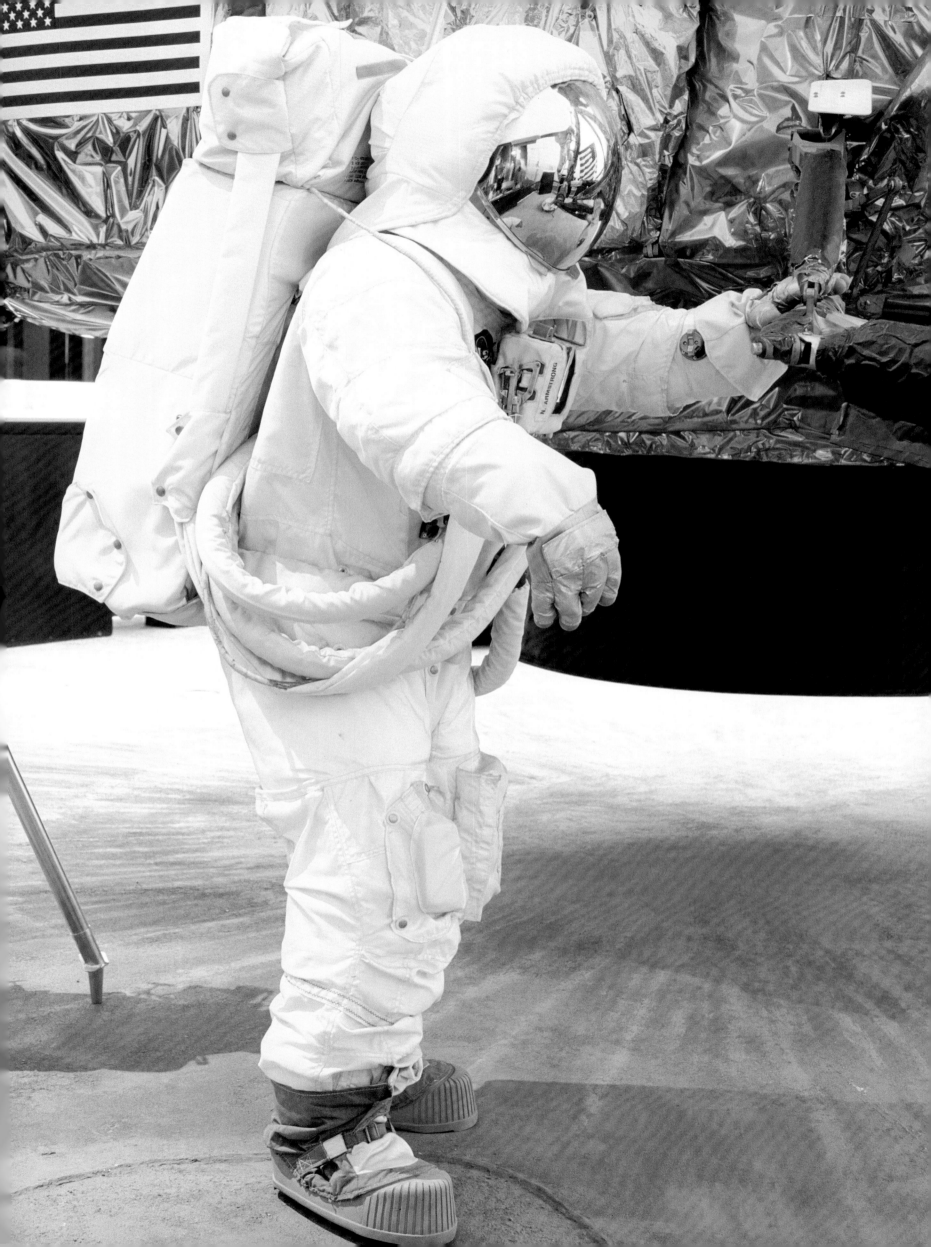

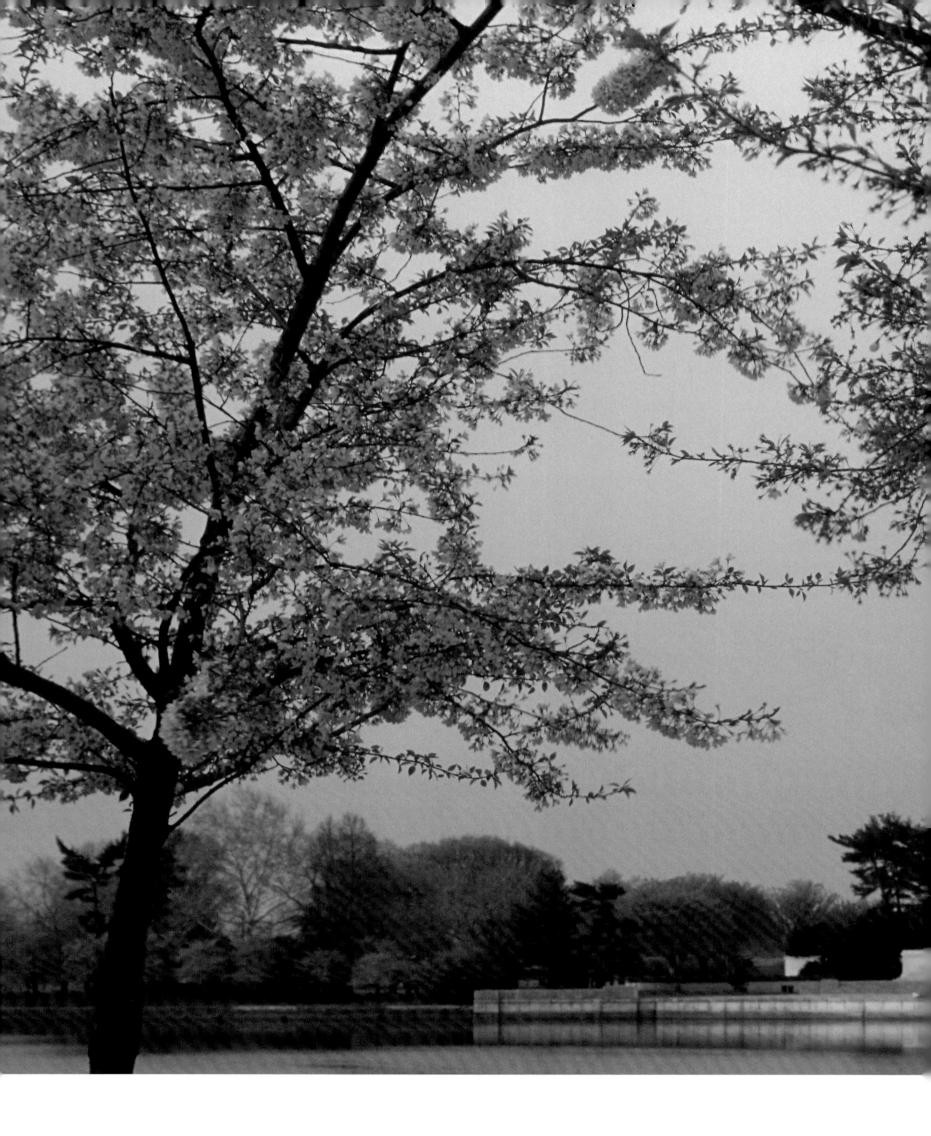

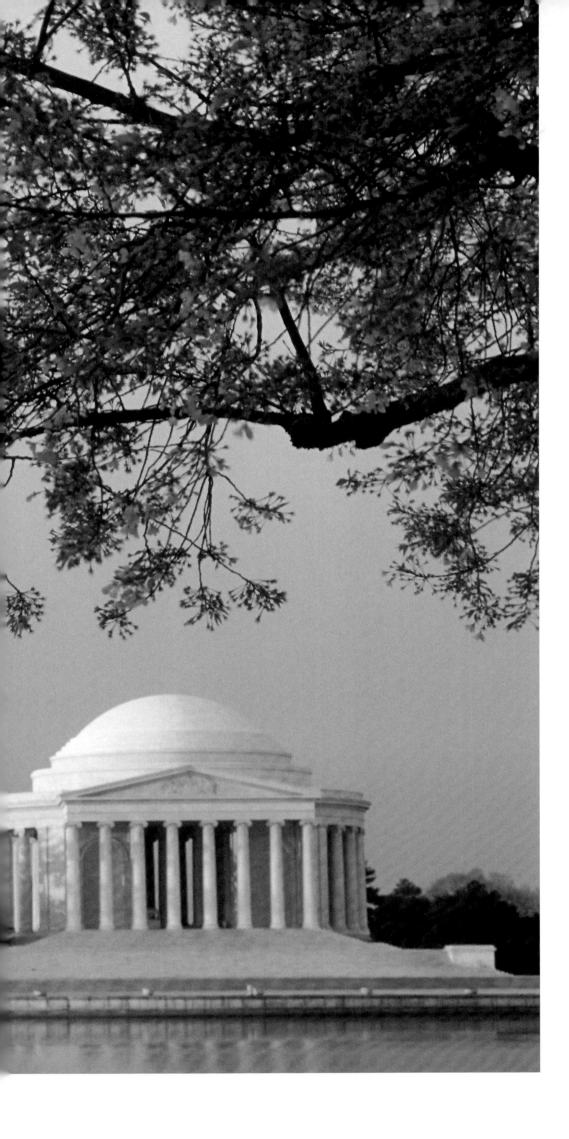

Commemorating Thomas Jefferson, the third President of the United States and one of America's founding fathers, the neoclassical Jefferson Memorial is based on the Pantheon of Rome. The cornerstone of this stately building with a white marble rotunda and 26 columns was laid in 1939.

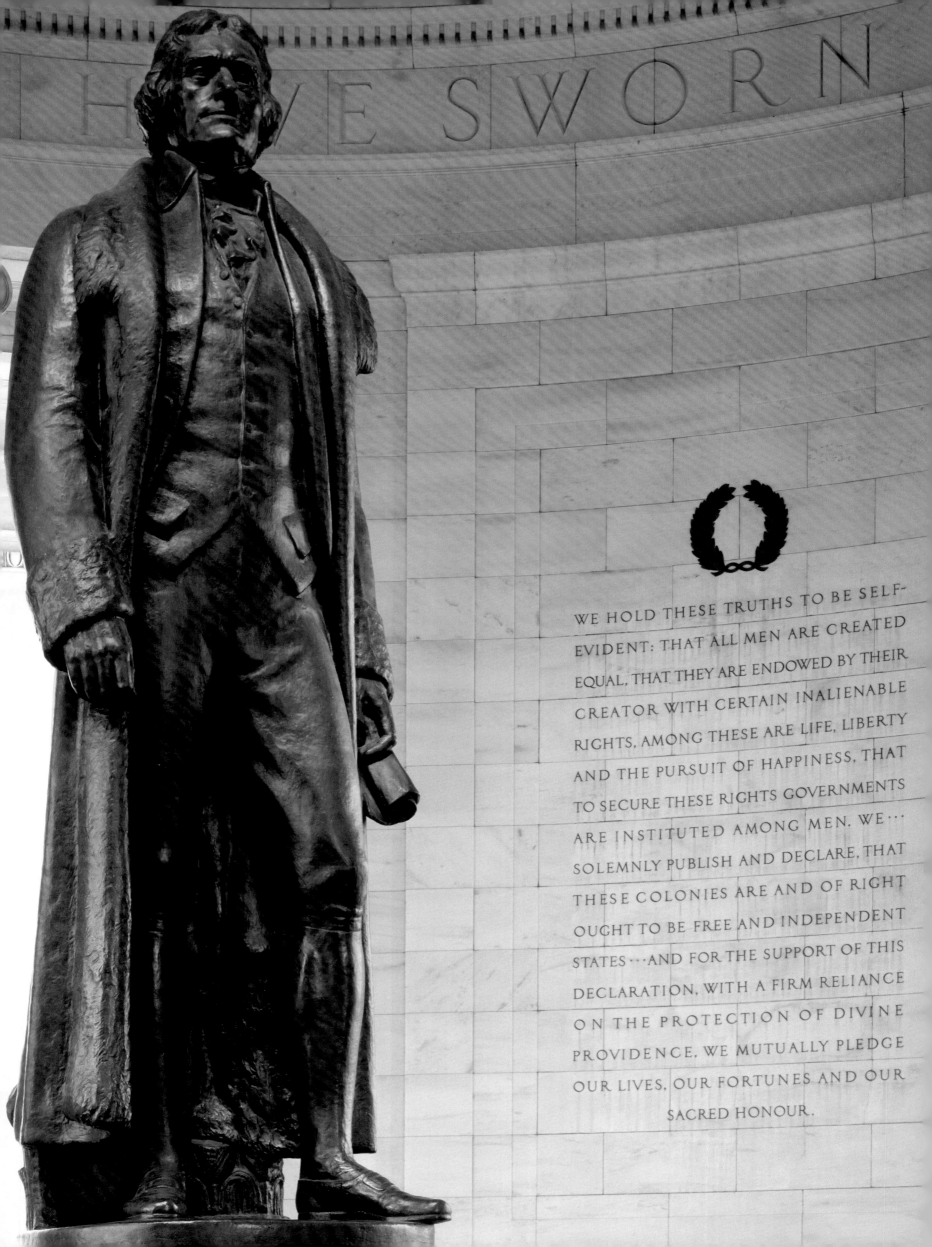

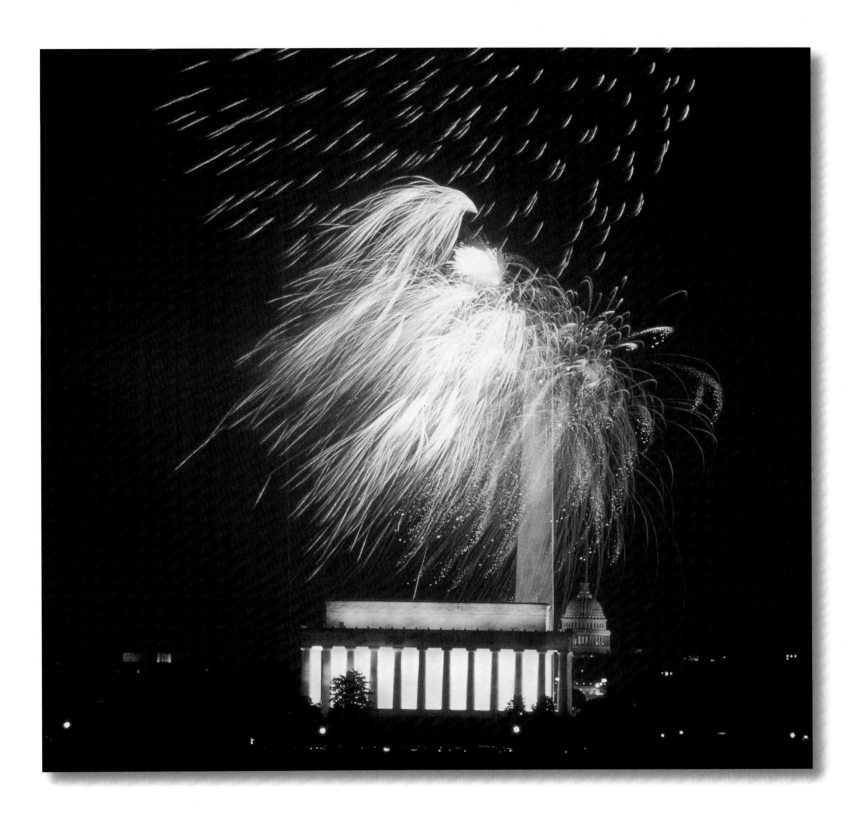

On Independence Day, fireworks illuminate three of Washington, D.C.'s most dignified sights: the Lincoln Memorial, the Washington Monument, and the United States Capitol building. Huge festivities commemorate the Fourth of July, the date on which the Declaration of Independence was signed in 1776 in America's capital city.

A 10,000-pound bronze statue of Thomas Jefferson stands 19 feet tall within the Jefferson Memorial on the National Mall. Inscribed on the walls around the iconic figure are excerpts from his writings, notably the Declaration of Independence. Proclaiming the 13 colonies' independence from the Kingdom of Great Britain and the founding of the United States of America, the declaration was adopted by congress on July 4, 1776. (*left*)

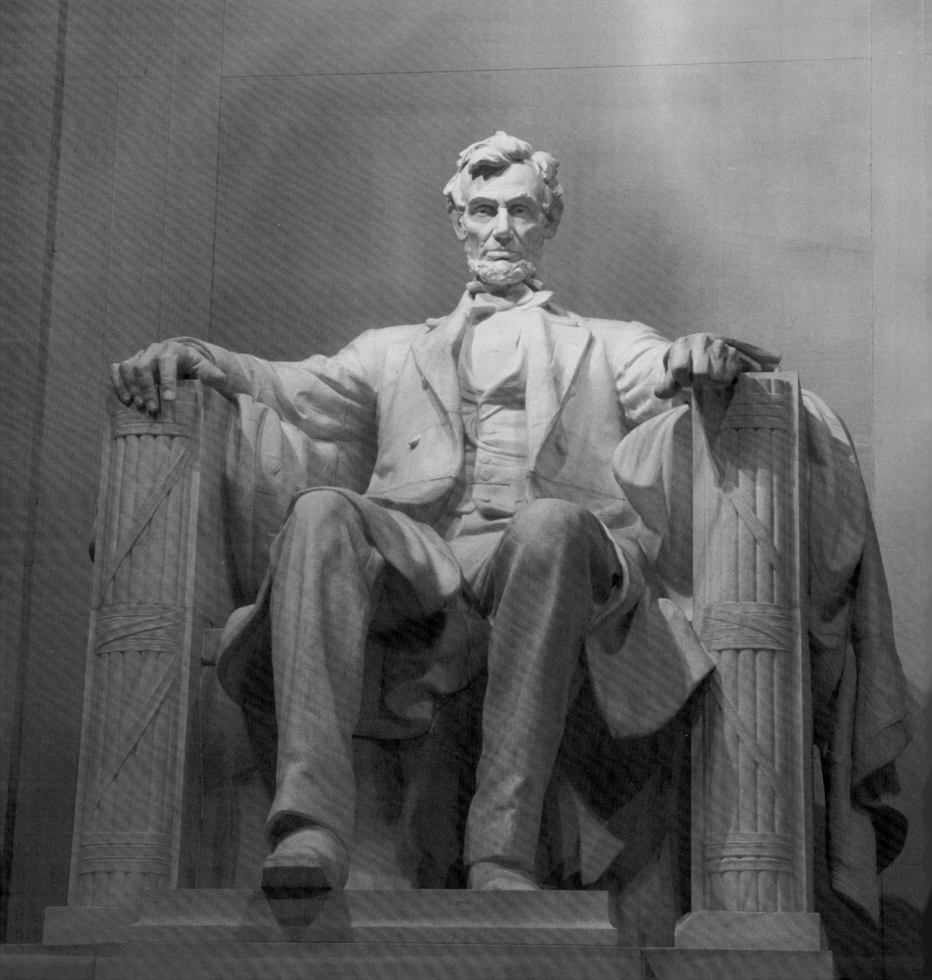

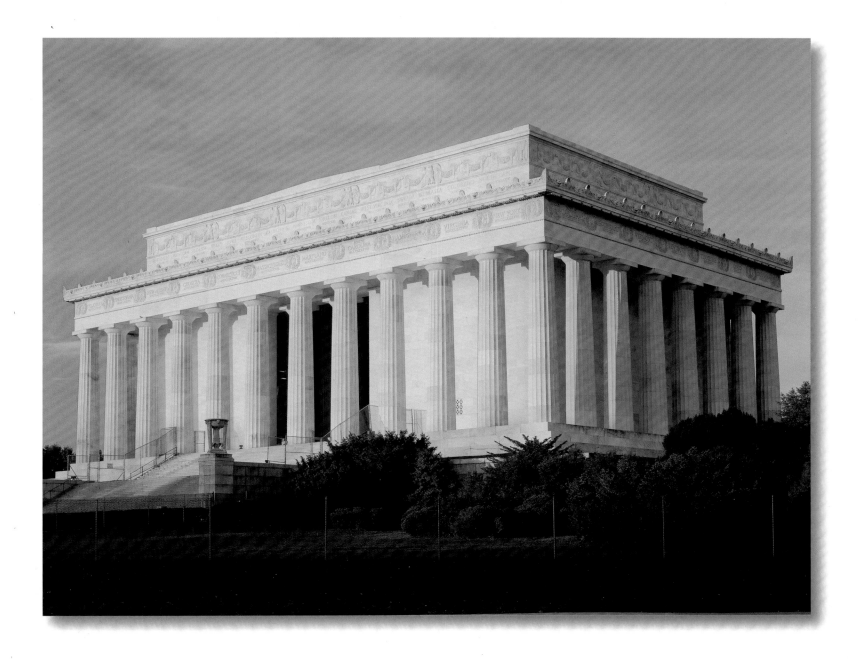

This Greek-style temple was built to honor Abraham Lincoln, the 16th President of the United States. The elegant memorial's 36 columns represent the number of states that were part of the Union when Lincoln was assassinated in 1865. The names of the 48 states that comprised America in 1922 when the memorial was completed are engraved around the top. The Lincoln Memorial is an important center for social activism, hosting marches, speeches, and protests. It was here in 1963 that Martin Luther King Jr. delivered his "I Have a Dream" speech.

This striking figure of Abraham Lincoln sits inside the elegant Lincoln Memorial, with celebrated lines from his second inaugural address and the Gettysburg Address engraved on the walls around him. Daniel Chester French carved the 19-foot-tall statue out of 28 blocks of white Georgia marble, striving to depict both the determination and compassion for which Lincoln is remembered. (*left*)

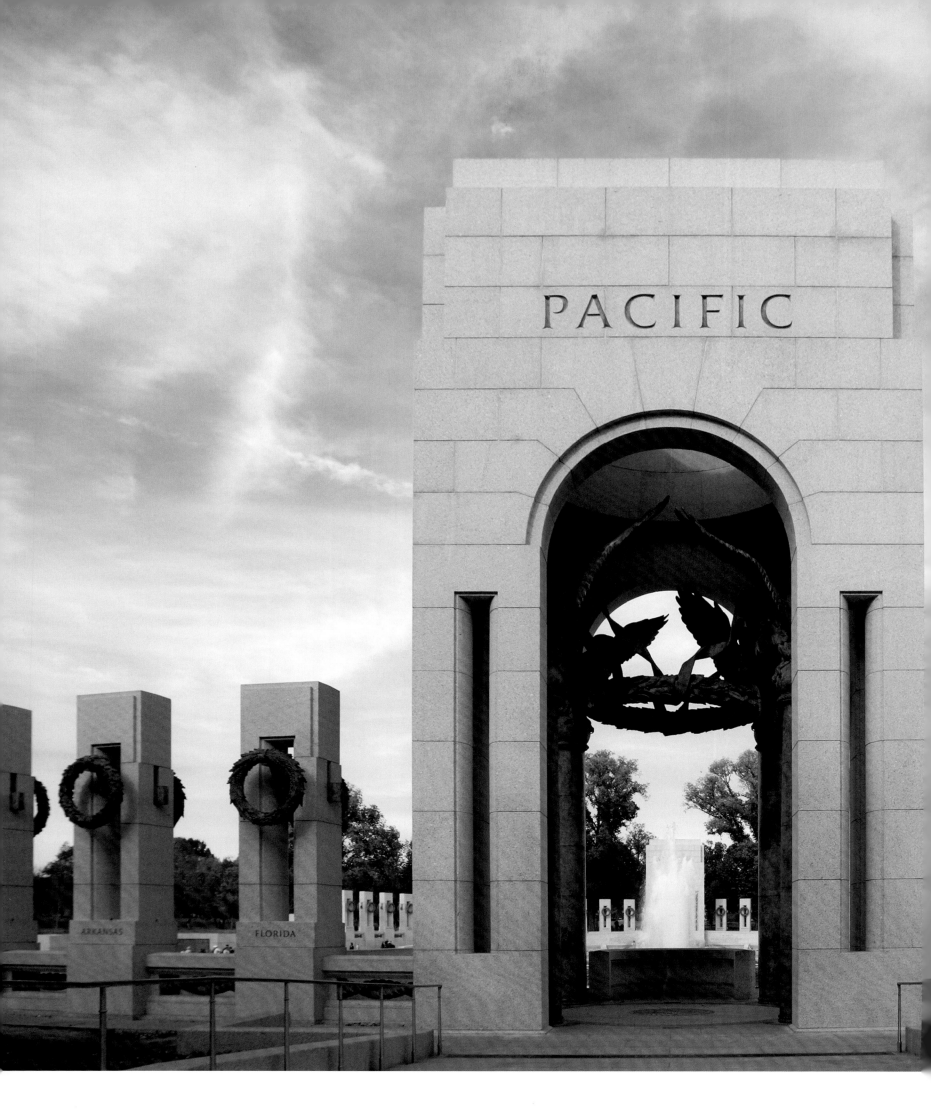

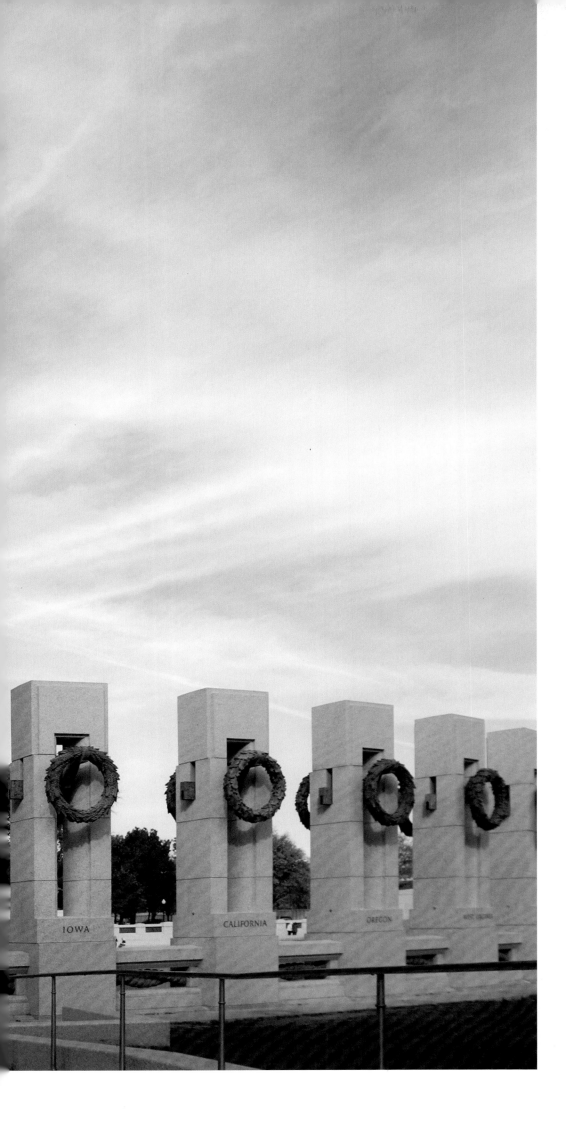

Honoring the 16 million soldiers who served the United States in World War II and those who supported the effort from home, the WWII Memorial is the only commemorative site on the central axis of the National Mall dedicated to a 20th-century event. Presiding over each end of the memorial are 43-foot-tall arches, named for the Pacific and Atlantic Oceans. Designed by Friedrich St. Florian, the monument opened to the public in 2004.

The Washington Monument is framed by two of the 56 pillars at the World War II Memorial. Forty-eight of the 17-foot-tall pillars are inscribed with the names of the American states during the Second World War. The remaining columns are named for the District of Columbia, Alaska, Hawaii, Puerto Rico, the Philippines, Guam, Samoa, and the Virgin Islands.

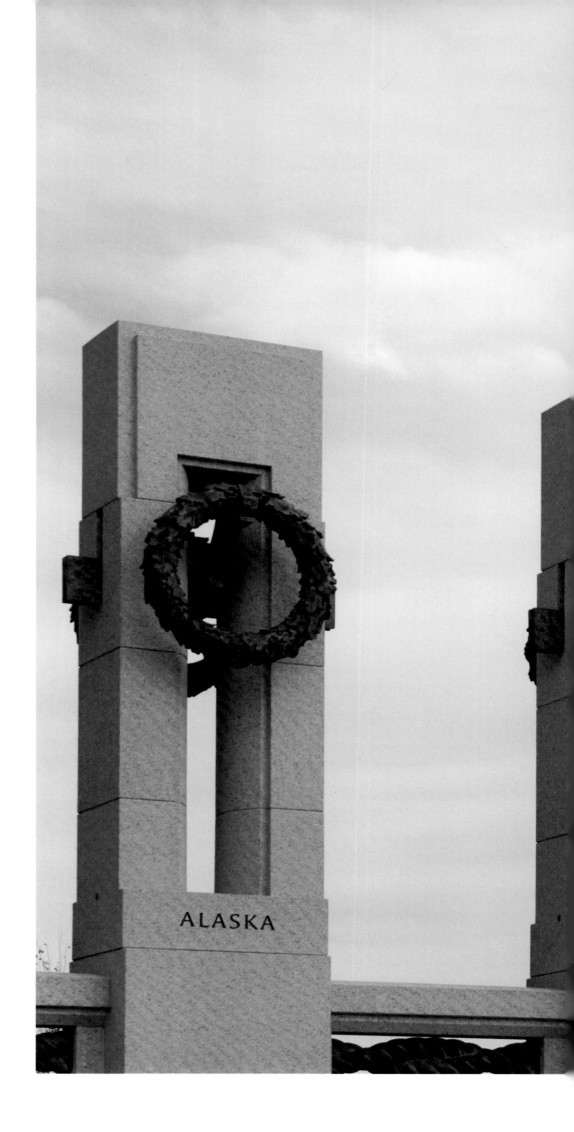

ALASKA

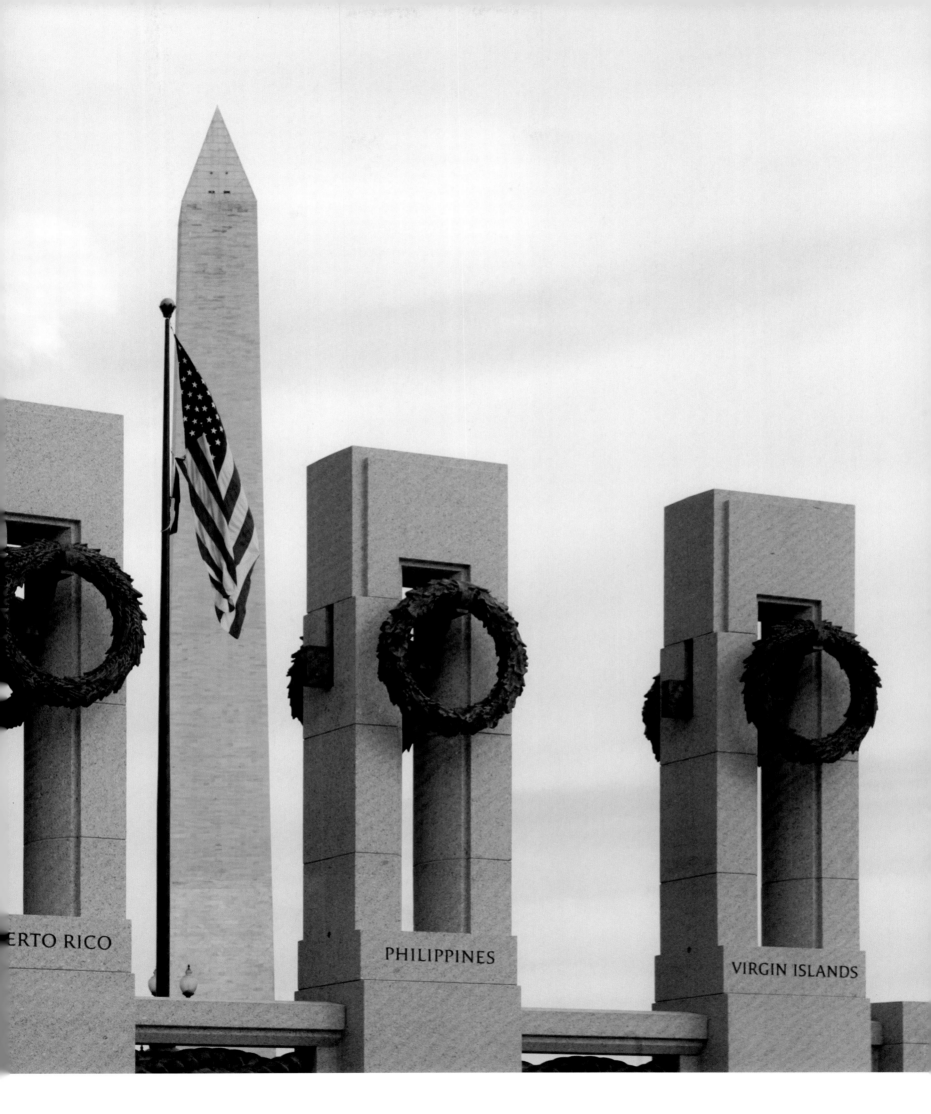

ERTO RICO

PHILIPPINES

VIRGIN ISLANDS

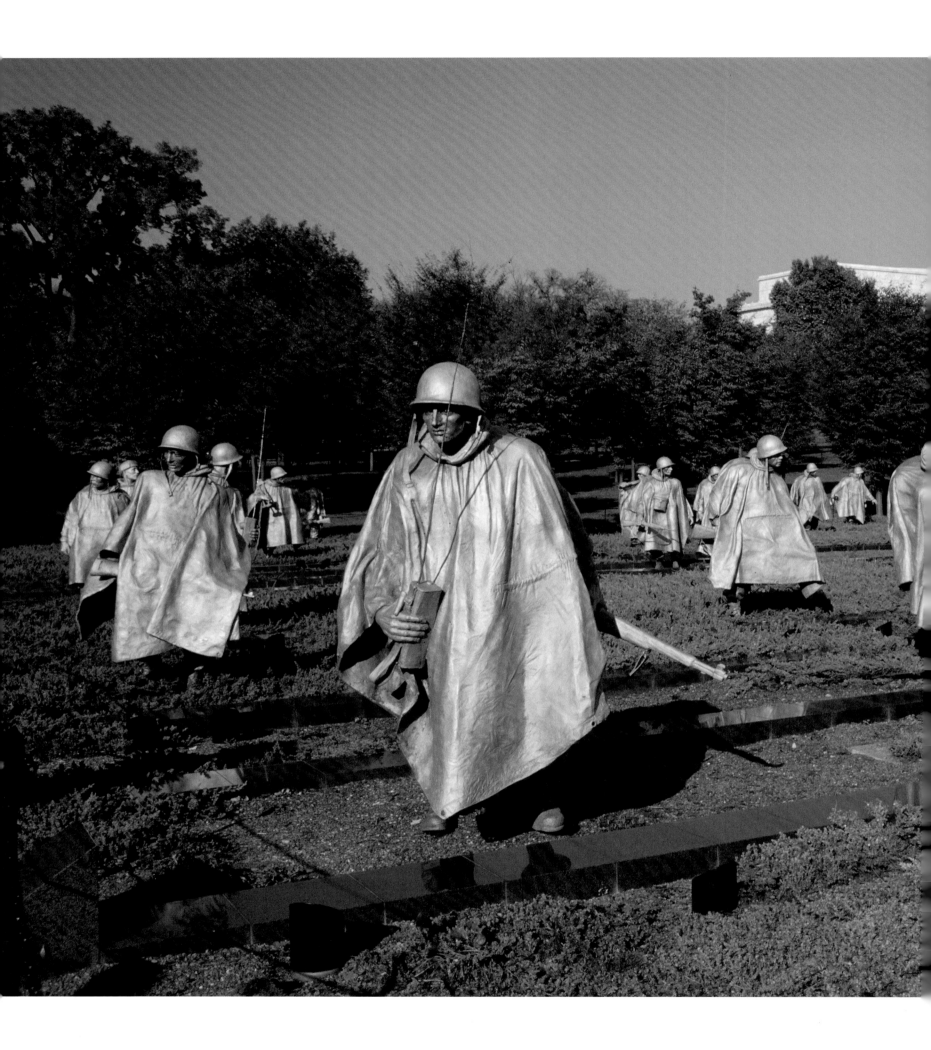

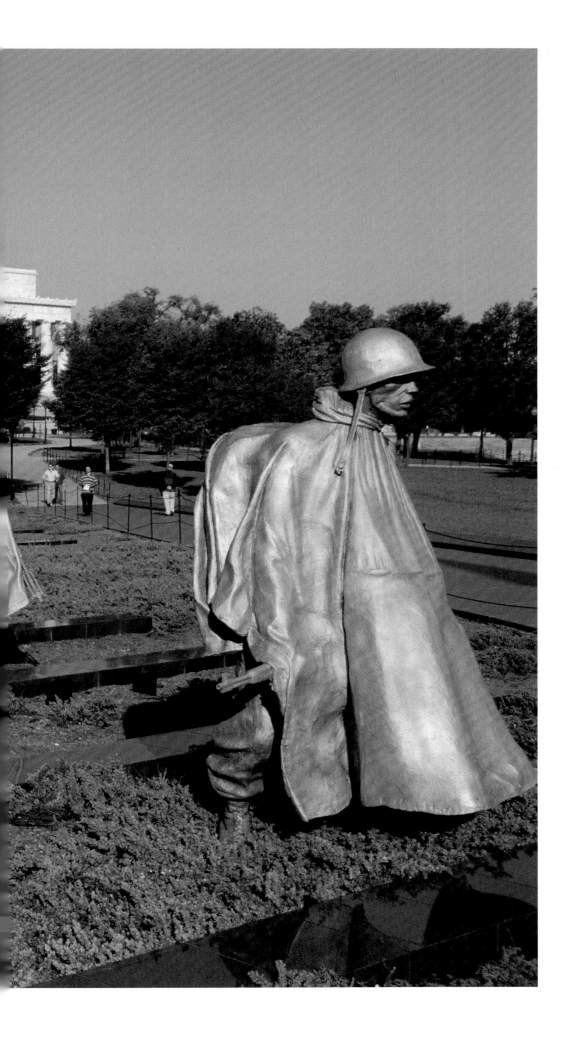

Nineteen larger-than-life soldiers stand on the National Mall in the Field of Remembrance as part of the Korean War Veterans Memorial. Each over seven feet tall, the stainless steel statues represent a combat squad dressed in full military gear trekking through the Korean landscape. Dedicated in 1995, the monument also features the Pool of Remembrance and a 164-foot-long granite wall etched with images of soldiers and equipment that bears the inscription "Freedom is not free."

——THE VIETNAM VETERANS MEMORIAL——

One of the most visited sites on the National Mall, the Vietnam Veterans Memorial is composed of three separate tributes to those who fought, fell, and supported the American cause in the Vietnam War.

After the dust of the controversial war settled, former infantry corporal Jan Scruggs committed himself to a new cause — establishing a monument on the National Mall to all the conflict's casualties. In 1979 Scruggs founded the Vietnam Veterans Memorial Fund, Inc. (VVMF), a nonprofit organization with the goal of building a tribute to every American who died or went missing during the 1956 – 79 conflict. Inscribed with the fallen soldiers names, the monument was to be an apolitical tribute that could repair the national rift caused by the divisive war and reunite the country through mourning and reverence.

There was overwhelming support for the VVMF's cause. More than a quarter of a million people, corporations, unions, and other foundations donated over $8.4 million to build the Vietnam Veterans Memorial. Intent on building the tribute among the other national monuments on the mall, the VVMF appealed to Congress for permission to erect the Vietnam Veterans Memorial near the Lincoln Memorial.

Once Congress passed a bill assigning two acres on the mall for the memorial, the VVMF held a national competition for its design. A panel of eight internationally recognized artists and designers unanimously selected Yale student Maya Lin's plan for a stark memorial wall from almost 1,500 entries. Anchored onto the National Mall with one panel pointing towards the Lincoln Memorial and the other to the Washington Monument, Lin's design of two 247-foot-long black granite walls inscribed with over 58,000 names is a profound memorial that led to another storm of controversy.

Many viewed the simple monument as an inadequate legacy for Vietnam's casualties, too plain to sit among the extravagant monuments on the National Mall. In keeping with the spirit of reconciliation, a compromise was reached, and sculptor Frederick Hart's more traditional *Three Servicemen* statue depicting young soldiers draped in weapons and ammunition was also erected on the memorial site.

Inspired by a former army nurse who didn't feel properly represented by the Vietnam Veterans Memorial, the monument's latest addition is the Vietnam Women's Memorial. A bronze sculpture of three women tending to a wounded soldier, the memorial pays tribute to the 11,000 women stationed in Vietnam, the eight who died, and the thousands of women who supported the cause from American soil.

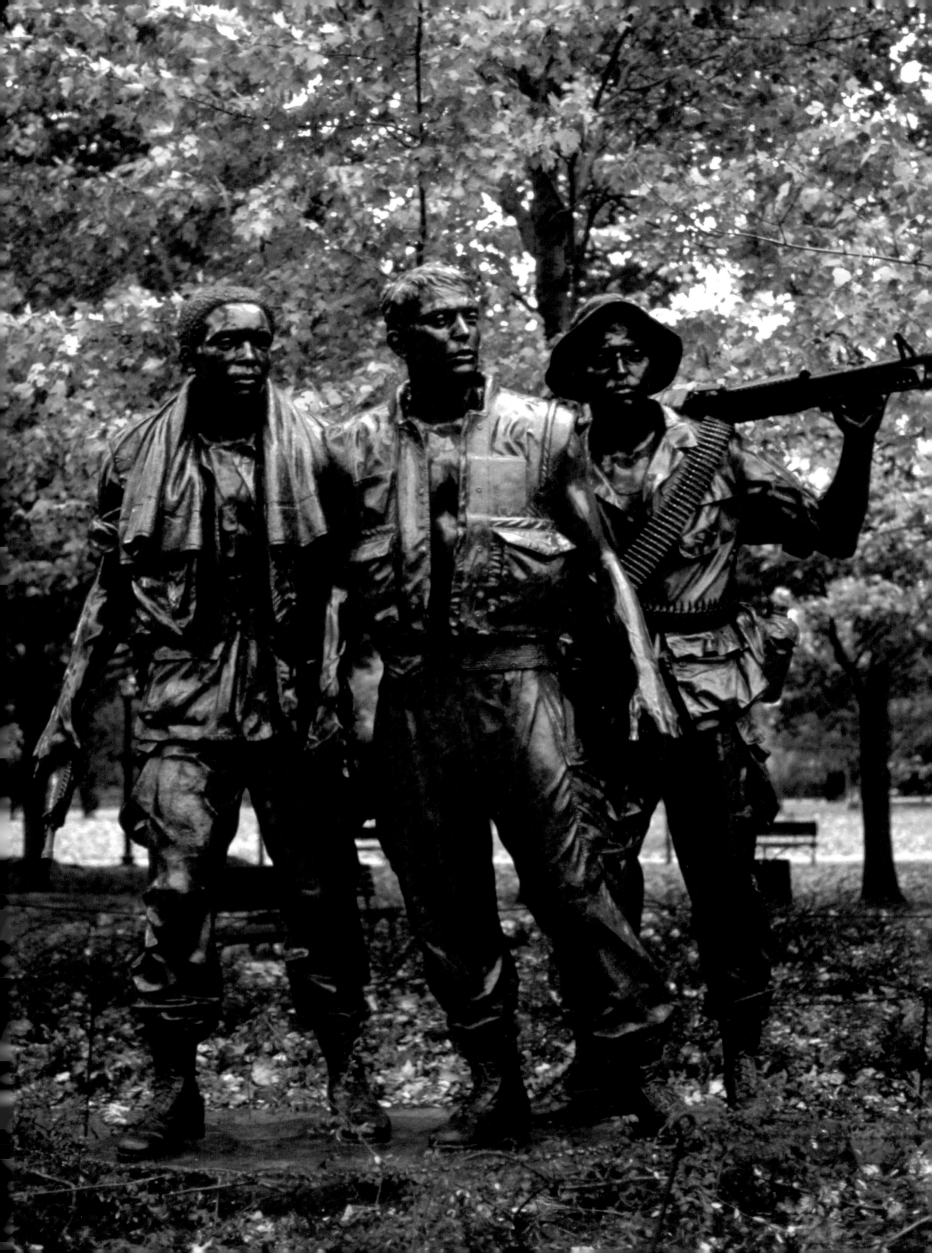

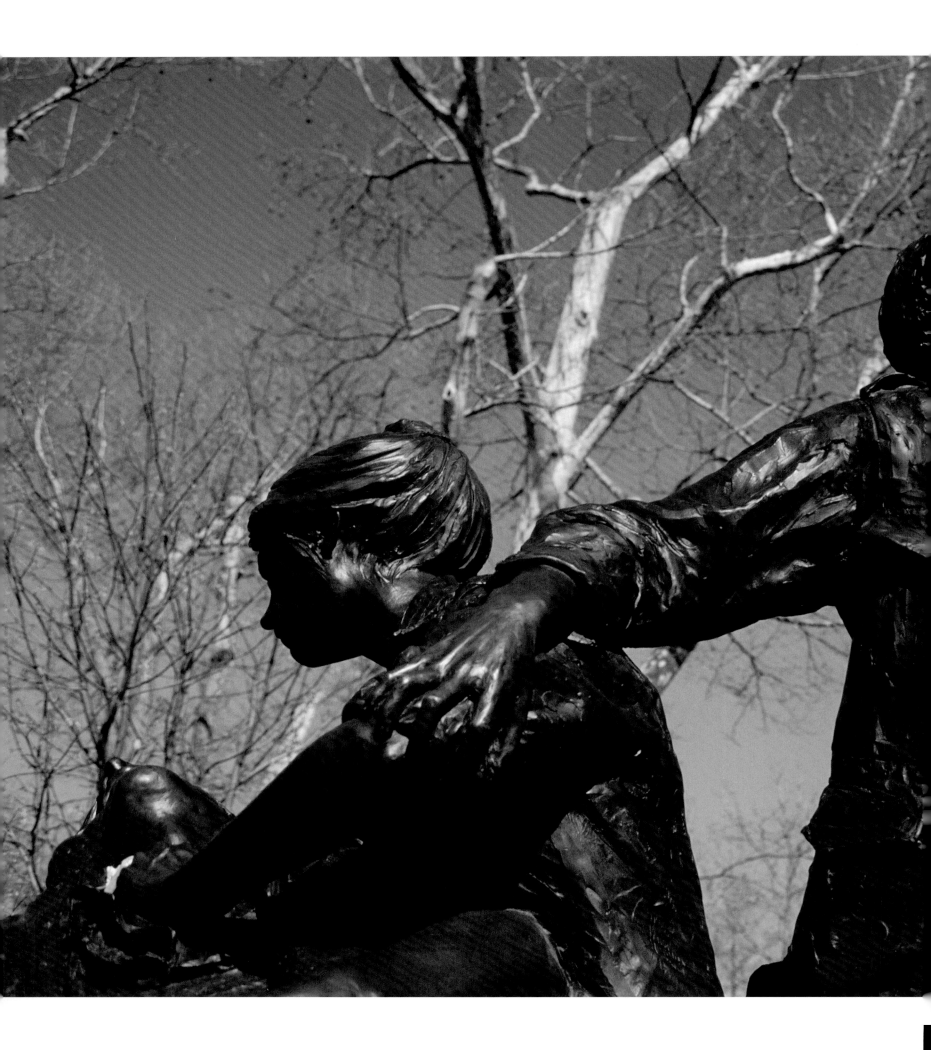

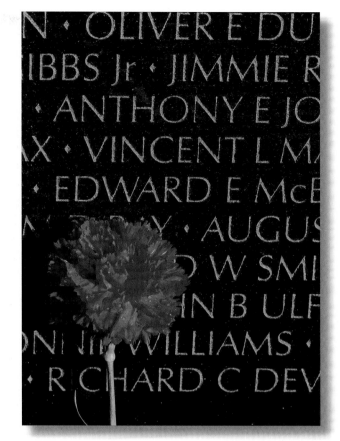

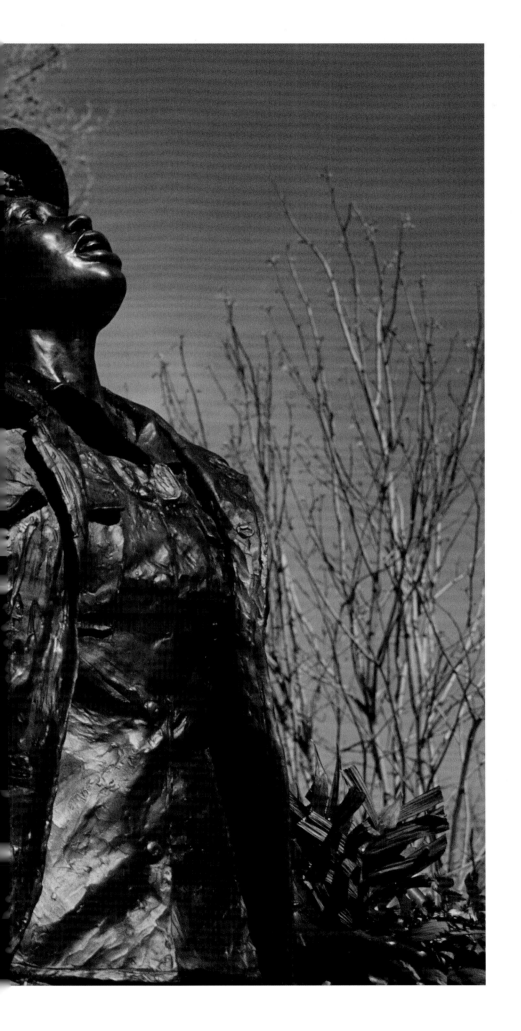

The two 247-foot-long walls of the stark Vietnam Veterans Memorial Wall are made of granite that was imported from India for its unique reflective quality. When visitors face the Memorial Wall their reflections in the shiny black granite merge with the names of the almost 60,000 soldiers lost or killed during the Vietnam War, symbolically uniting past and present.

Uniformed women tend to a wounded man in the Vietnam Women's Memorial, the first national memorial commemorating female veterans. Dedicated on November 11, 1993, this bronze memorial honors the work of the approximately 11,500 American women who served in Vietnam. (*left*)

This expansive memorial dedicated to Franklin Delano Roosevelt, the 32nd President of the United States, is divided into four sections as a symbol of the number of terms he held office. FDR sits here with his beloved dog Fala, with lines from his speeches engraved on the wall behind him. Roosevelt served through both the Great Depression and World War II and is widely considered to be one of America's greatest presidents.

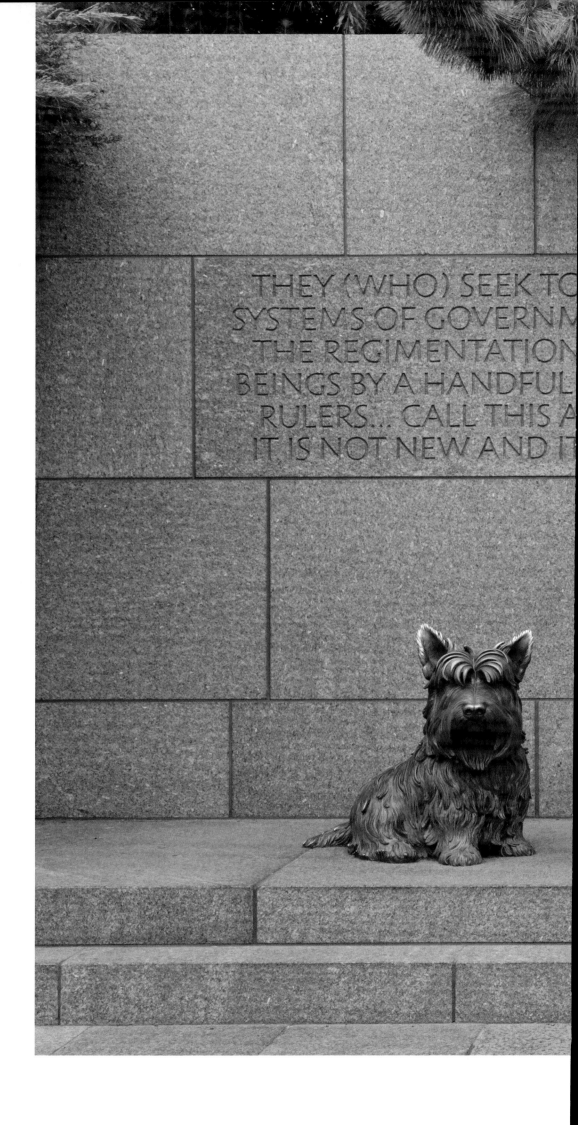

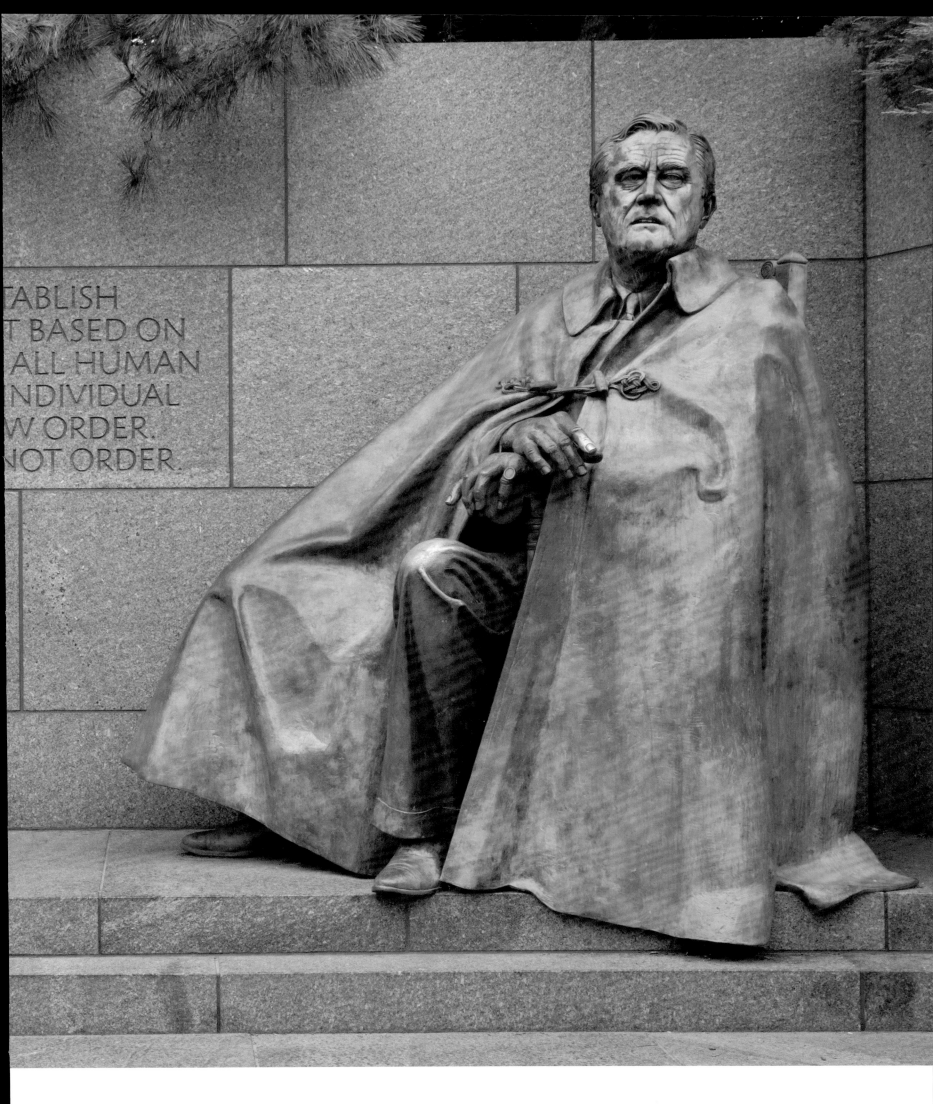

ABLISH
BASED ON
ALL HUMAN
NDIVIDUAL
W ORDER.
NOT ORDER.

Depicted standing before the United Nations emblem at the FDR Memorial, First Lady Eleanor Roosevelt is commemorated for her dedication to human rights and her role as a UN delegate. During her own political career, Eleanor was an activist who championed the rights of women, the New Deal, and civil rights. Eleanor was the first chair of the Commission on Human Rights, the committee that drafted and approved the Universal Declaration of Human Rights.

Stretching over a mile from the Washington Monument to the United States Capitol, the National Mall was designed by Pierre L'Enfant Charles in his original plans for Washington in the 18th century but not fully realized until the early 20th century. The extensive network of gardens, canals, and green spaces of this dignified stretch is home to some of the city's most epic monuments, memorials, and museums — from the Jefferson Memorial to the Vietnam Veterans Memorial and the National Museum of Natural History. (*overleaf*)

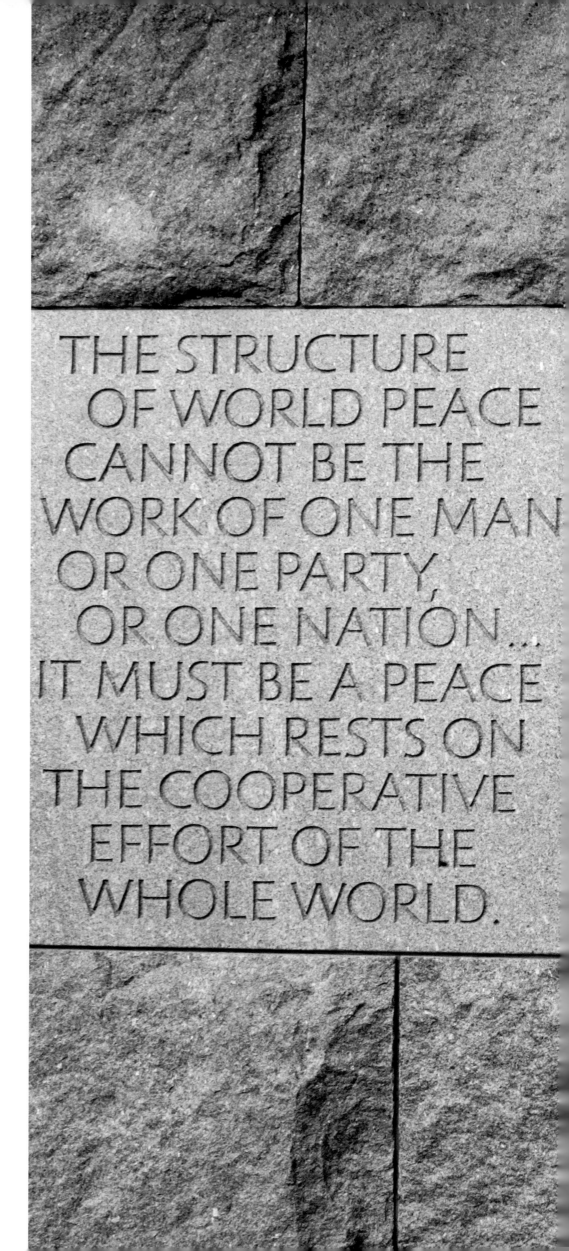

THE STRUCTURE OF WORLD PEACE CANNOT BE THE WORK OF ONE MAN OR ONE PARTY, OR ONE NATION... IT MUST BE A PEACE WHICH RESTS ON THE COOPERATIVE EFFORT OF THE WHOLE WORLD.

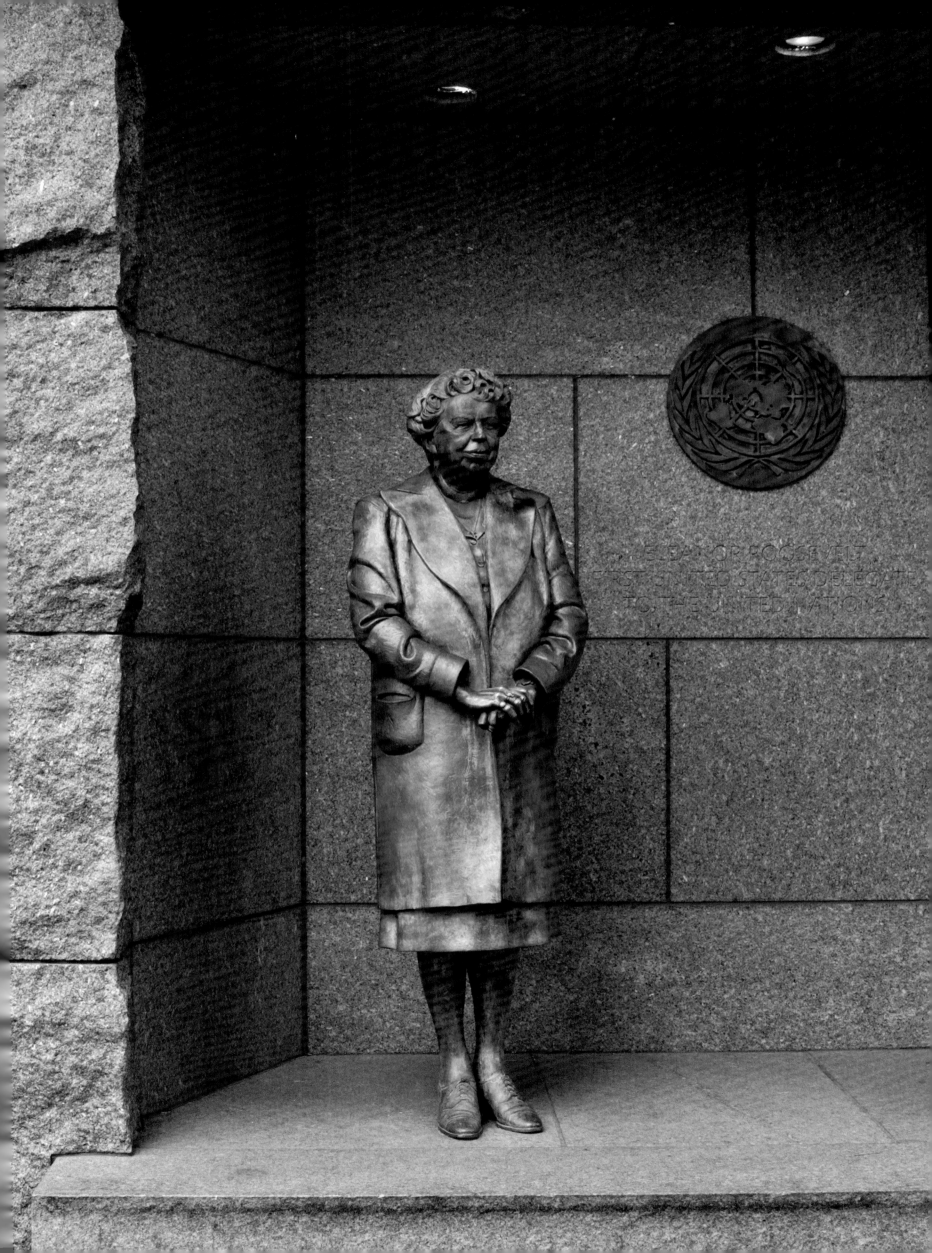

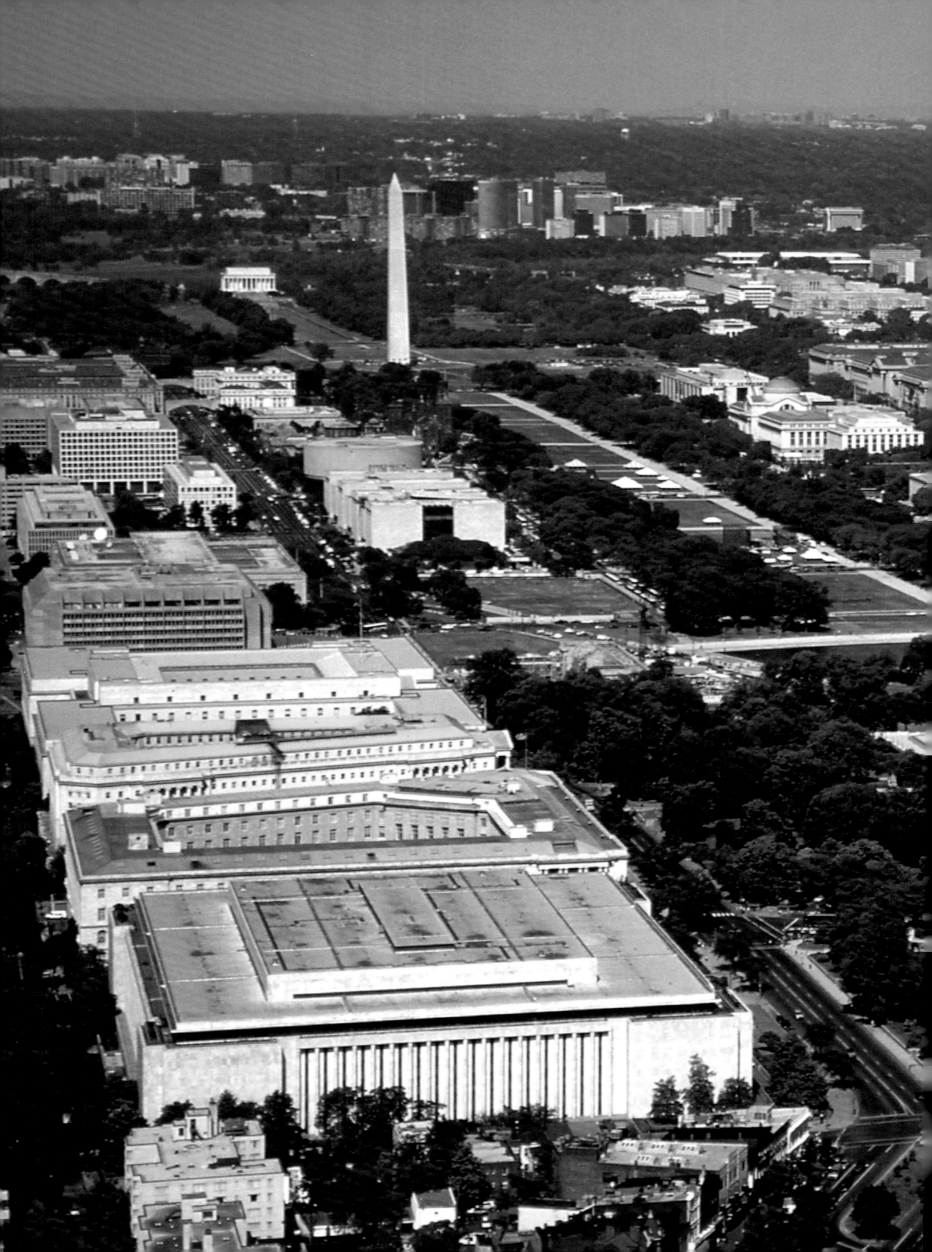

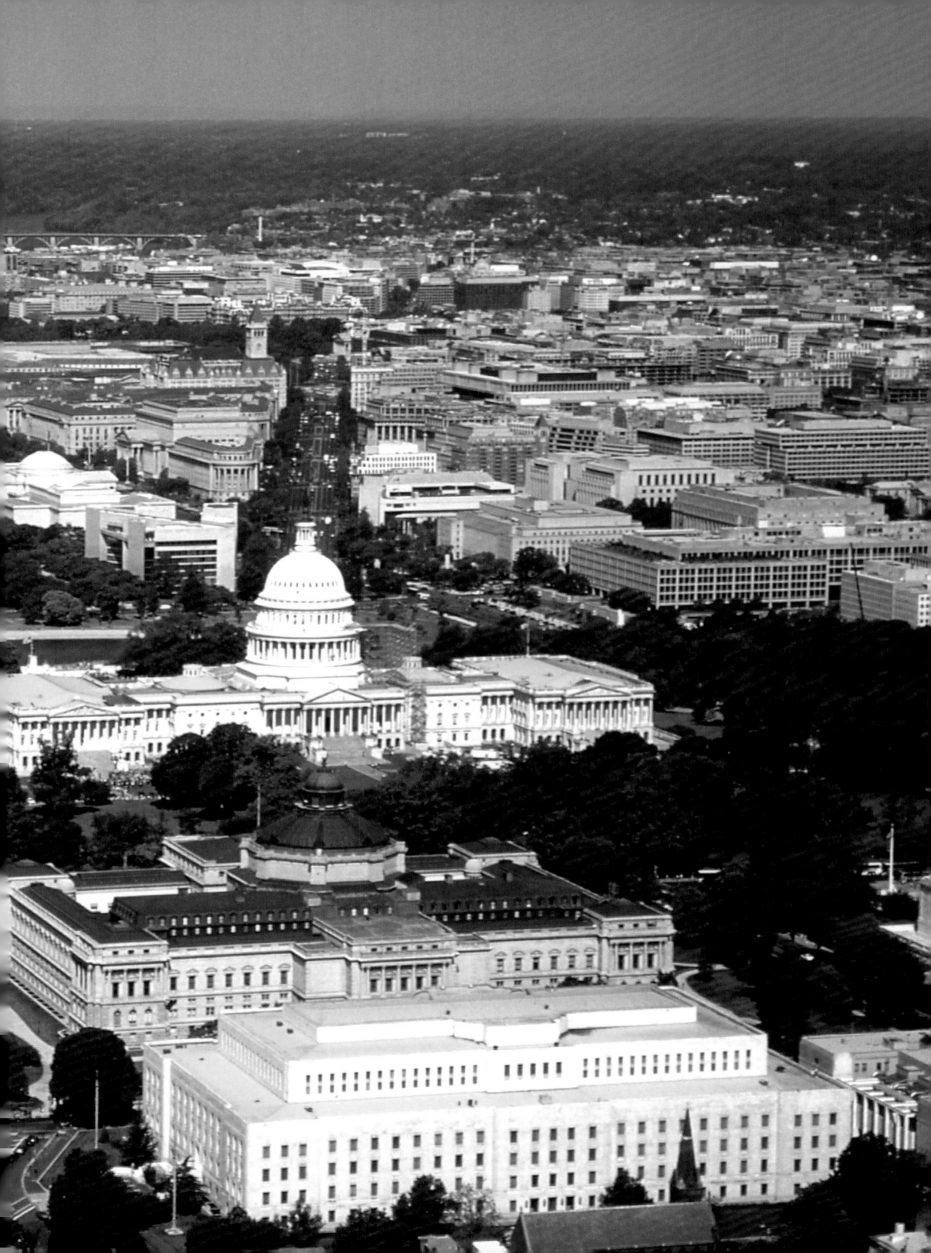

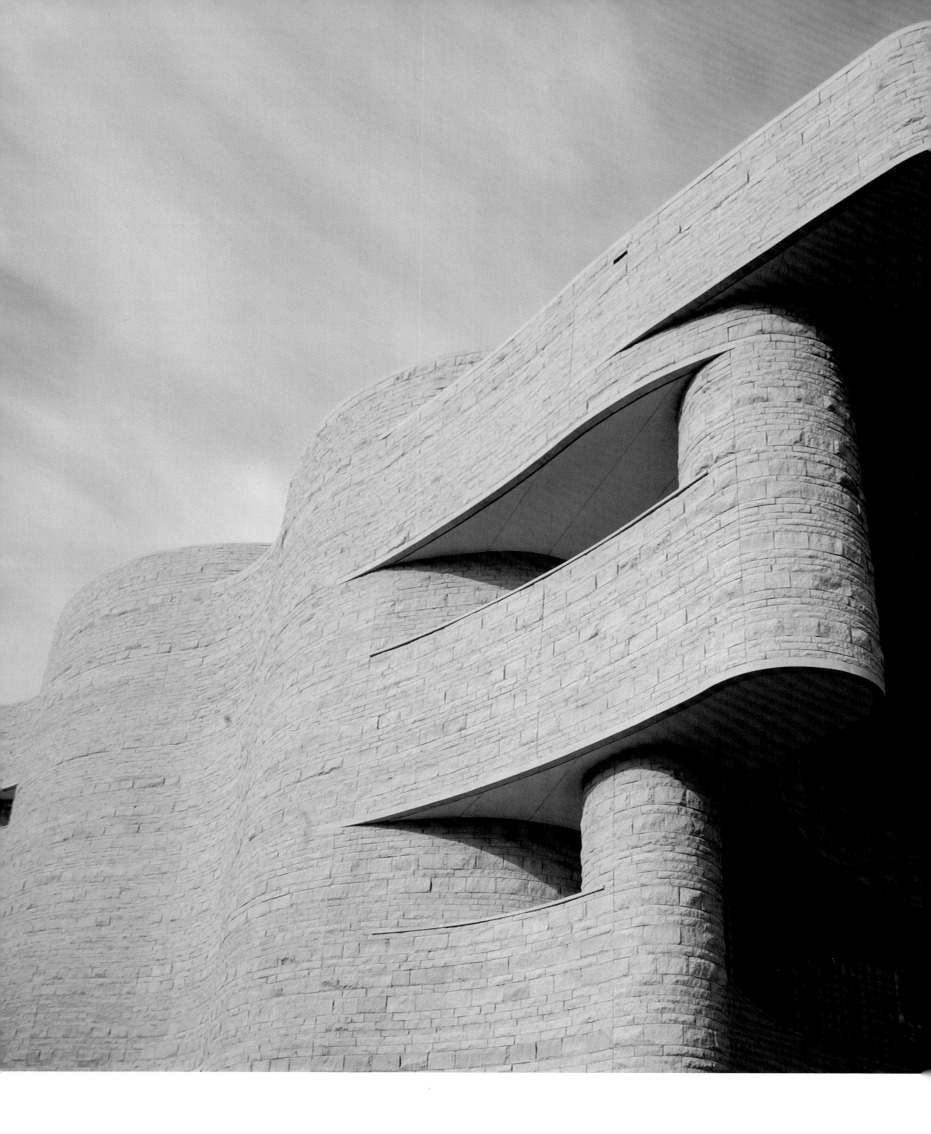

Designed to look like a natural rock formation eroded by wind and water, the National Museum of the American Indian houses almost a million artifacts from thousands of years ago. The museum is dedicated to the languages, history, art, and literature of North American natives.

Lined with over a thousand cherry trees given to America by Japan, the Tidal Basin was originally designed as a water reservoir. The trees on the banks of the basin, situated on the National Mall between the Lincoln and Jefferson Memorials, bloom every spring and are celebrated with an annual Cherry Blossom Festival. (*overleaf*)

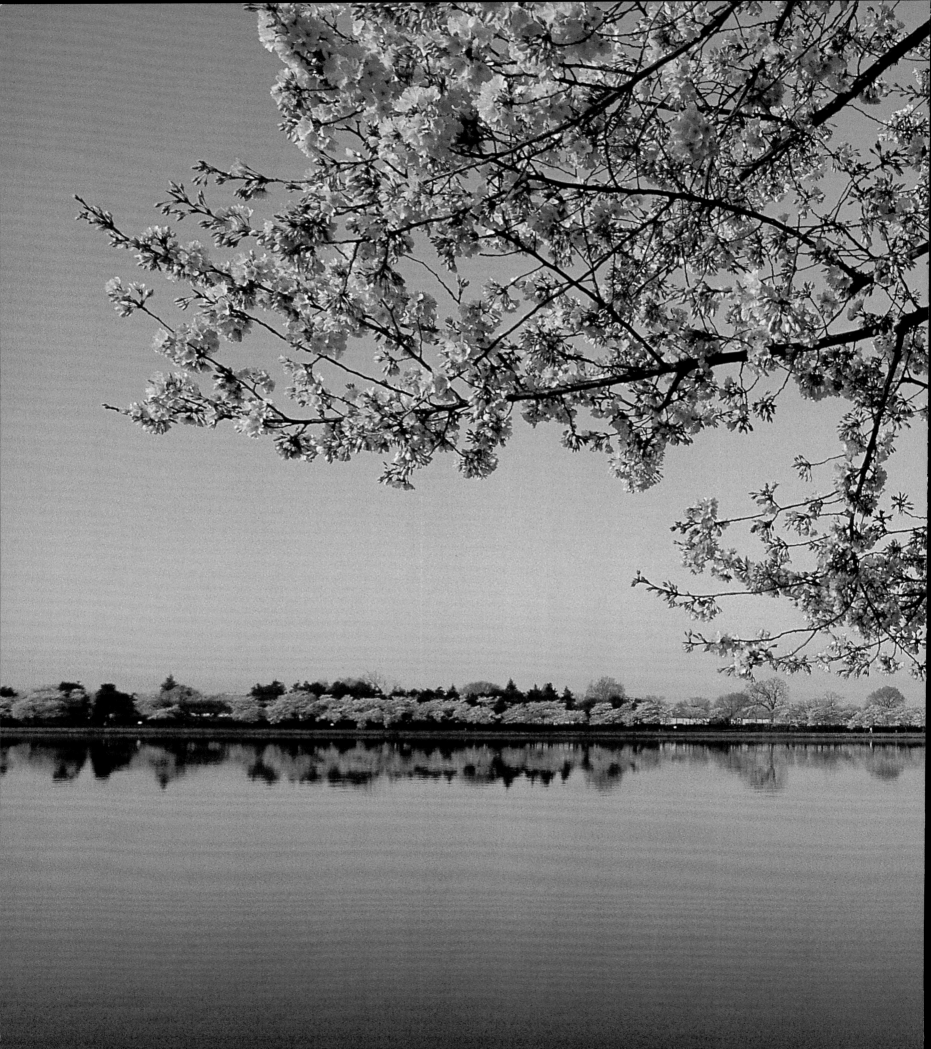

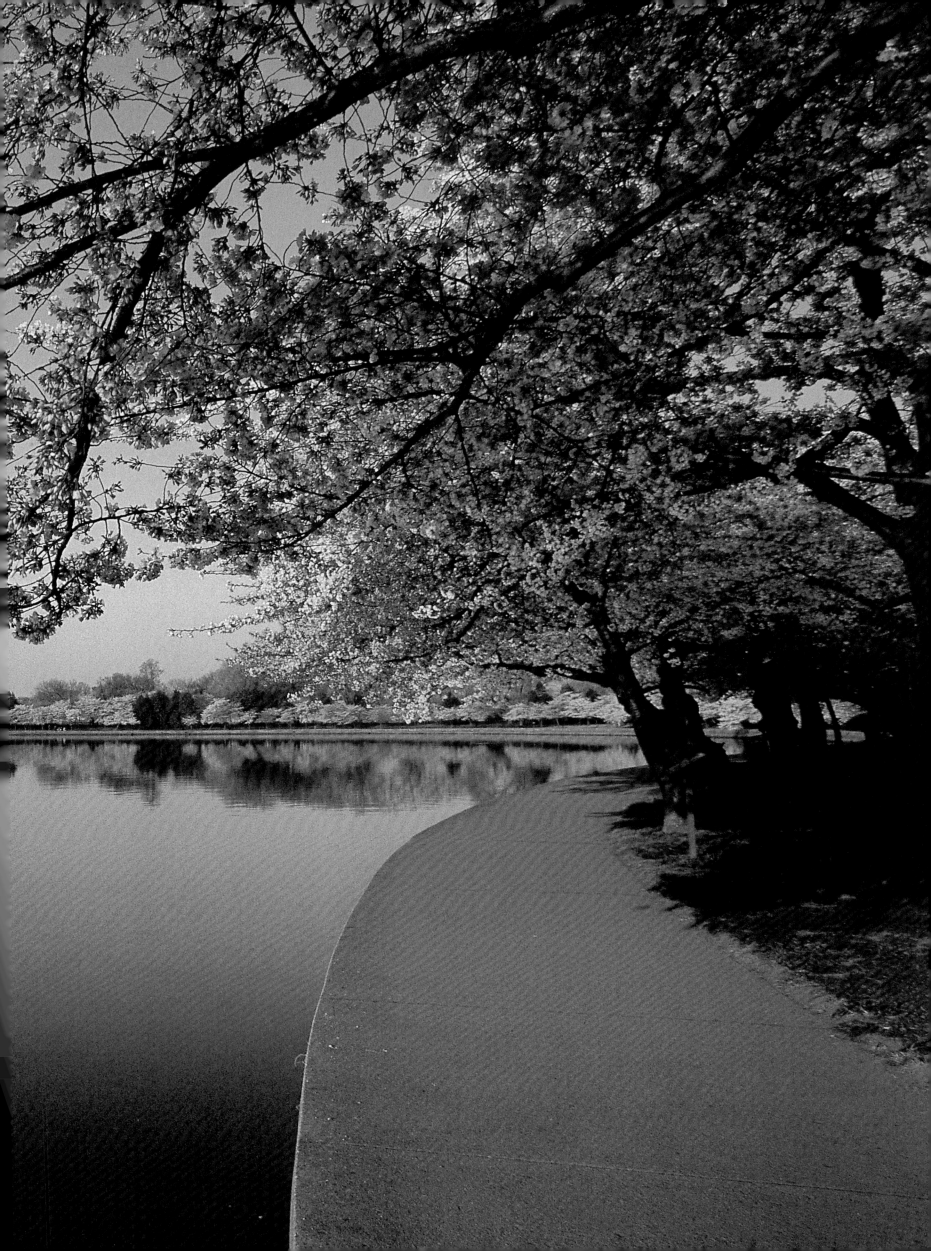

—The Washington Monument—

A tribute to the nation's first president, the elegant obelisk of the Washington Monument ranks among the world's tallest masonry structures. At 555 feet, the striking monument to George Washington can be seen from almost anywhere in the capital city.

Dubbed the "father of the nation" for leading America to victory in the War of Independence and establishing the foundations of American government, George Washington was originally going to be celebrated with a more extravagant monument. Intent on paying proper tribute to the nation's first president, Chief Justice John Marshall and fourth President James Madison founded the National Monument Society in 1833 to raise the building funds for Washington's monument and host a competition for its design.

Famous for his Greek revival United States Treasury Building, architect Robert Mills won the contest with a grandiose design — far more ornate than today's Washington Monument. Mills' neoclassical design featured a flat-topped obelisk — bearing a large statue of Washington driving a horse-drawn chariot — rising out of a grand circular colonnade. The center of the colonnade was to be decorated with the statues of 30 eminent revolutionary war heroes.

A lack of funds prevented realizing every aspect of Mills' monument, except for the obelisk. Construction of the pared-down version of the monument began in 1848 and continued for five years, when financial difficulties and the outbreak of the Civil War put it on hold for another 20 years. A faint line at the obelisk's 150-foot mark shows where work finally resumed in 1876 with a slightly different shade of marble. The monument's design was simplified again at this stage, to produce its clean lines and pyramid top.

At its completion in 1884, the Washington Monument was the world's tallest structure, its soaring height anchored by a base extending 55 feet. Made of over 35,000 pieces of marble and granite, the monument is embedded with 193 carved memorial stones from diverse individuals, societies, states, and nations — from every state in America to the Cherokee Nation and the Vatican. The stones' diversity demonstrates the scope of George Washington's influence over America and the world. (*right*)

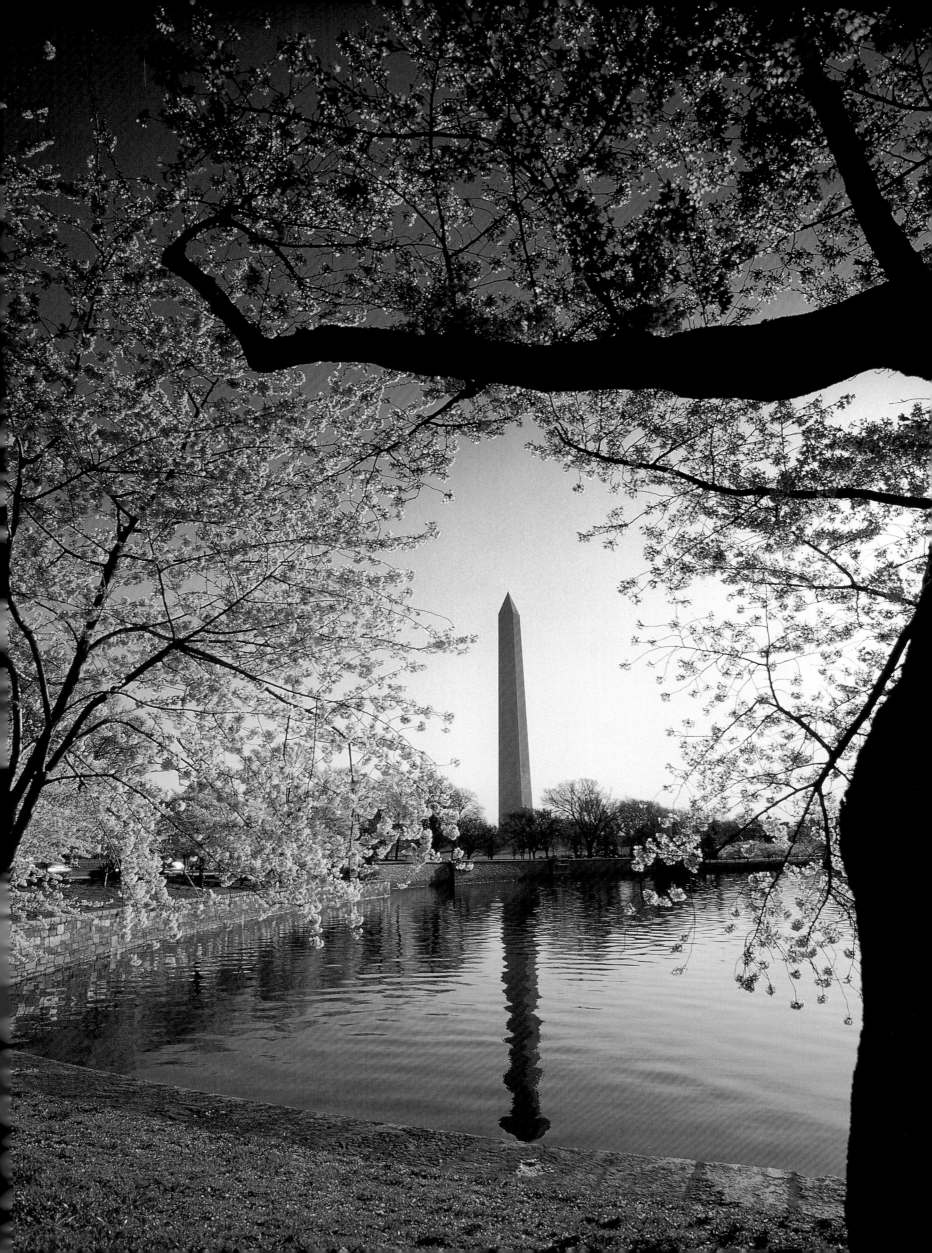

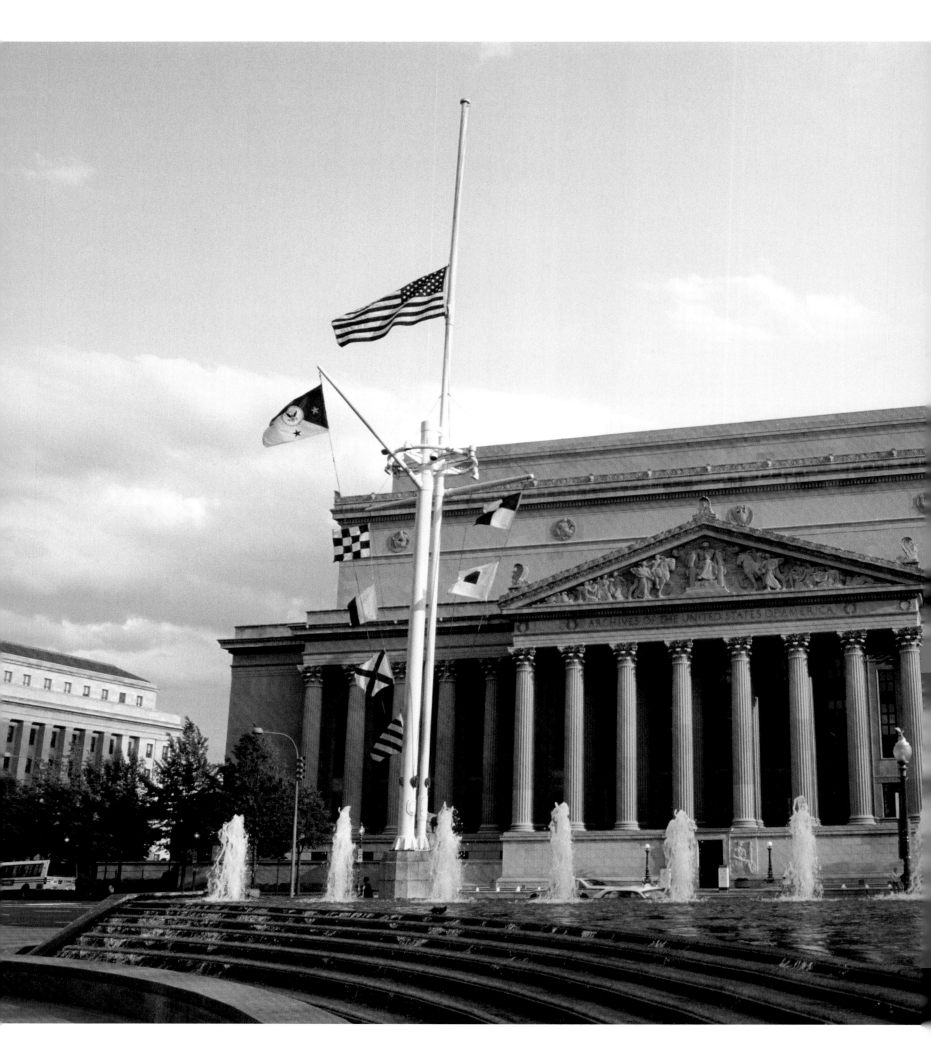

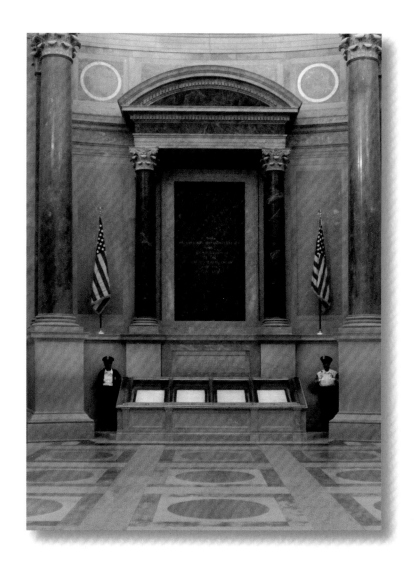

The original copies of the three texts that form the bedrock of America — the Declaration of Independence, the Constitution, and the Bill of Rights — are carefully displayed at the National Archives Building. The Charters of Freedom, as the triad is called, are kept in airtight containers filled with gas to protect them.

A colossal number of records are stored here inside the neoclassical National Archives Building, including America's most legendary texts — the Declaration of Independence, the U.S. Constitution, and the Bill of Rights. Kept along with these founding manuscripts are millions of documents that date back to the 1700s, including treaties of war, maps, pictures, and film reels. (*left*)

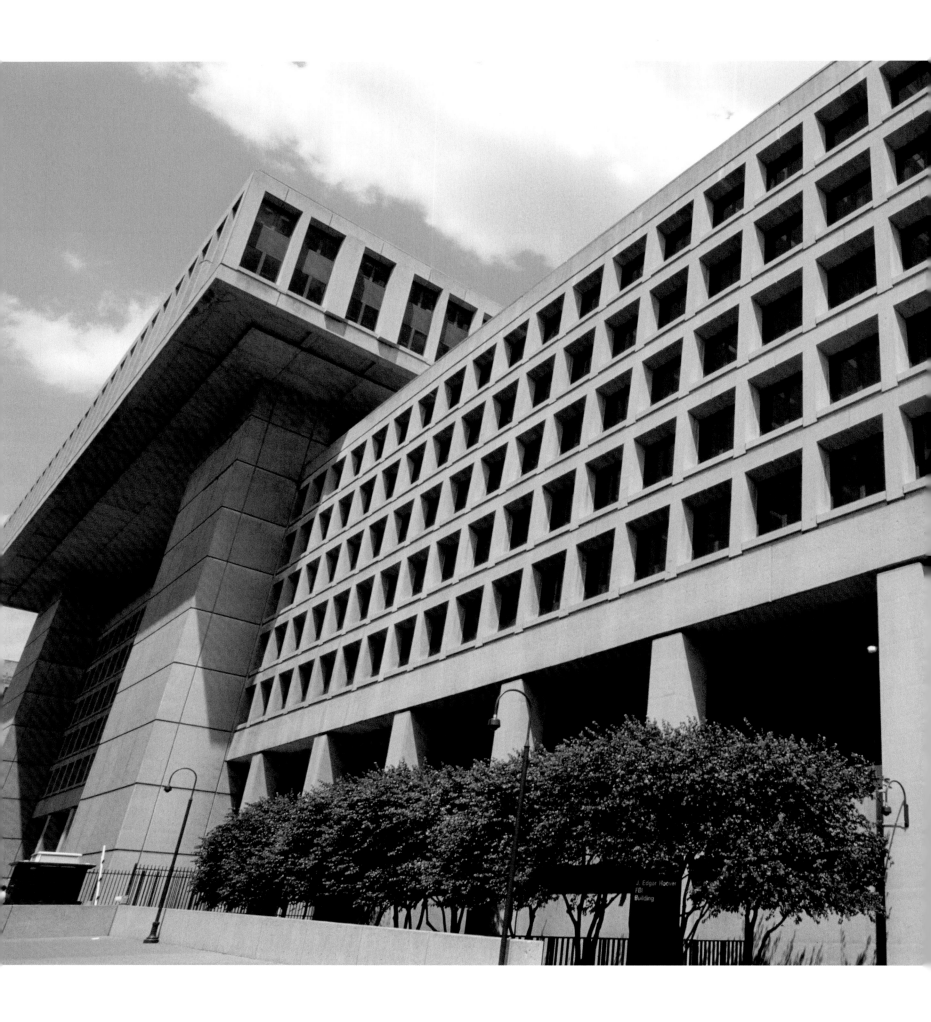

The Federal Bureau of Investigation headquarters were officially named the J. Edgar Hoover Building, after the department's director of 49 years, two days after Hoover's death in 1972. Hoover's FBI leadership spanned a series of dramatic events, including Prohibition, the Great Depression, World War II, the Korean War, the Cold War, and the Vietnam War. Based on its acronym, the FBI's motto is Fidelity, Bravery, Integrity.

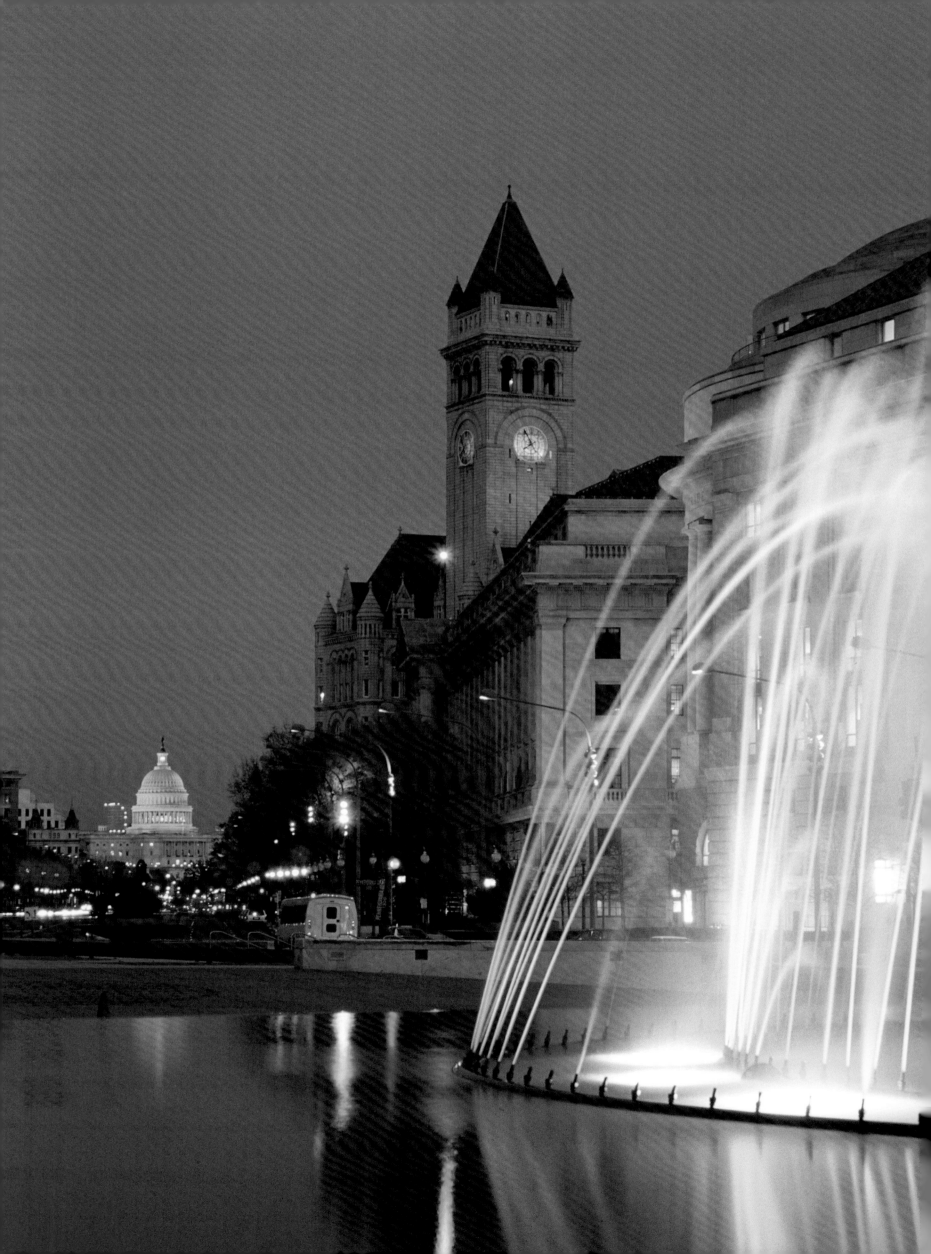

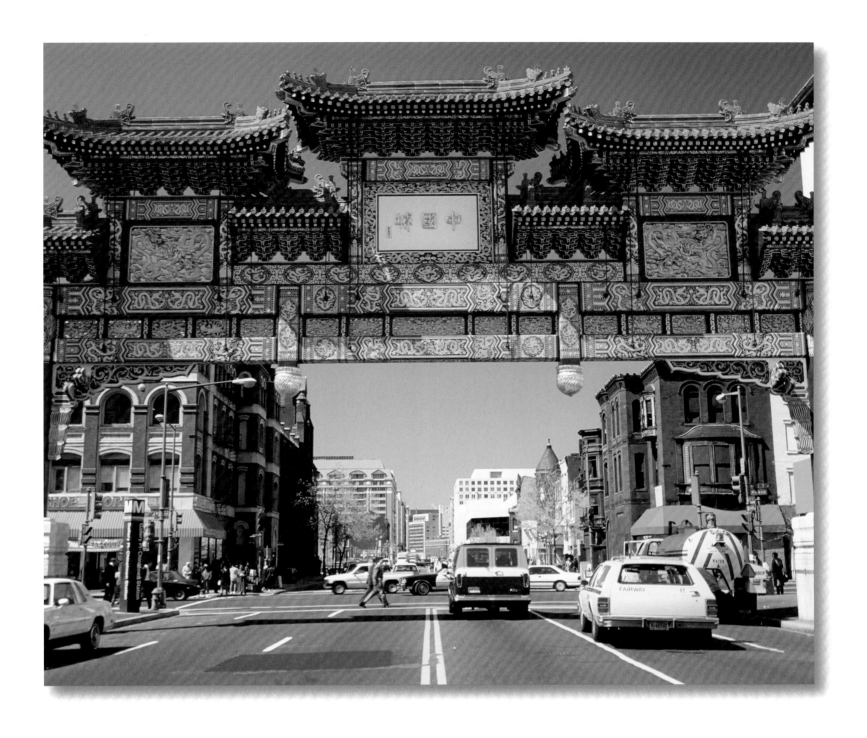

Dedicated in 1986 the Friendship Archway marks the entrance into D.C.'s Chinatown and celebrates Washington's relationship with Beijing, its sister city. With seven roofs reaching up to 60 feet and decorated with over 7,000 tiles, the intricate, vibrant arch is the center of the city's extensive Chinese New Year celebrations.

Freedom Plaza and its majestic fountain provide respite from the frenetic pace of Pennsylvania Avenue. Inlaid in the stone of Freedom Plaza is an enormous map of Pierre L'Enfant's original design of the District of Columbia. Engraved with quotes by famous Americans like Alexander Graham Bell, Martin Luther King Jr., and Walt Whitman, Western Plaza was renamed in honor of Martin Luther King Jr., who penned his famous "I Have a Dream" speech in a nearby hotel. (*left*)

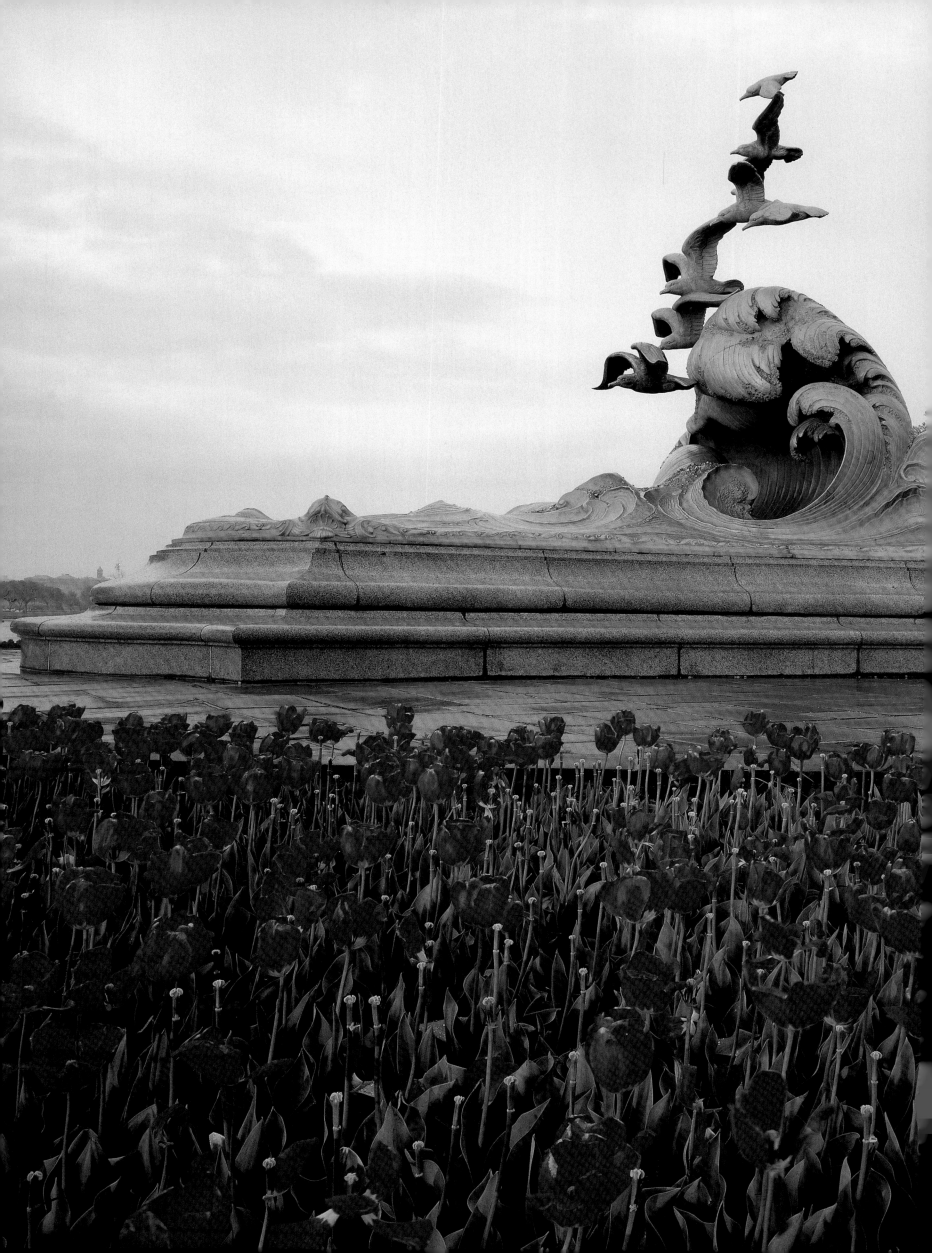

Nicknamed "Waves and Gulls" for its aluminum depiction of seagulls skimming the crest of a wave, the Navy and Marine Monument in Lady Bird Johnson Park commemorates United States naval officers and merchant marines who died at sea. Designed by Ernesto Begni del Piatta, this 30-foot-long and 35-foot-tall monument was dedicated in 1934.

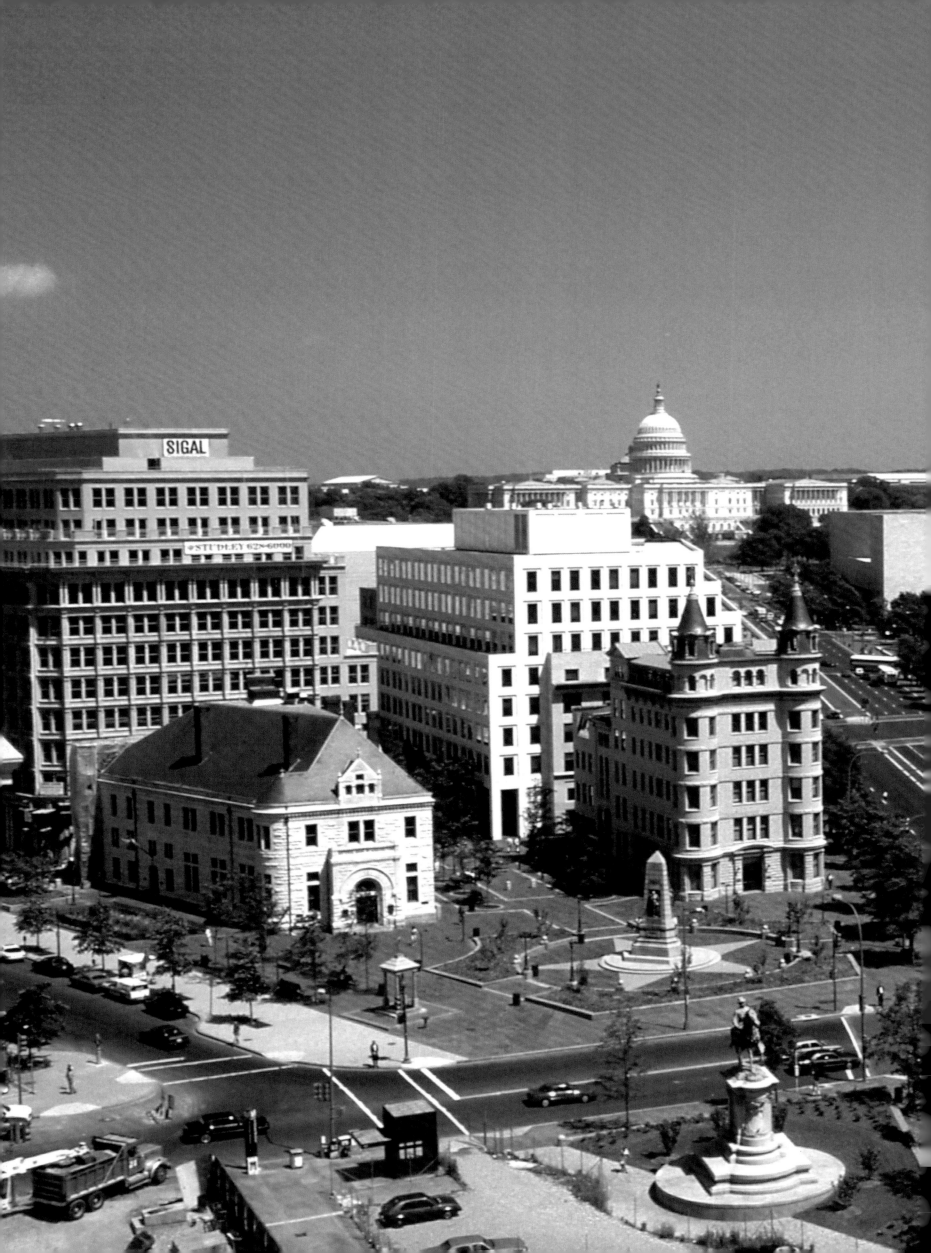

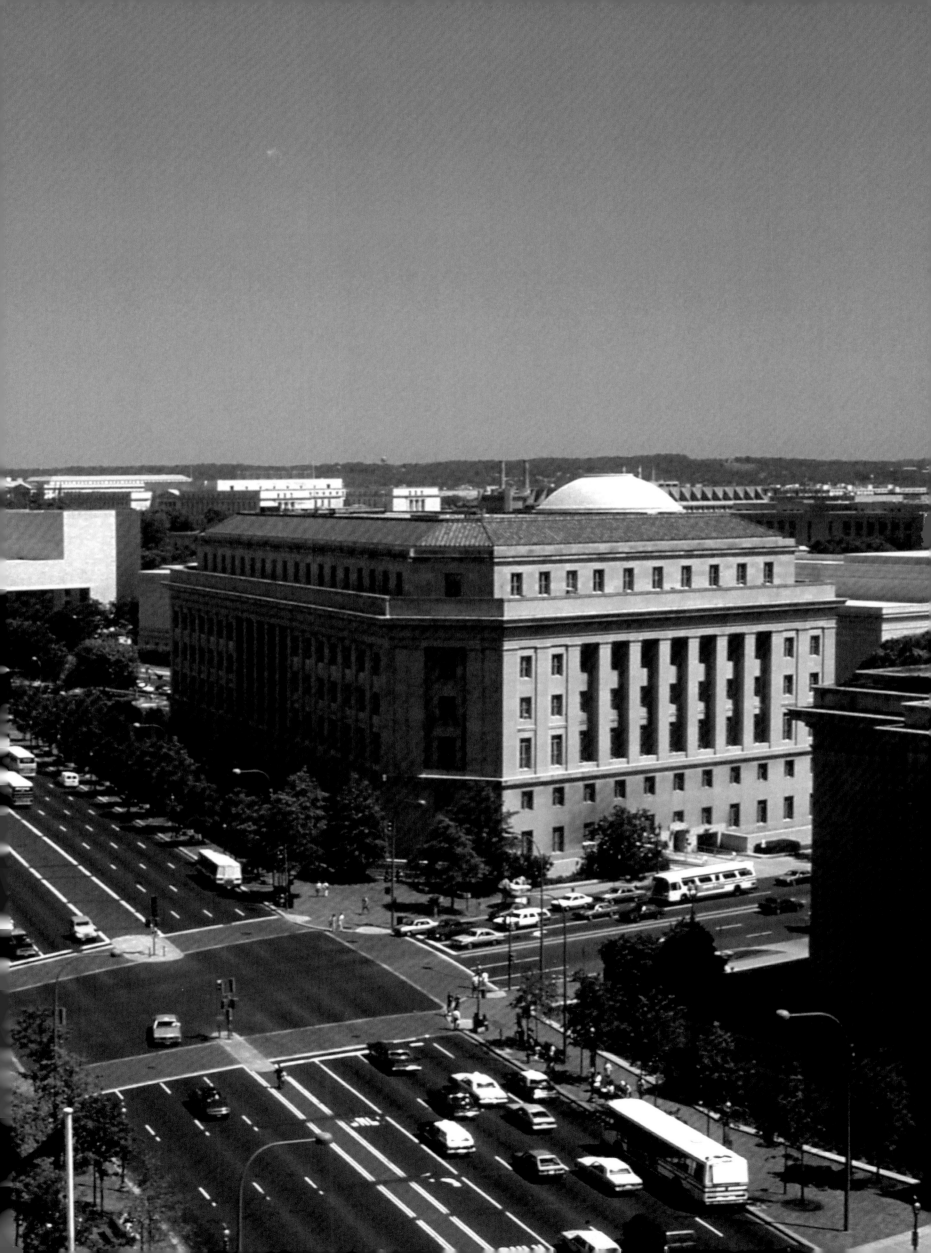

Sitting on five acres between the White House and the Capitol Building, the Main Treasury Building is the third-oldest federally occupied building in Washington, D.C. The original plans for Washington intended for the White House and Capitol Building to face each other unobstructed at each end of Pennsylvania Avenue. Legend has it that bad relations between Congress and President Andrew Jackson prompted the 7th president to construct the Main Treasury Building where it would block his view of the Capitol Building.

A wide and stately avenue that connects the United States Capitol building with the White House, Pennsylvania is one of Washington, D.C.'s main arteries. Home to some of the nation's most dignified buildings, the avenue has been dubbed "America's Main Street." (*previous pages*)

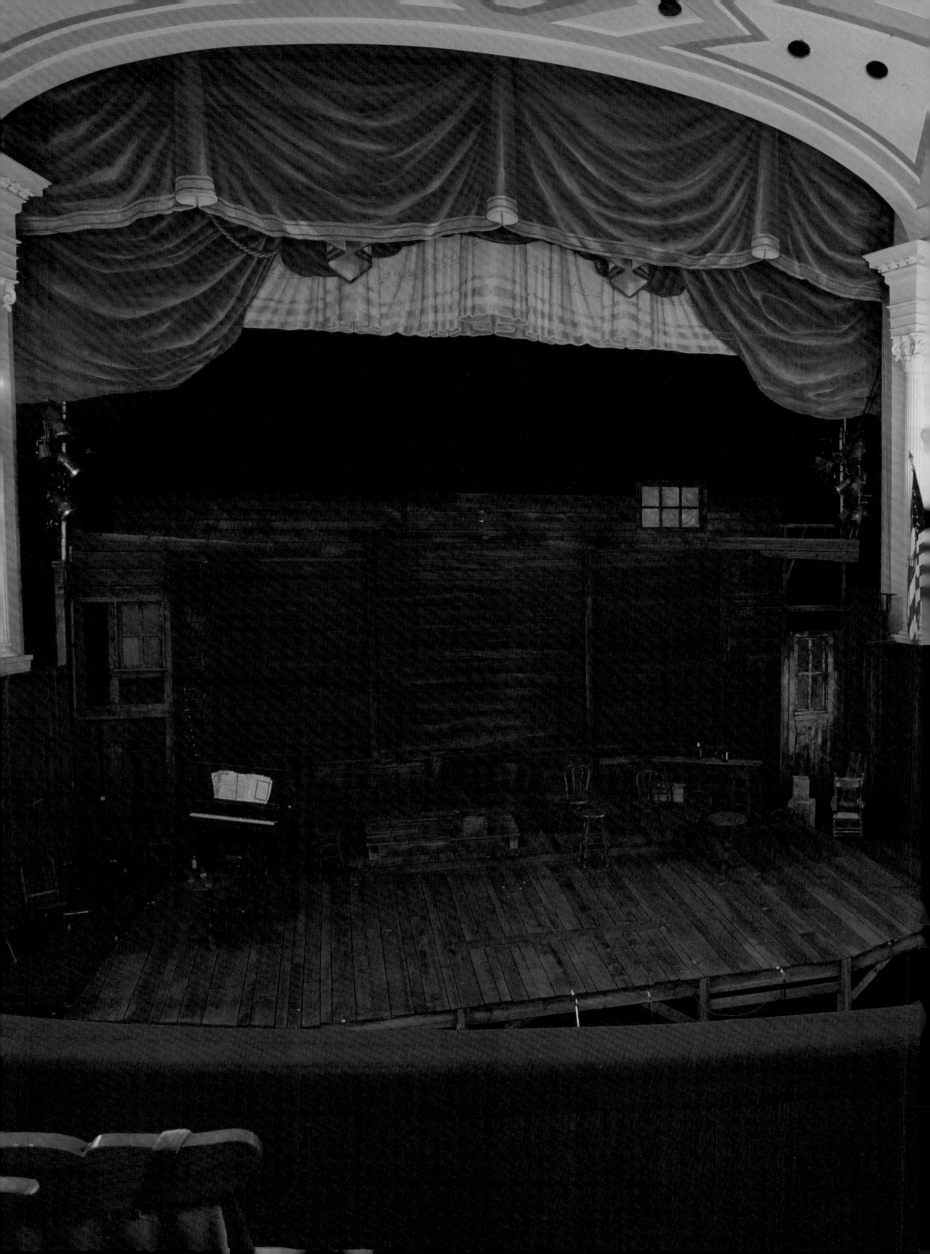

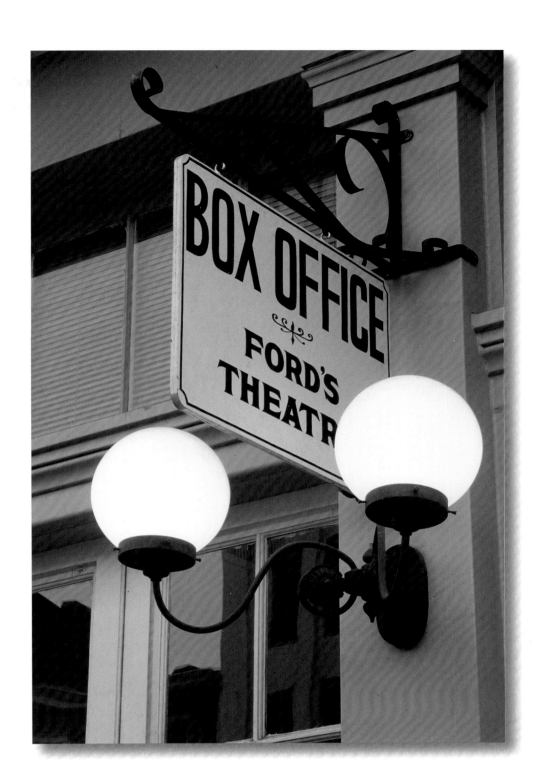

It was here at Ford's Theatre on April 14, 1865, that actor and Confederate supporter John Wilkes Booth fatally shot President Abraham Lincoln during a performance of *Our American Cousin*. Occurring just days after the Confederate surrender at Appomattox that marked the end of the Civil War, the assassination prompted the theatre's closure for over a century. When it re-opened its doors in 1968, the National Historic and Cultural Site featured a completely restored interior.

One of America's most famous playhouses, the restored Ford's Theatre not only hosts live performances but is also home to the Lincoln Museum. Among the exhibits on the events leading up to the assassination of the 16th President of the United States and the ensuing trials are John Wilkes Booth's diary and murder weapon. (*left*)

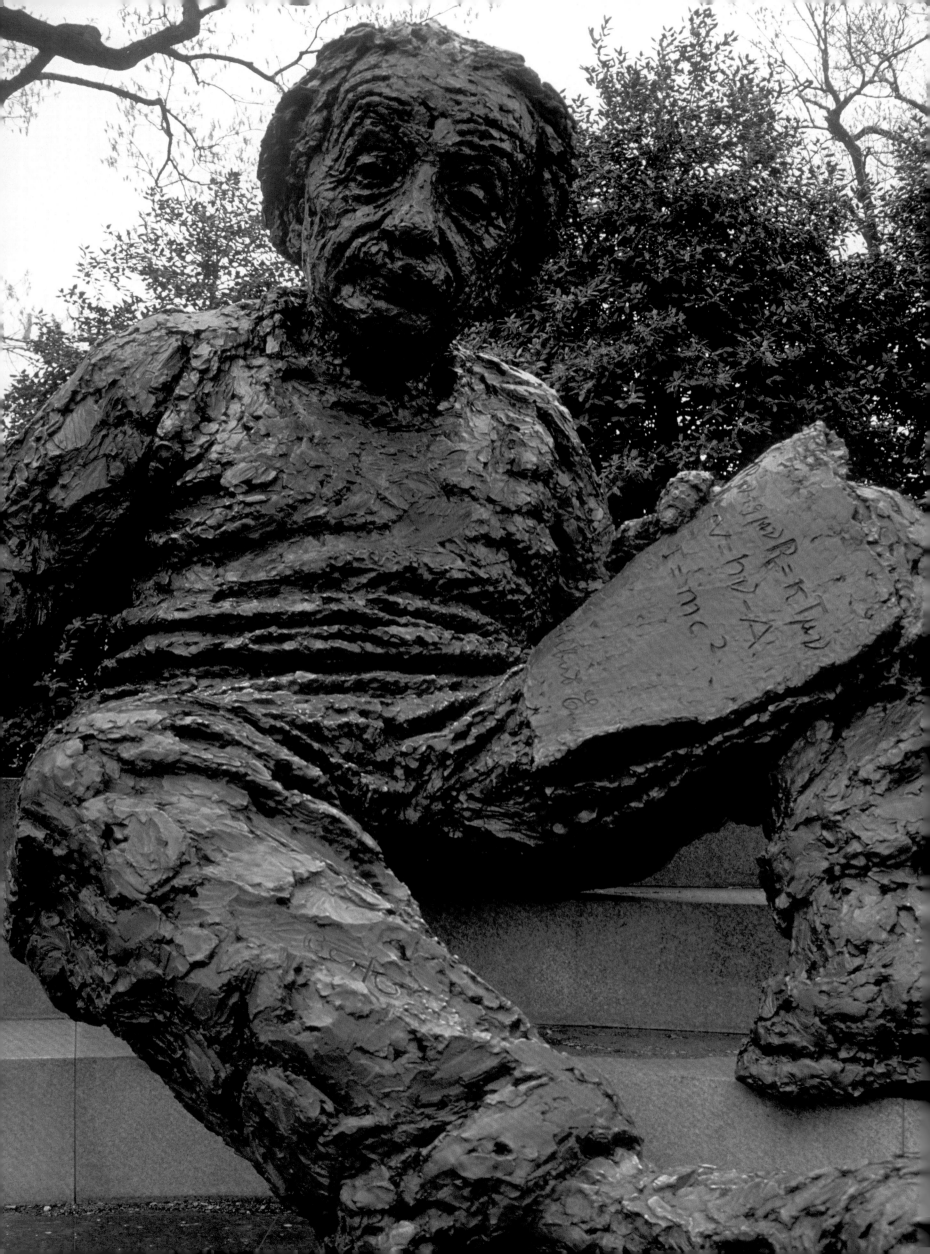

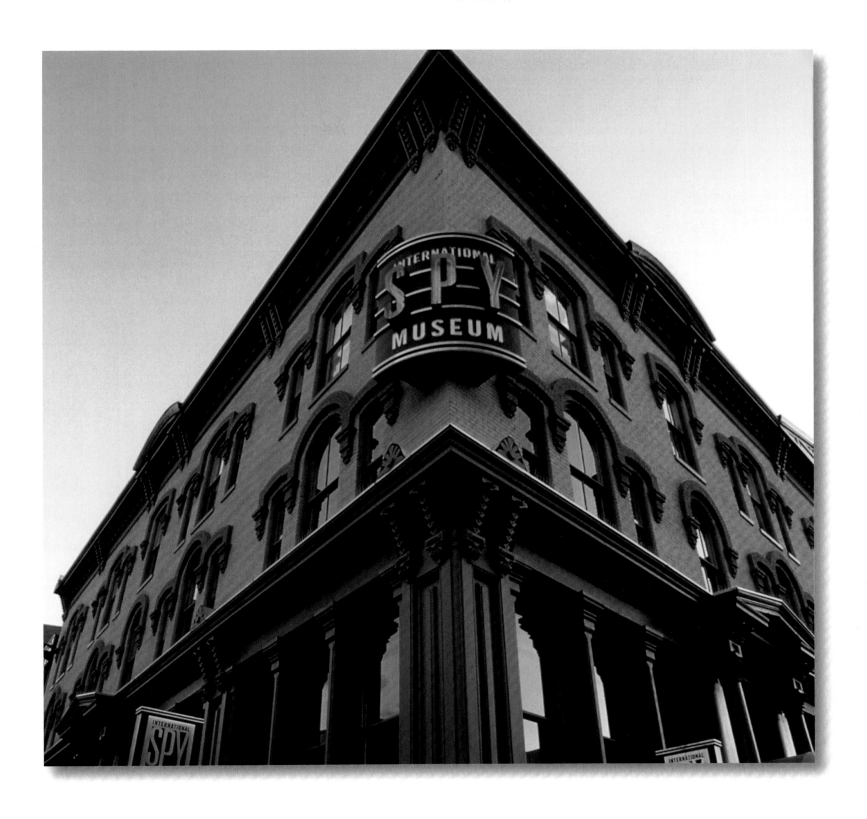

From the Trojan horse to the Cold War, thousands of years of espionage are showcased at the International Spy Museum in the largest collection of spy artifacts ever displayed. Occupying the 19th-century buildings that housed the American Communist Party during World War II, the museum offers visitors an insider's glimpse of undercover weapons, codes, spies, and missions through interactive displays, videos, and exhibits.

A larger-than-life Albert Einstein sits outside the National Academy of Sciences, holding a piece of paper inscribed with his three most famous formulas and a map of the universe at his feet. Created by sculptor Robert Berks, who also made the John F. Kennedy bust at the Kennedy Center, this bronze statue celebrates the physicist who won the Nobel Prize for Physics in 1921 and formulated the theory of relativity. (*left*)

Comprised of upscale offices, apartments, and a hotel, the Watergate complex will always be synonymous with the Watergate scandal that led to President Richard Nixon's resignation in 1974. It was here in 1972 that members of Nixon's re-election campaign were caught breaking into the offices of the Democratic Party, a scandal that led to further allegations against Nixon and ultimately his resignation. He is the only U.S. president to resign from office.

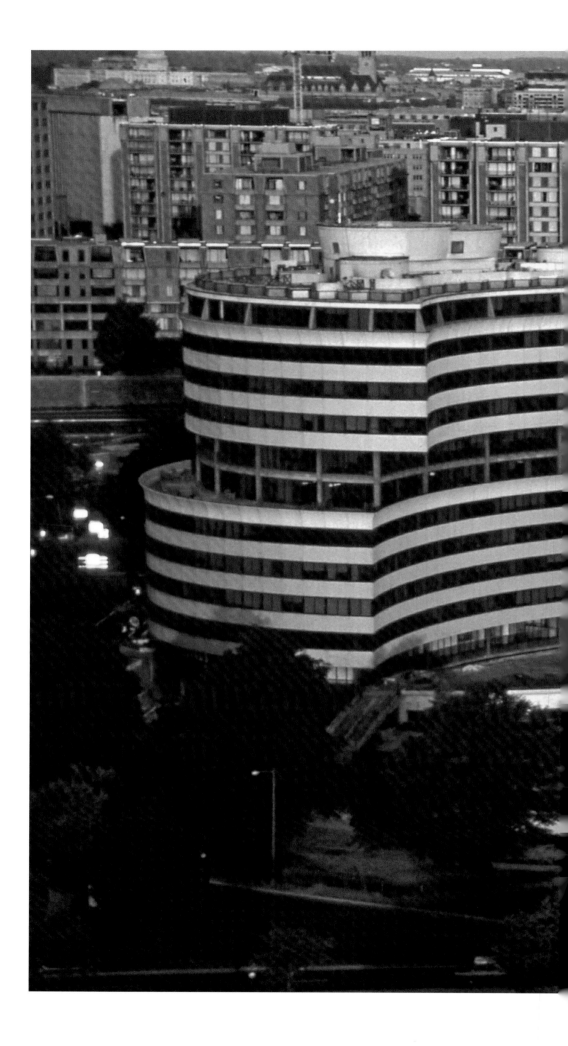

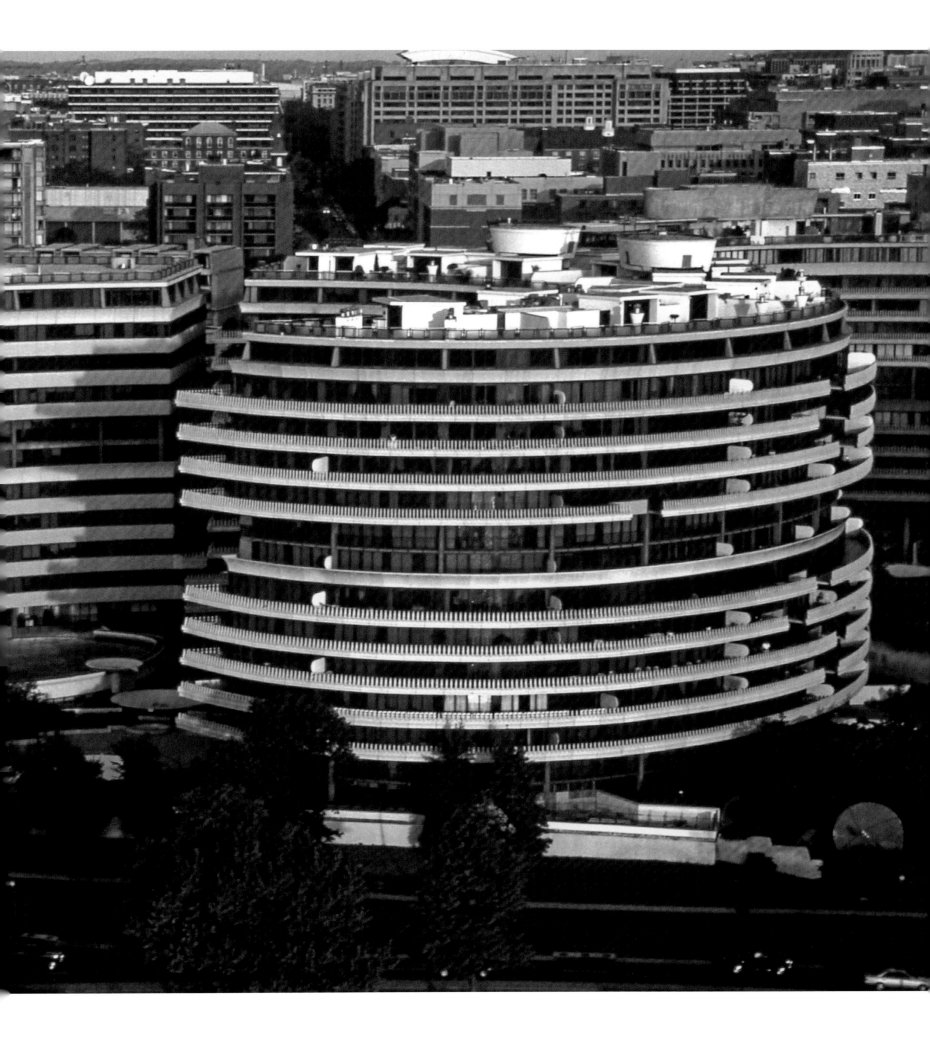

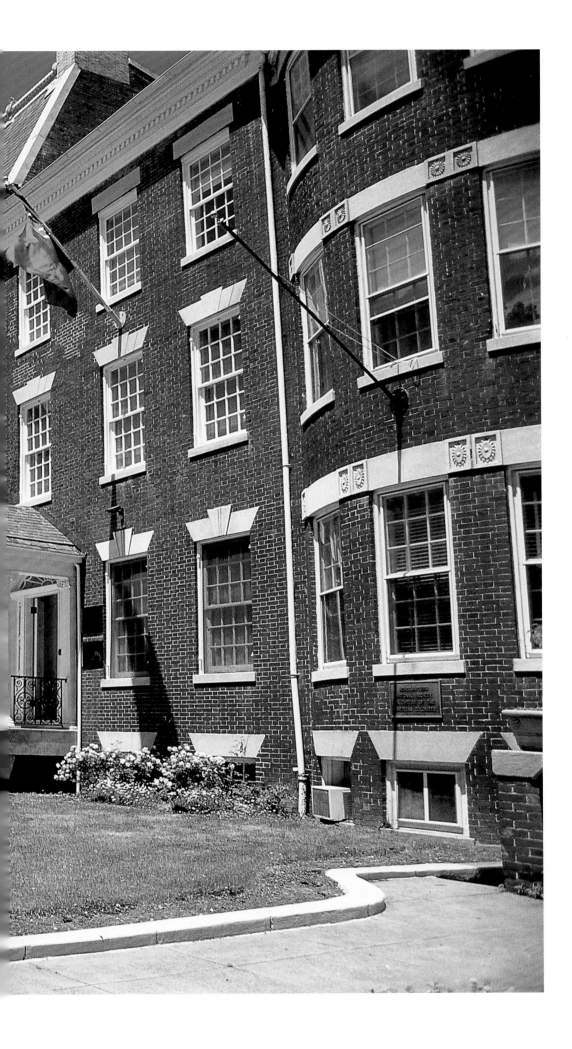

A colorful medley of international flags line Massachusetts Avenue, also known as Embassy Row. The beaux arts mansions along this dignified avenue house the embassies of over 70 nations, from Australia and Belize to Uzbekistan and Zambia.

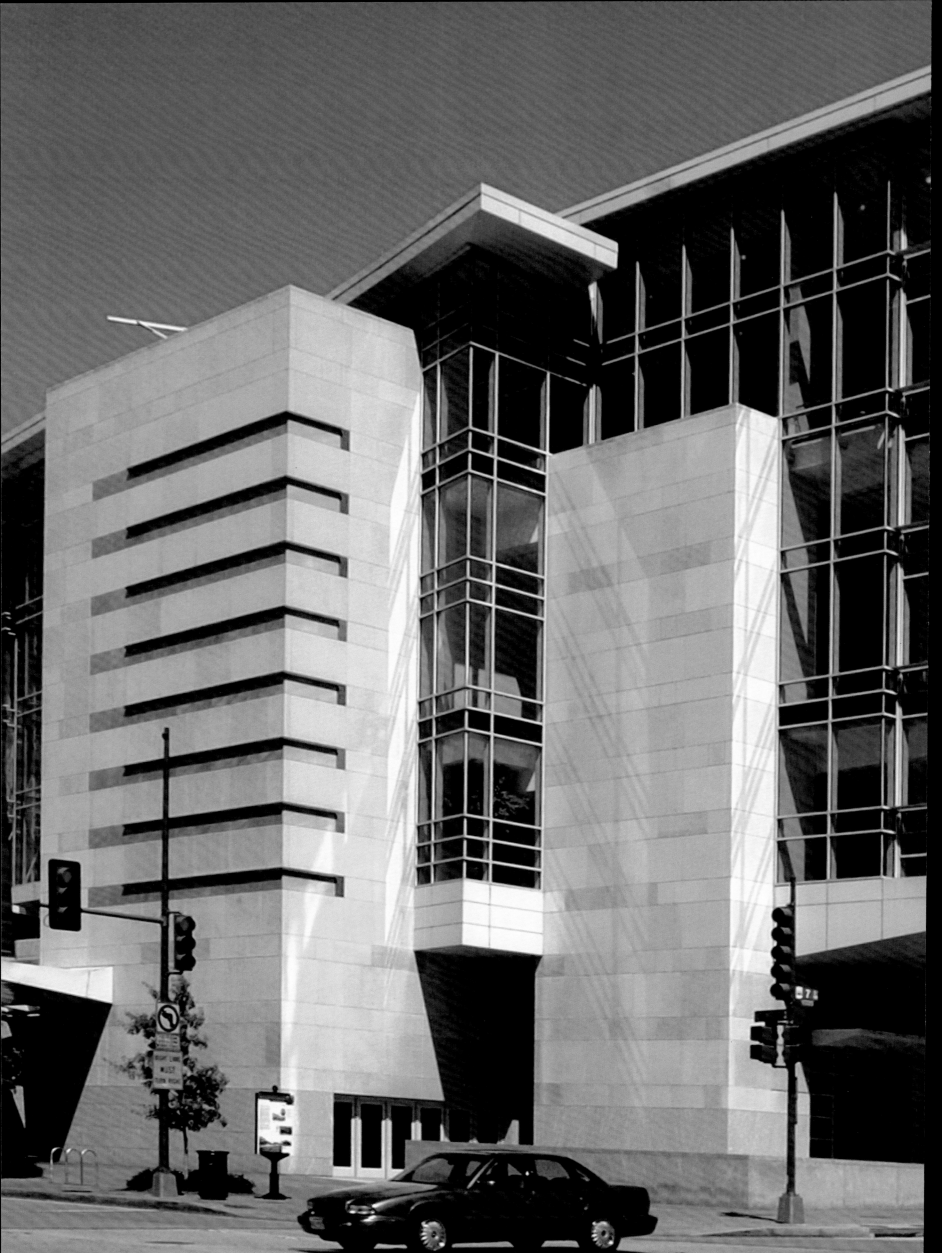

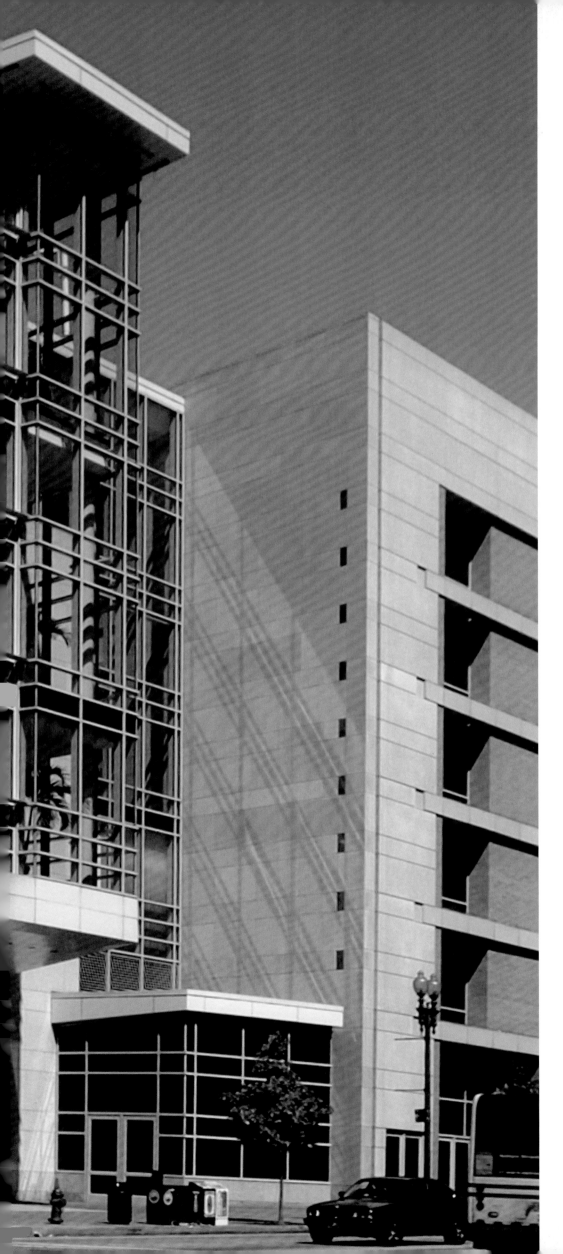

Twice the length of the Washington Monument — or six football fields — D.C.'s new Convention Center is the largest building in Washington. Only two blocks from the site of Washington's first 1874 Convention Center, this massive building with 31 elevators and 68 bathrooms opened in 2003 and hosted most of the parties for President George W. Bush's 2005 Inaugural Ball. The 2.3-million-square-foot facility houses an art collection worth $4 million.

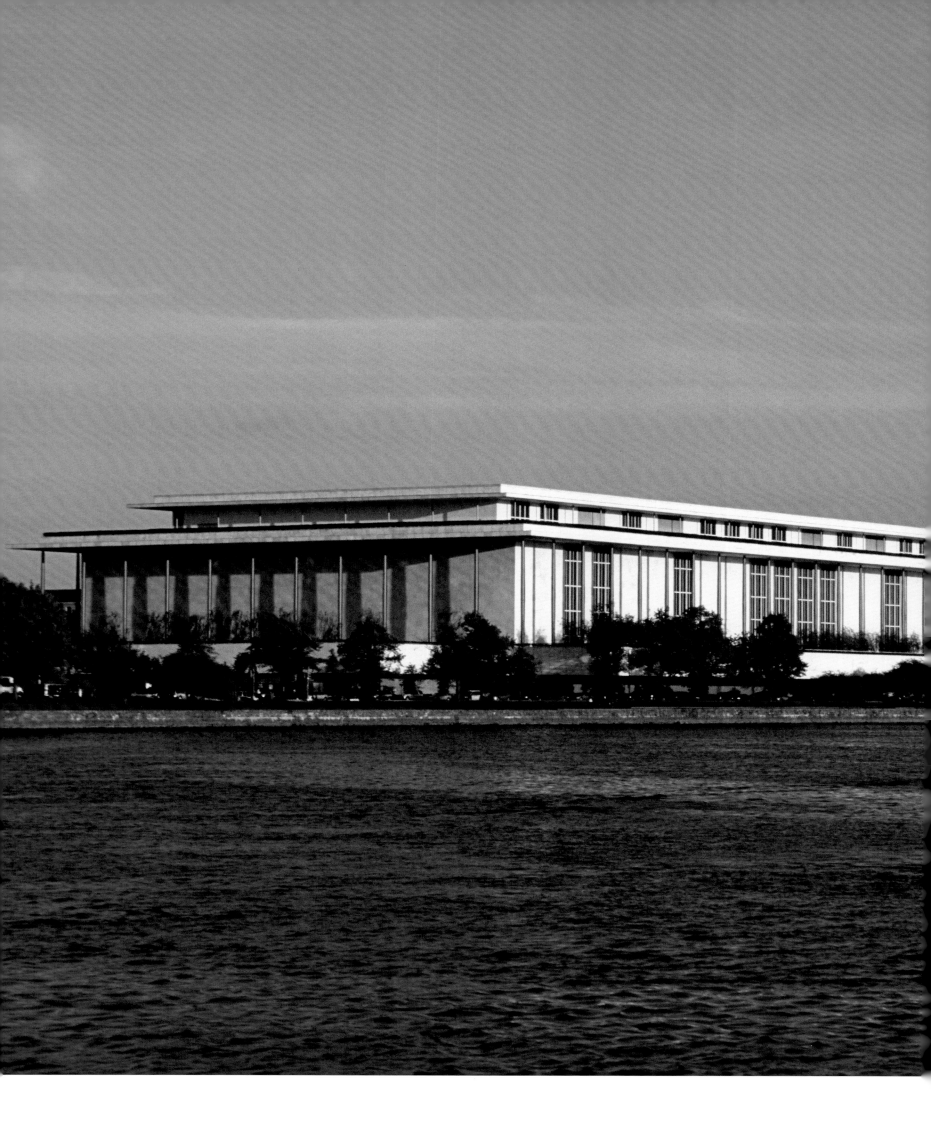

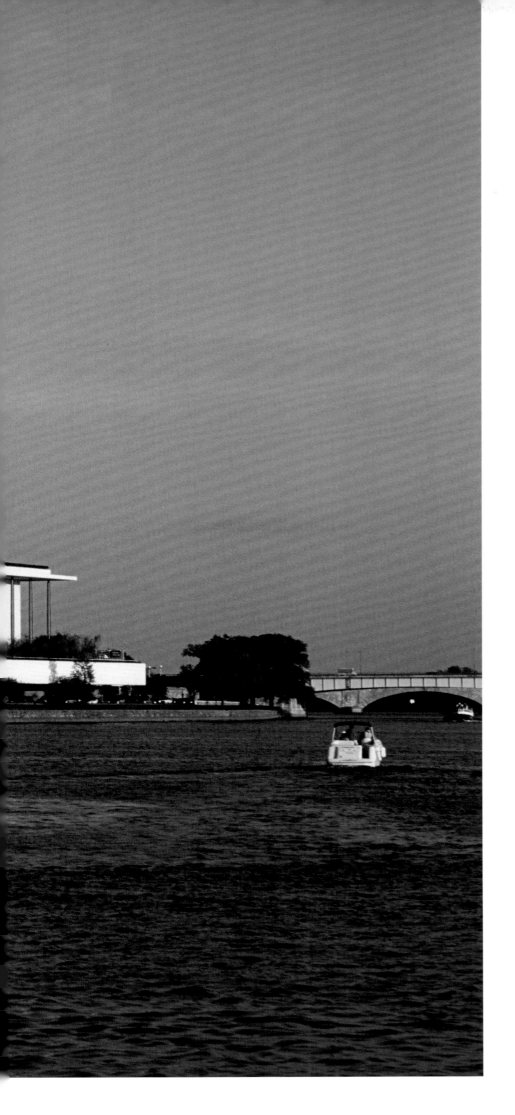

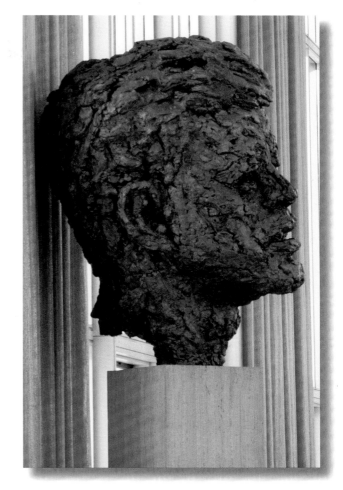

This 8-foot-tall sculpture of John F. Kennedy's head graces the lobby of the building named for the late president. Perhaps the most famous piece by prolific American sculptor Robert Berks, this bronze JFK bust features his signature highly textured design. Berks is also renowned for sculpting monuments to Albert Einstein and Mary McLeod Bethune.

The first national cultural centre in America's capital, the John F. Kennedy Center for the Performing Arts is both a monument to the late president and, as home base for the National Symphony Orchestra and the Washington National Opera, a hub for the arts. Situated on the banks of the Potomac, the massive white marble Kennedy Center houses four main auditoriums, multiple exhibition halls, the Hall of States, and the Hall of Unions. (*left*)

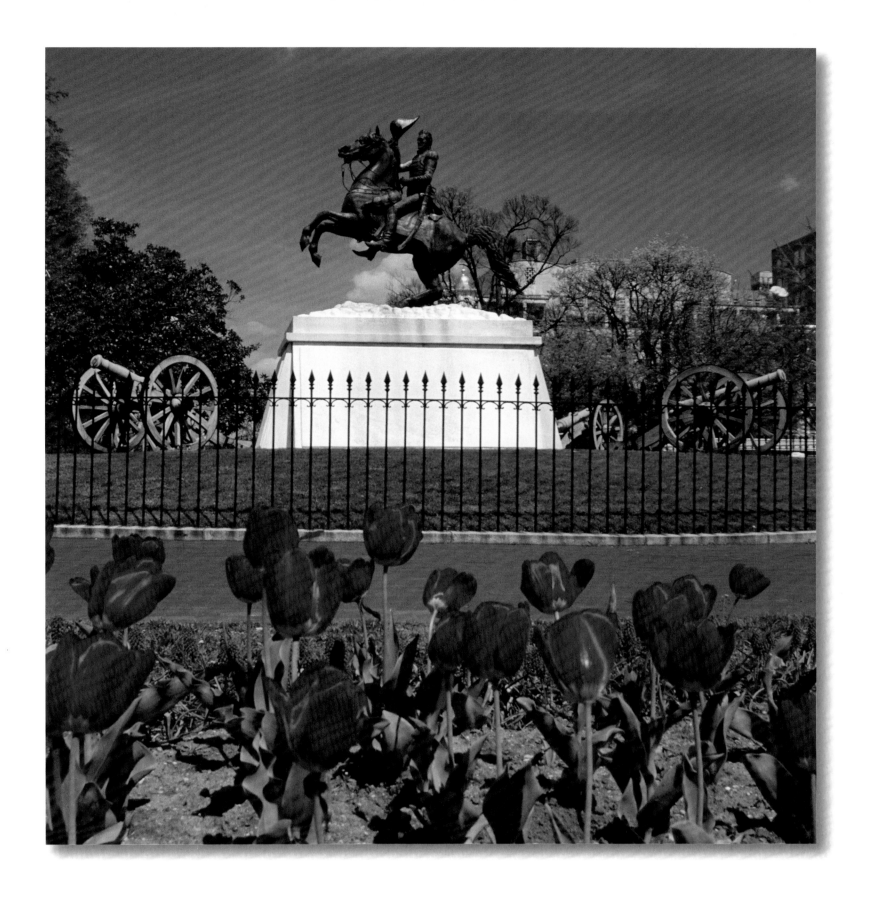

Erected in 1853 this statue of Andrew Jackson, the seventh President of the United States, stands in Lafayette Square. Named after Revolutionary War hero Marquis de Lafayette, this square was designated a National Historic Landmark in 1970.

The inspiration for this ornate building was none other than the Louvre in Paris. Built in 1888 as a home for the State, War, and Navy Departments, the Eisenhower Old Executive Office Building is now an office for White House staff, notably the vice president. (*left*)

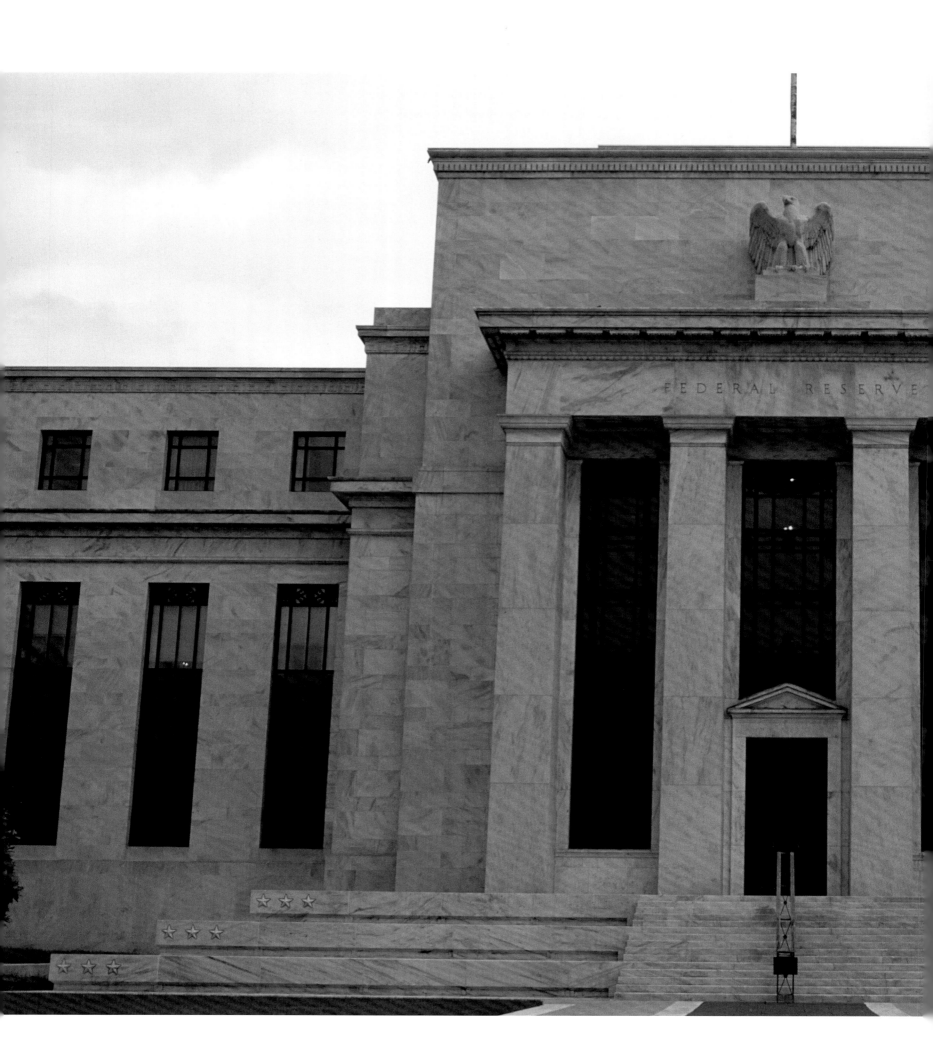

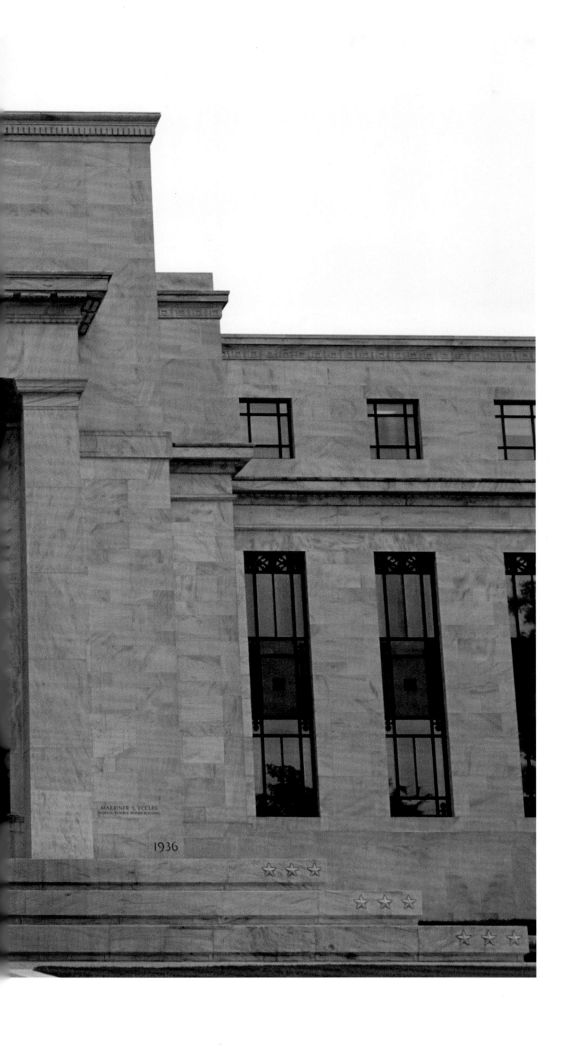

Named for the former Chairman of the Federal Reserve, Marriner S. Eccles, the imposing headquarters of the Federal Reserve is where the country's money and gold reserves are controlled. Designed by Paul Cret, the Eccles Building, which is also an art gallery, opened in 1937.

Located a few blocks away from the Smithsonian Air and Space Museum, the NASA headquarters take up a large portion of E Street. The National Aeronautics and Space Administration was established in 1958, one year after the Soviets launched the first man-made satellite, *Sputnik 1*, into orbit. NASA spearheaded the Apollo Program from 1961–74, fulfilling its mission of transporting people to the moon and back. (*overleaf*)

Bearing the motto "Taxes Are What We Pay for a Civilized Society," the neoclassical Internal Revenue Services building was the first federal building in D.C.'s Federal Triangle, which stretches from the White House to the Capitol Building. The IRS, which collects taxes and enforces revenue laws, temporarily evacuated this building in 2006 because of flooding, causing the displacement of over 2,000 employees.

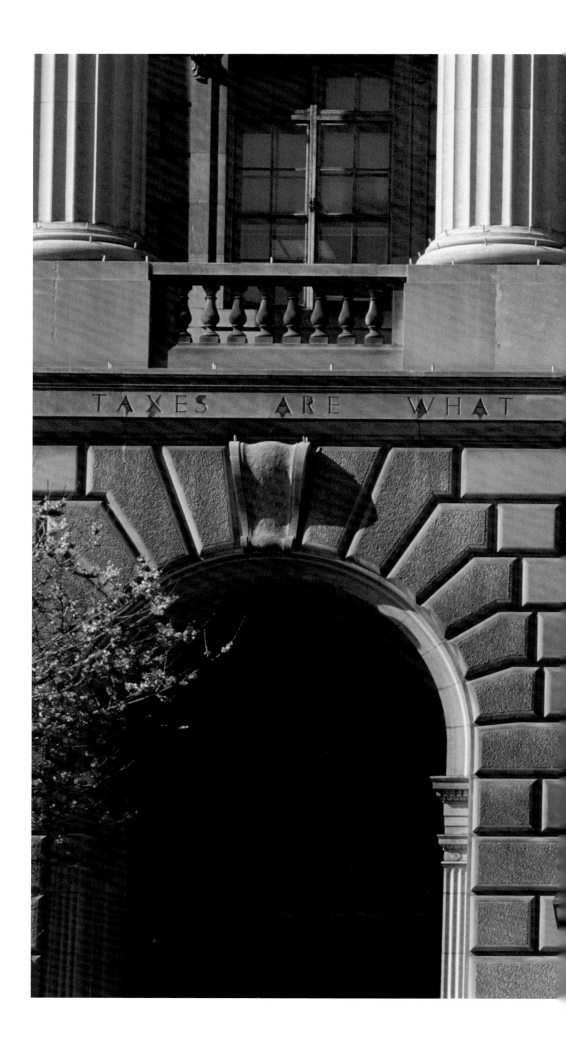

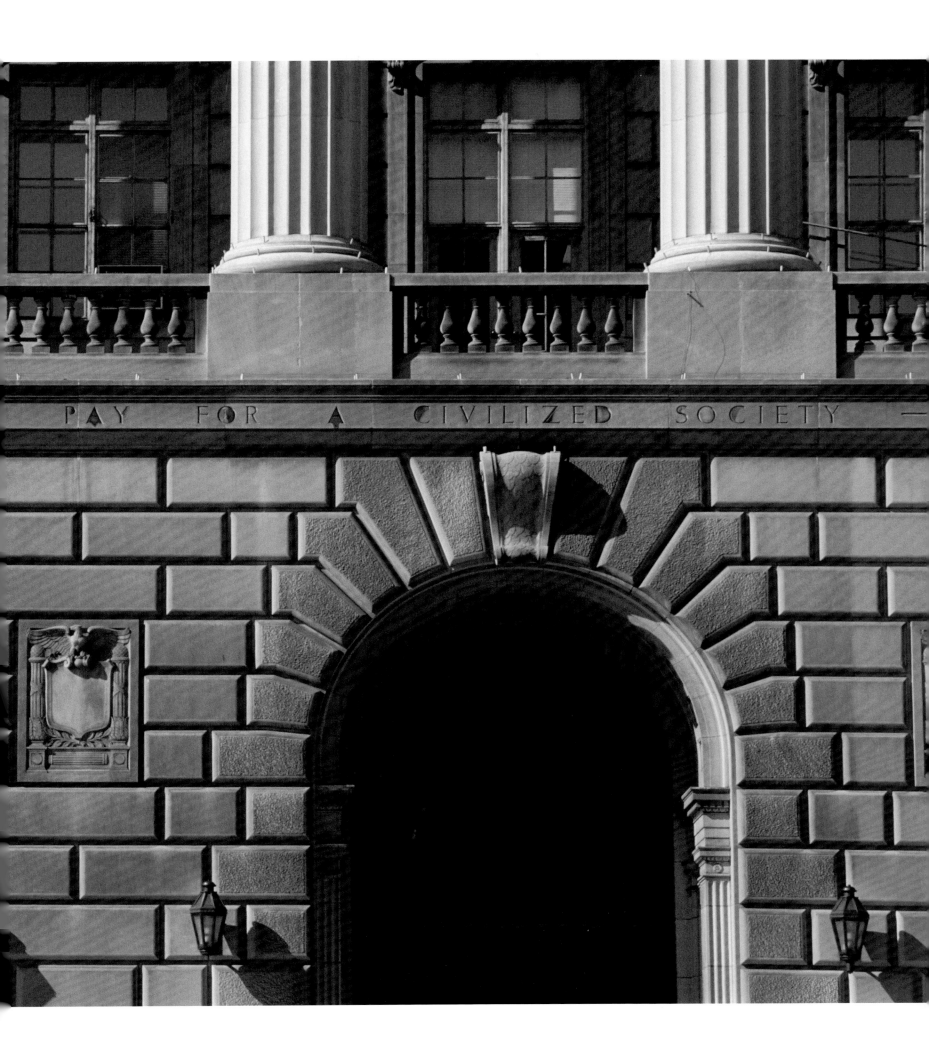

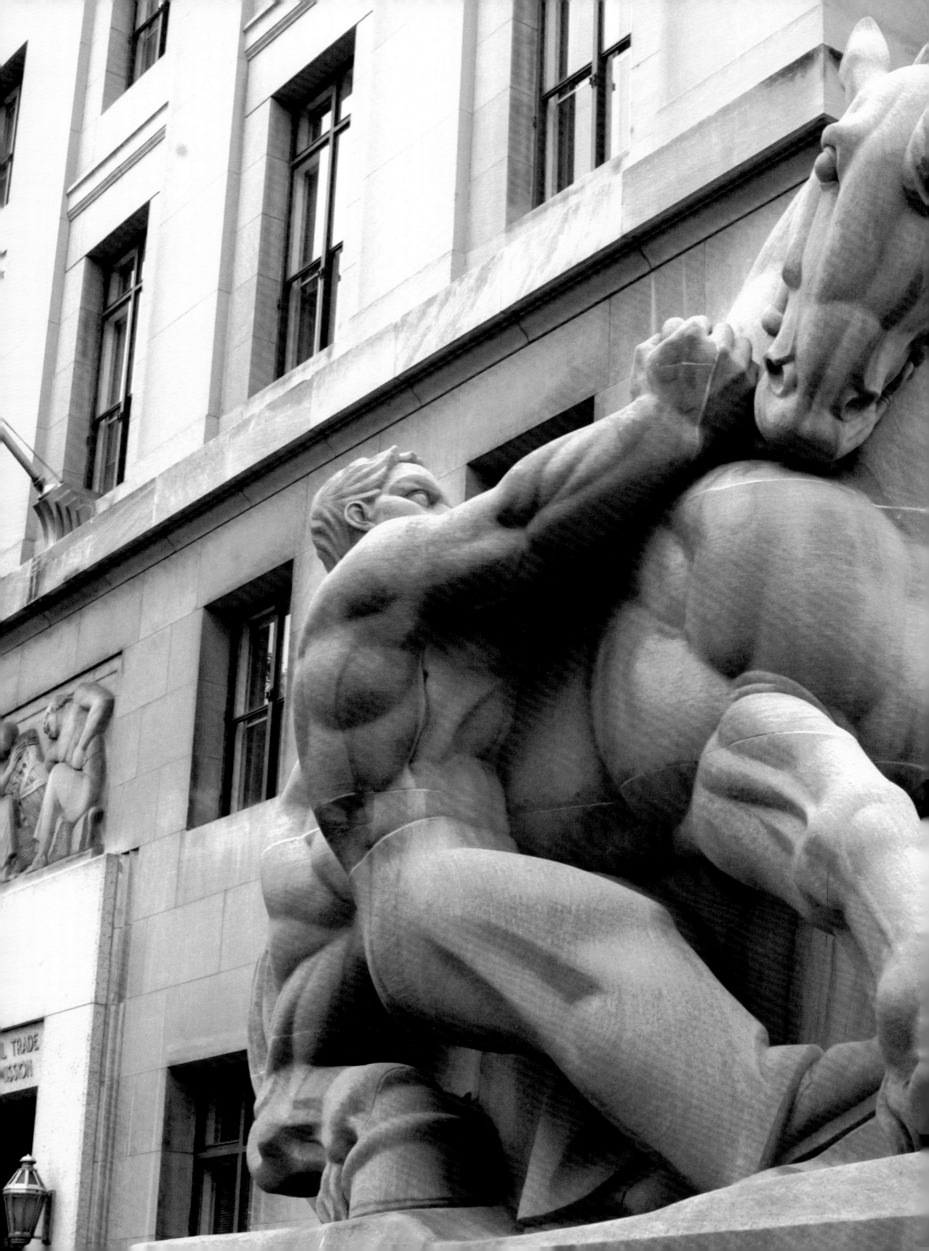

A man wrestles a horse in the arresting statue *Man Controlling Trade* by American sculptor Michael Lantz. One of a pair, this statue sits outside the Federal Trade Commission Building, for which it was commissioned in 1942. Established in 1914 by President Woodrow Wilson, the Federal Trade Commission protects consumer interests and aims to maintain a competitive business market.

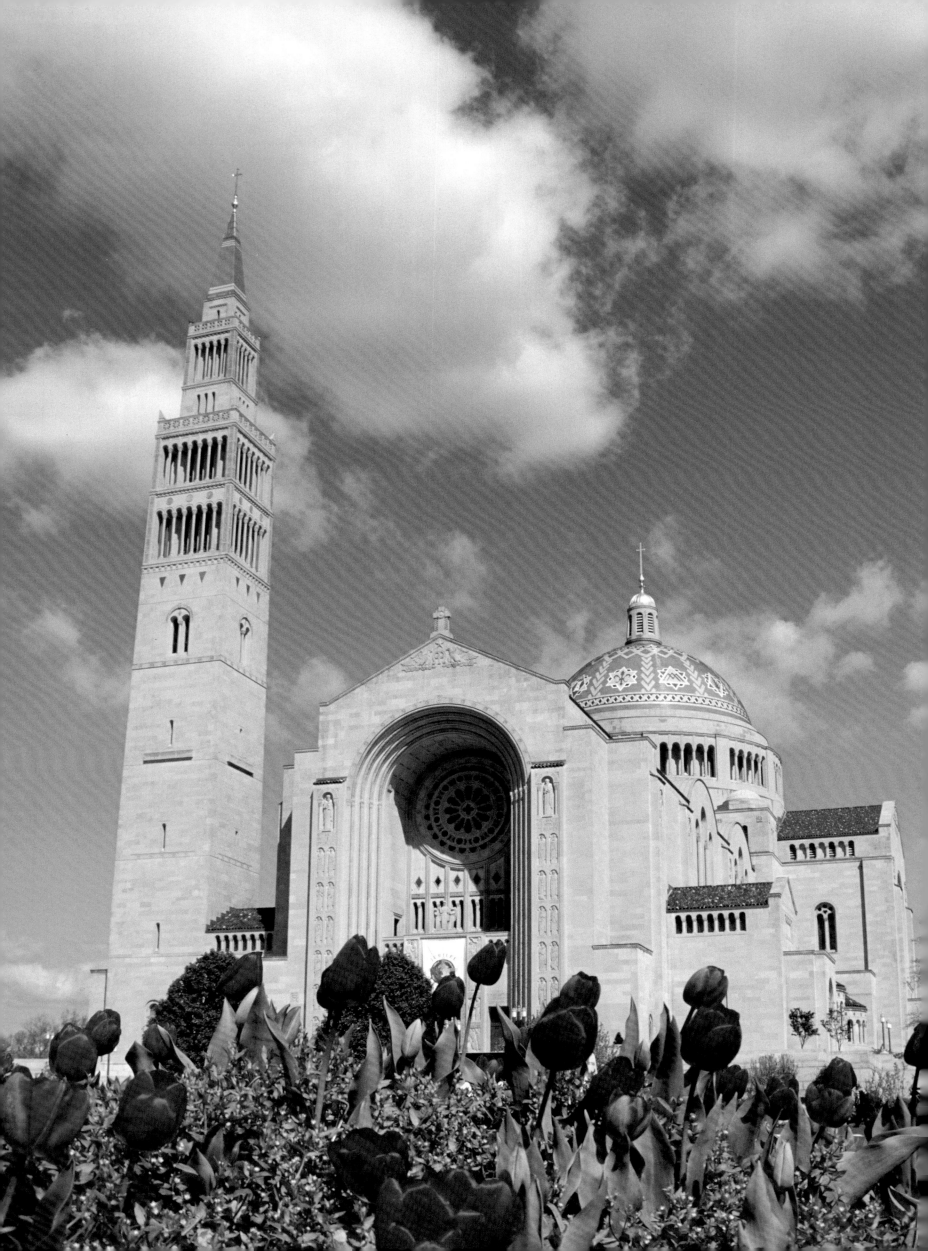

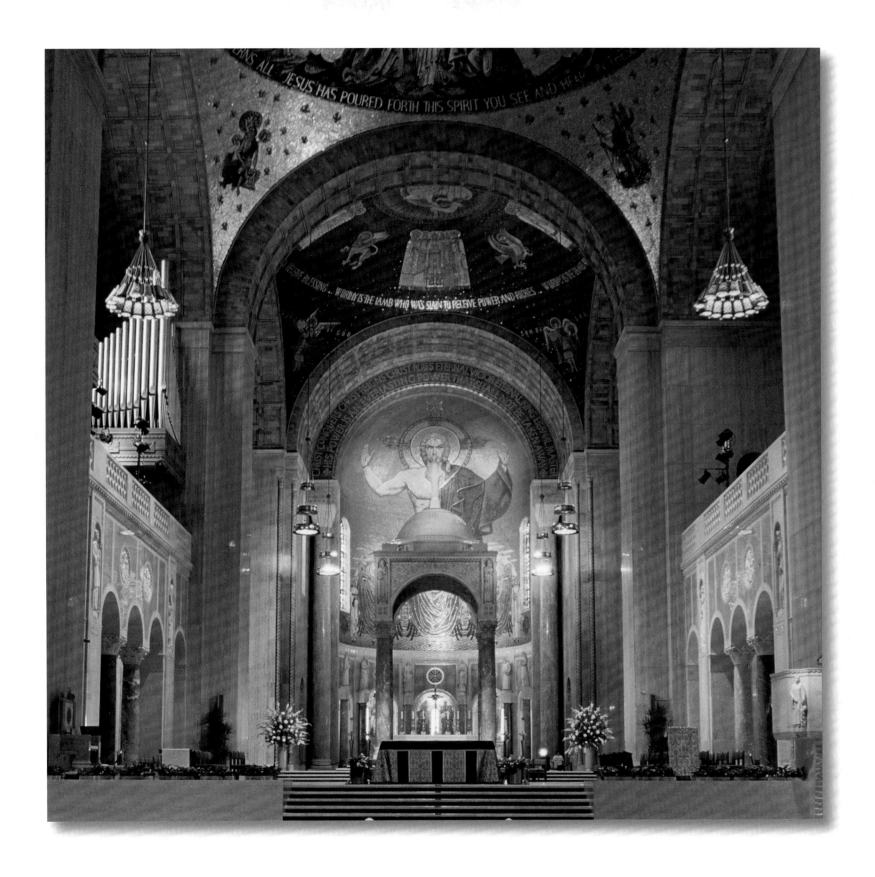

Named a minor basilica by Pope John Paul II in 1990, the Basilica of the Shrine of Immaculate Conception hosts millions of pilgrims every year. The inside of the shrine, one of the largest religious buildings in the world, features a succession of ornately decorated domes, which culminate in the stunning Christ in Majesty mosaic. The size of the main dome rivals that of the United States Capitol building.

Older than some states, the Basilica of the National Shrine of Immaculate Conception is built in the style of Europe's medieval churches. Made entirely of stone, brick, tile, and mortar, without any steel beams or columns, the Basilica houses the largest collection of contemporary ecclesiastical art in America. (*left*)

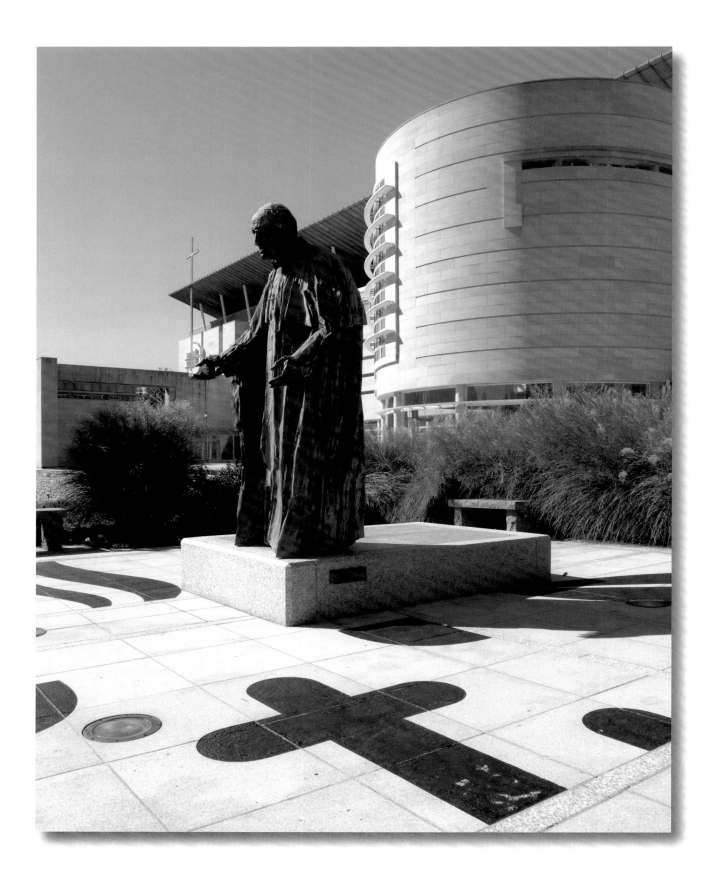

This statue of Pope John Paul II stands on the grounds of the Pope John Paul II Cultural Center, adjacent to the Basilica of the Shrine of Immaculate Conception. Dedicated to exploring the art and culture of the Catholic faith and the heritage of its namesake, the center consists of five interactive galleries.

Flags of the world's Islamic nations are displayed on the grounds of the Islamic Center of Washington. The cornerstone of this intricately decorated building housing one of the largest mosques in the United States was laid in 1949. A 162-foot-high minaret crowns this opulent white limestone building with panes of elaborately stained glass. The building also houses a cultural center. (*right*)

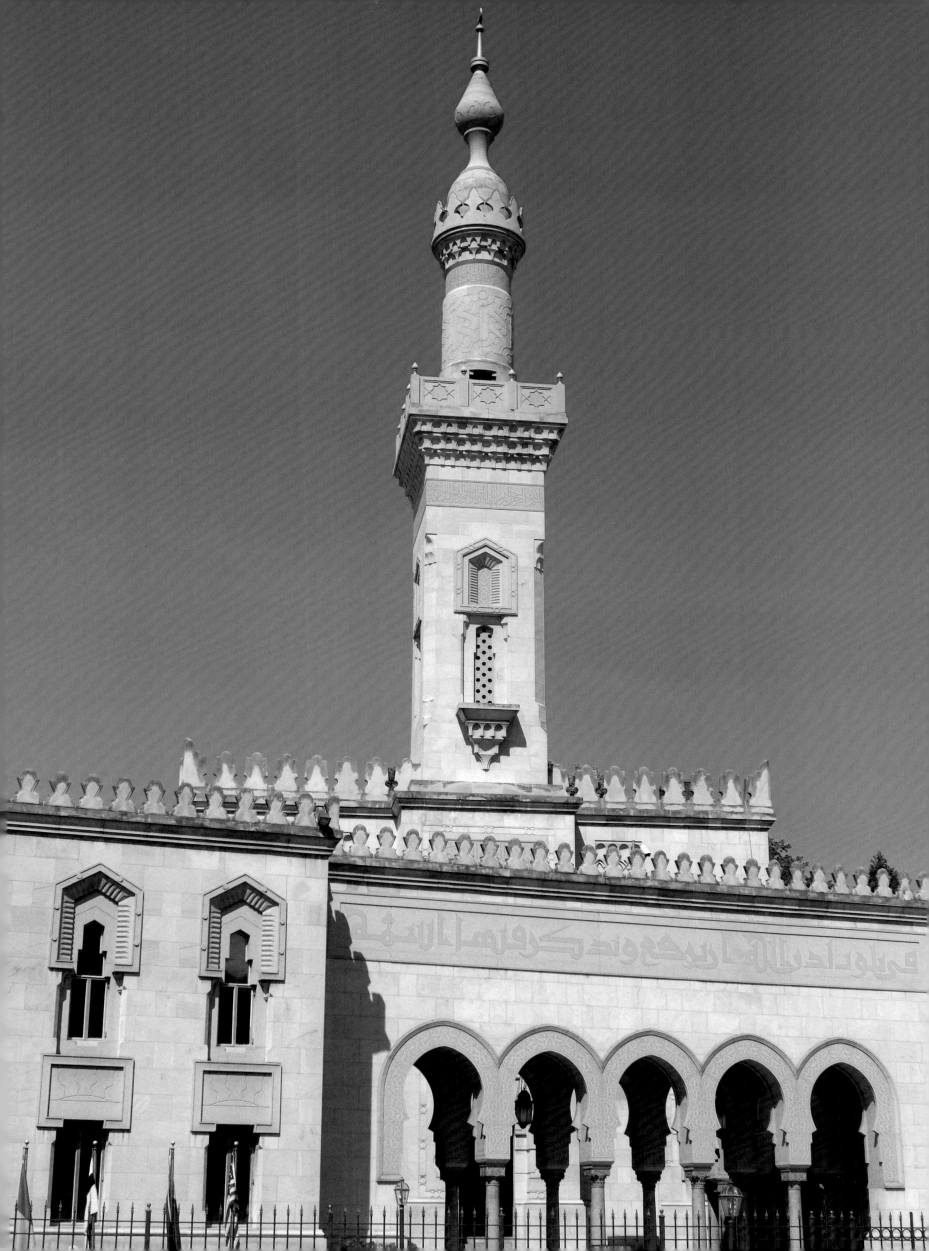

—THE NATIONAL CATHEDRAL—

Perched on Mount Saint Alban, the splendid Gothic Washington National Cathedral is the world's sixth-largest cathedral and the second-largest in the United States after the Basilica of Immaculate Conception, also in Washington, D.C. Officially called the Cathedral Church of Saint Peter and Saint Paul and listed on the National Register of Historic Places, this Episcopal cathedral is the nation's designated National House of Prayer.

Plans for a national cathedral can be traced back to the drawing board of the capital city itself. At the end of the 18th century, Washington, D.C.'s primary city planner, Pierre L'Enfant, envisioned a non-denominational house of worship and learning open to all. The plans for the cathedral were not ratified until almost a century later when Congress signed a charter granting the Protestant Episcopal Cathedral Foundation of D.C. the right to establish a cathedral. While the cathedral is affiliated with the government it does not receive any government funding: the money for its construction and maintenance comes from the private sector.

Although the cathedral has been in use since its Bethlehem Chapel opened in 1912, its construction has spanned 83 years and 16 presidencies. Theodore Roosevelt attended the laying of the foundation stone in 1907, and George H. W. Bush presided over the placement of the final ornament in 1990.

An exquisite display of gothic architecture — with pointed arches, flying buttresses, vaulted ceilings, and over 200 stained glass windows — the Washington National Cathedral is a lavish memorial chronicling American history, as well as a house of worship. It houses statues of presidents George Washington and Abraham Lincoln. A commemorative arch bears the inscription "I Have a Dream" in honor of Martin Luther King Jr. who preached his last sermon here before he was assassinated in Memphis, Tennessee.

The Washington National Cathedral is the final resting place for many distinguished Americans, including deaf, mute advocate Helen Keller and her teacher Anne Sullivan, and Woodrow Wilson, the 28th President of the United States. It has served as the site of state funerals for three presidents: Dwight D. Eisenhower, Gerald R. Ford, and Ronald Reagan.

Even in a city of such architectural magnificence as Washington, D.C., the cathedral stands out as a stunning achievement. While it was a long time in the making, the cathedral has proven a spectacular gathering place for people of all faiths. (*right*)

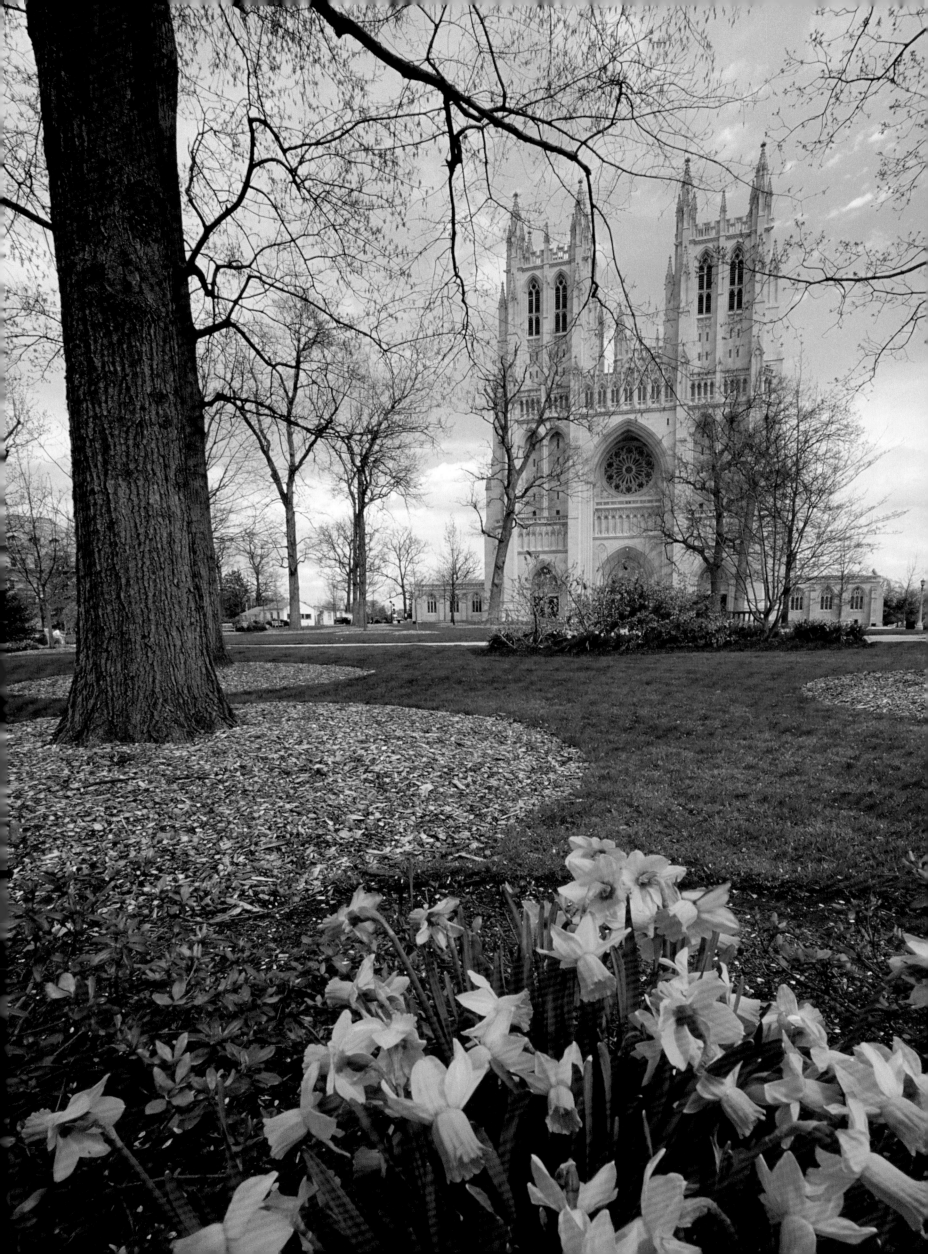

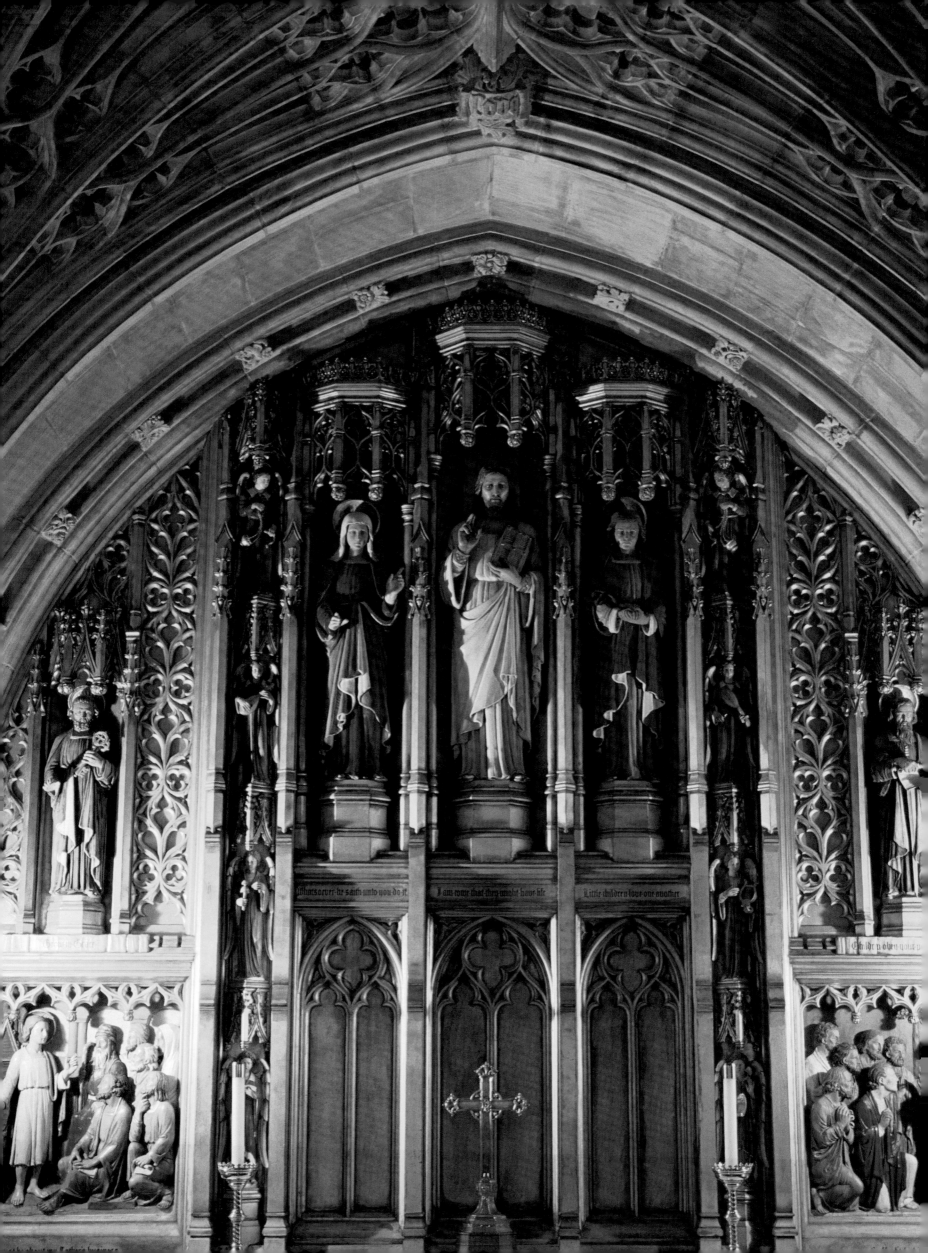

Over a century old, the church and Franciscan monastery at Mount St. Sepulchre include a replica of the catacombs in Rome, extensive gardens with replicas of shrines in the Holy Land, and a library. Dedicated in 1899 the building, which is partly modeled after the Hagia Sofia in Istanbul, was designated a National Historic Monument in 1991. The order of St. Francis maintains Roman Catholic holy sites around the globe.

The ornate interior of the Washington National Cathedral contains many memorials among its stained glass windows and intricate doors. The splendid cathedral hosts statues of George Washington and Abraham Lincoln, Woodrow Wilson's sarcophagus, the stained glass Space Window commemorating the flight of Apollo II, and an arch memorializing Dr. Martin Luther King Jr. (*left*)

Five of Washington's busiest roads meet at Dupont Circle, a traffic circle and a public park. Crowds often gather in Dupont Circle for protests, rallying around the park's fountain, which is decorated with three figures representing the wind, the sea, and the stars. Installed in 1921, the piece was commissioned by the Dupont family and designed and sculpted by the co-creators of the Lincoln Memorial.

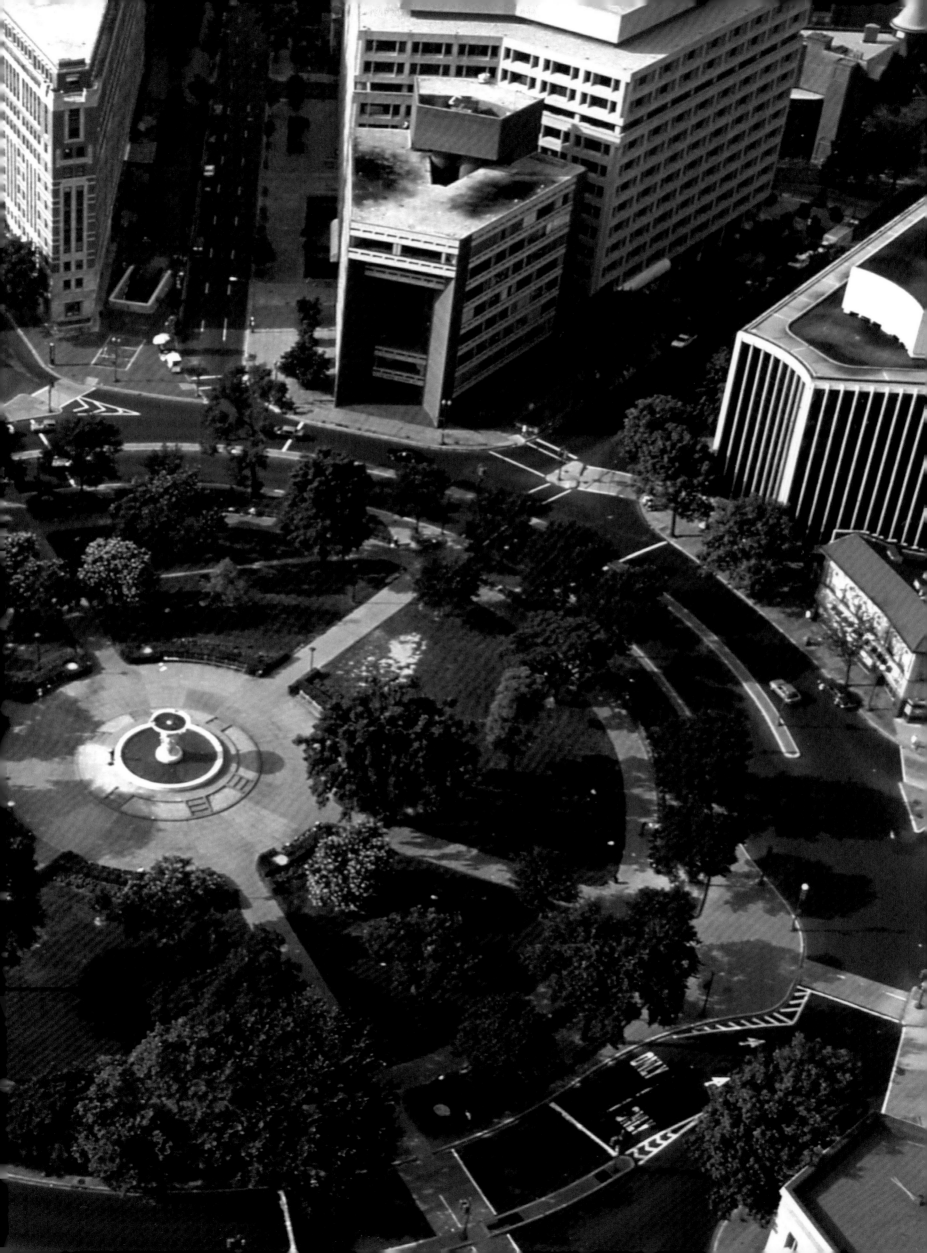

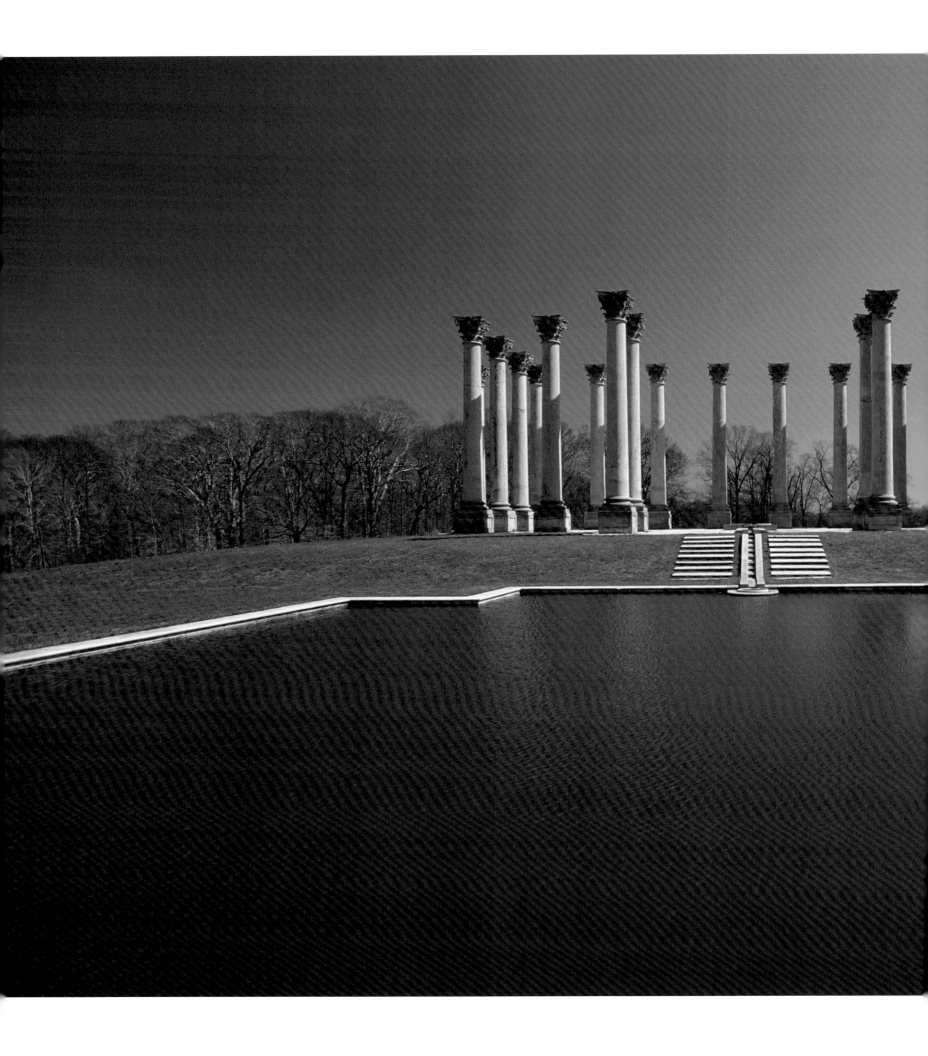

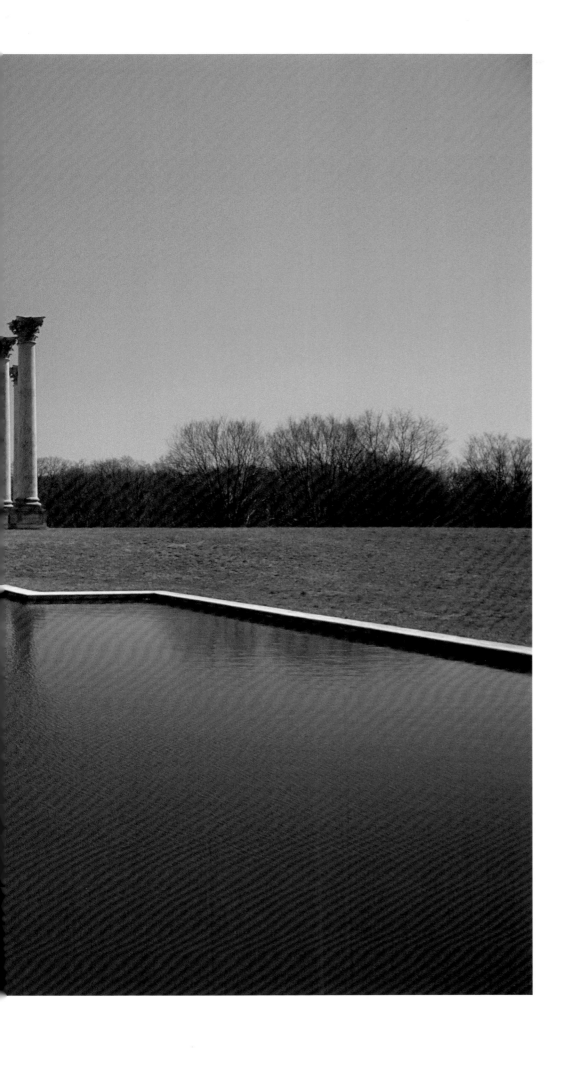

The granite Capitol Columns of the National Arboretum are a surreal sight. Once providing support for the east portico of the United States Capitol building, these 22 Corinthian columns formed the setting for presidential inaugurations from Jackson to Eisenhower. When the Capitol building was renovated in 1958, the columns were taken out and later moved here to the Arboretum's Ellipse Meadow.

Azaleas bloom amid the Dogwood Collection at the 446-acre National Arboretum. A botanical garden of trees, the National Arboretum features the National Grove of State Trees with trees and flora native to each state, the National Herb Garden, the Holly and Magnolia Collections, Fern Valley, and the Chinese and Japanese trees of the National Bonsai and Penjing Museum.

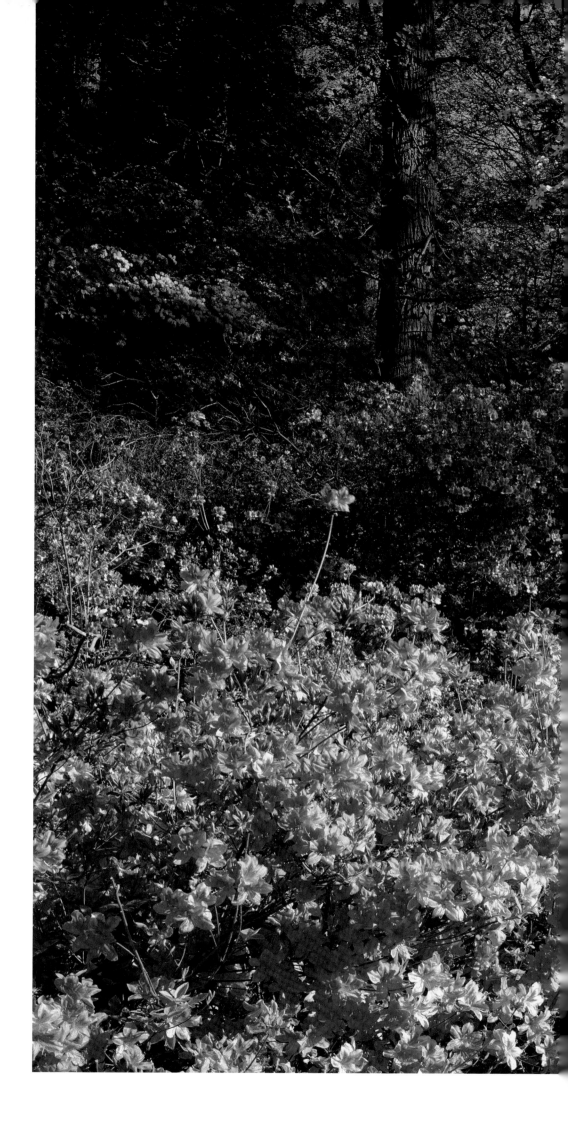

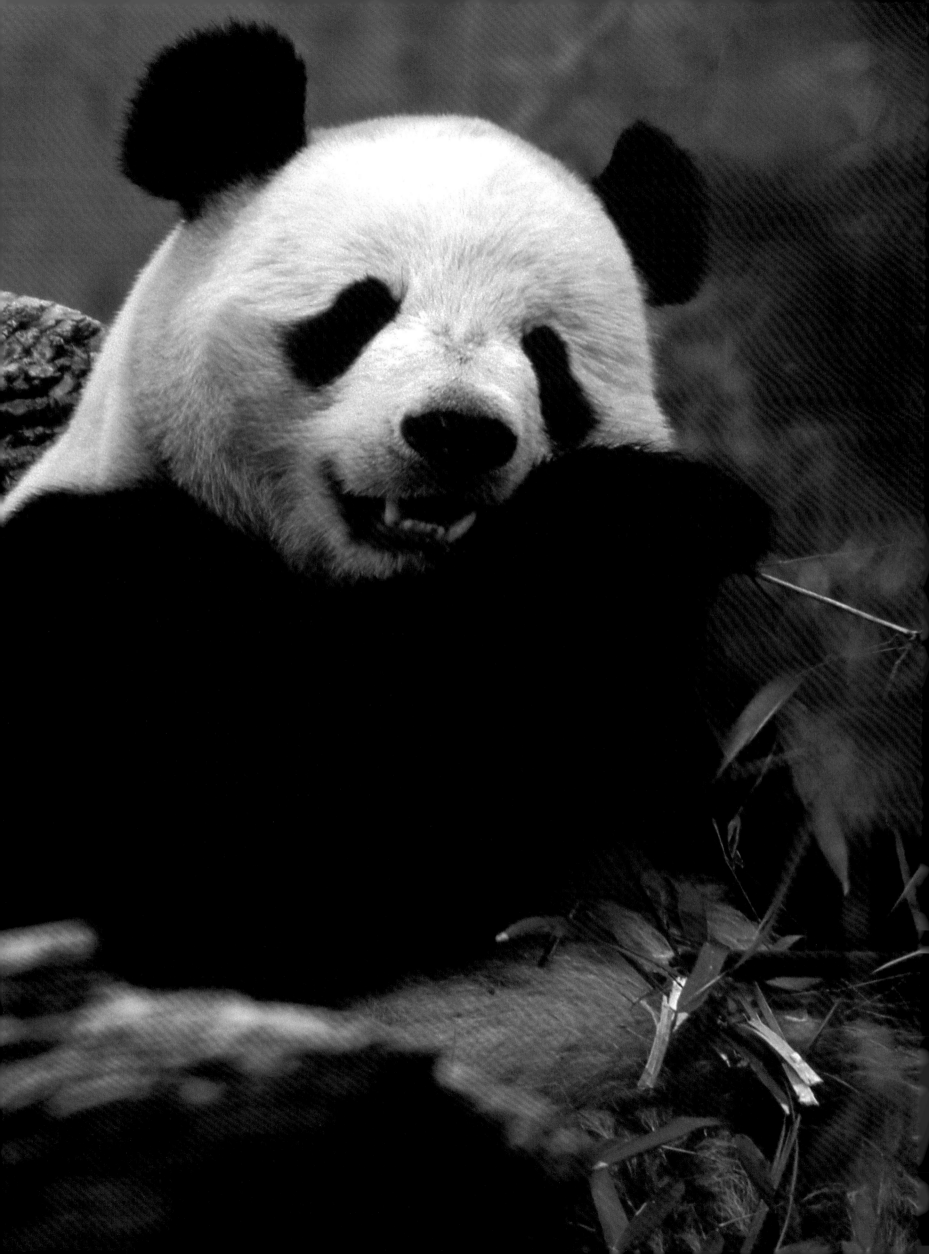

Spanning over 160 acres above Rock Creek Park, the Smithsonian National Zoological Park is home to over 2,400 animals and about 400 different species — including mammals, birds, reptiles, amphibians, fish, and invertebrates. Since its inception in 1889, the National Zoo's mission has been to provide a refuge for species on the road to extinction. In addition to its public facility in Washington, D.C., the Zoo also has a 3,200-acre Conservation and Research Center in Front Royal, Virginia, where animals are trained and studied.

Giant Pandas are a perennial favorite at the National Zoo. The first pair of pandas to call it home were Ling-Ling and Hsing-Hsing — who were given as a gift to the National Zoo by China after Richard Nixon became the first United States president to visit the country in 1972. Mei Xiang and Tian Tian, the zoo's second set of pandas, gave birth to cub Tai Shan in 2005 amid much fanfare and excitement. The cub was the third panda born in the United States that survived for more than a few days, and the first at the National Zoo. (*left*)

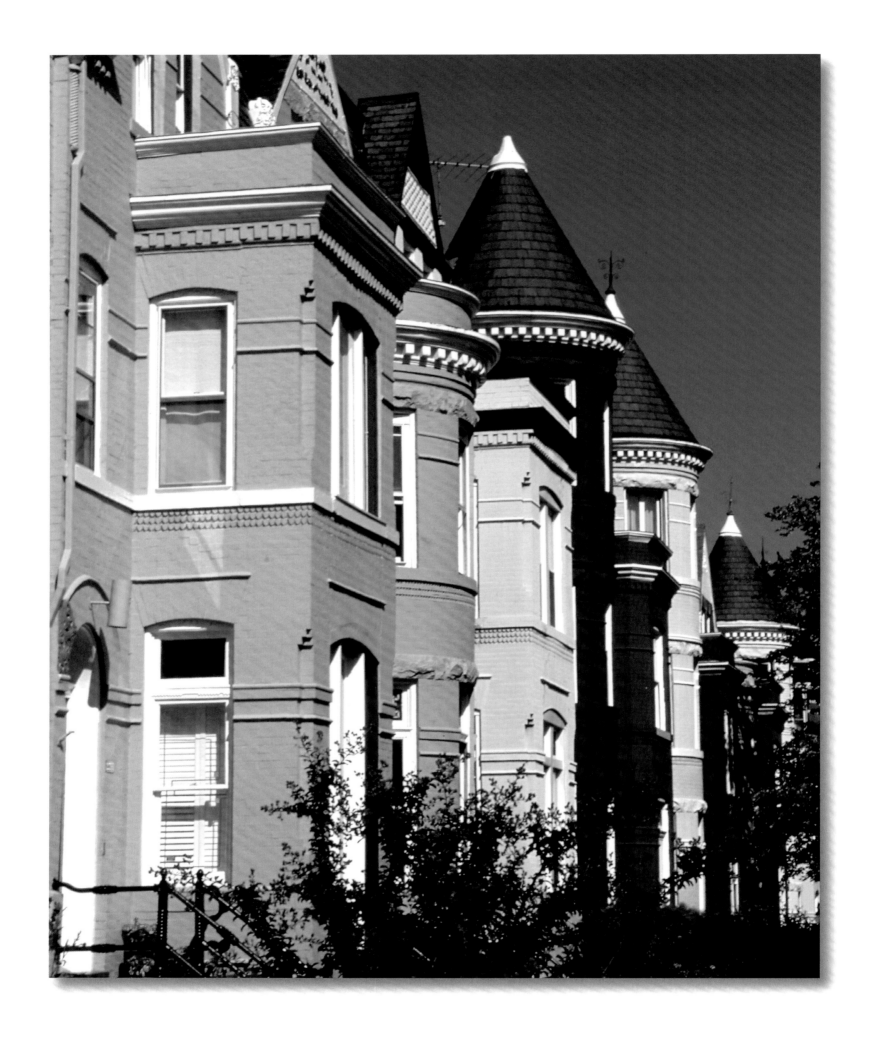

The picturesque houses in Georgetown are rich in history. They have housed legendary Americans like John and Jackie Kennedy, President Lincoln's son Robert Todd, and "Star-Spangled Banner" author Francis Scott Key.

—GEORGETOWN—

One of Washington, D.C.'s swankiest neighborhoods, Georgetown is known for its picturesque canal and beautiful well-preserved homes. The neighborhood's journey to becoming a posh little enclave of the capital city was dramatic, however, characterized by huge booms and busts.

Long before Washington, D.C. was designated America's capital, the site north of the Potomac was part of Maryland. A flourishing spot populated mainly by Scottish immigrants, the settlement was authorized with a town charter by the Maryland Assembly in 1751 and named Georgetown after King George II. It prospered with booming shipping and trade industries, becoming the largest tobacco port in the nation by the 1780s.

When President George Washington chose the shores of the Potomac as the site of the new Federal District in 1791 Georgetown was included, but it kept its charter and distinct character.

After a long period as a thriving hub, Georgetown declined following the Civil War. Decades of producing plentiful tobacco crops exhausted the soil, and the town could no longer produce high volumes of its cash crop. Furthermore, the new railroads popping up across the country were compromising Georgetown's status as an important shipping and trading site. The Chesapeake and Ohio (C&O) Canal was built to strengthen Georgetown's position in the shipping industry, but the channel was severely damaged in a flood at the end of the 19th century.

A weakened Georgetown was incorporated into Washington City in 1871, losing its charter. Georgetown's character was stripped away even further in 1895 when the street names were changed to correspond with Washington's. A bleak slum, the neighborhood wasn't rejuvenated until the New Deal era brought gentrification by white-collar residents.

Senator John F. Kennedy's move to Georgetown in the 1950s christened it as a fashionable place to live. The neighborhood's roster of prominent residents has grown over the years to include Senator John Kerry, intrepid Watergate reporter Bob Woodward, and former Secretary of State Madeleine Albright. Georgetown's distinct character became officially protected when in 1967 the area was declared a National Historic Landmark, and the C&O Canal was designated a historic park in 1971.

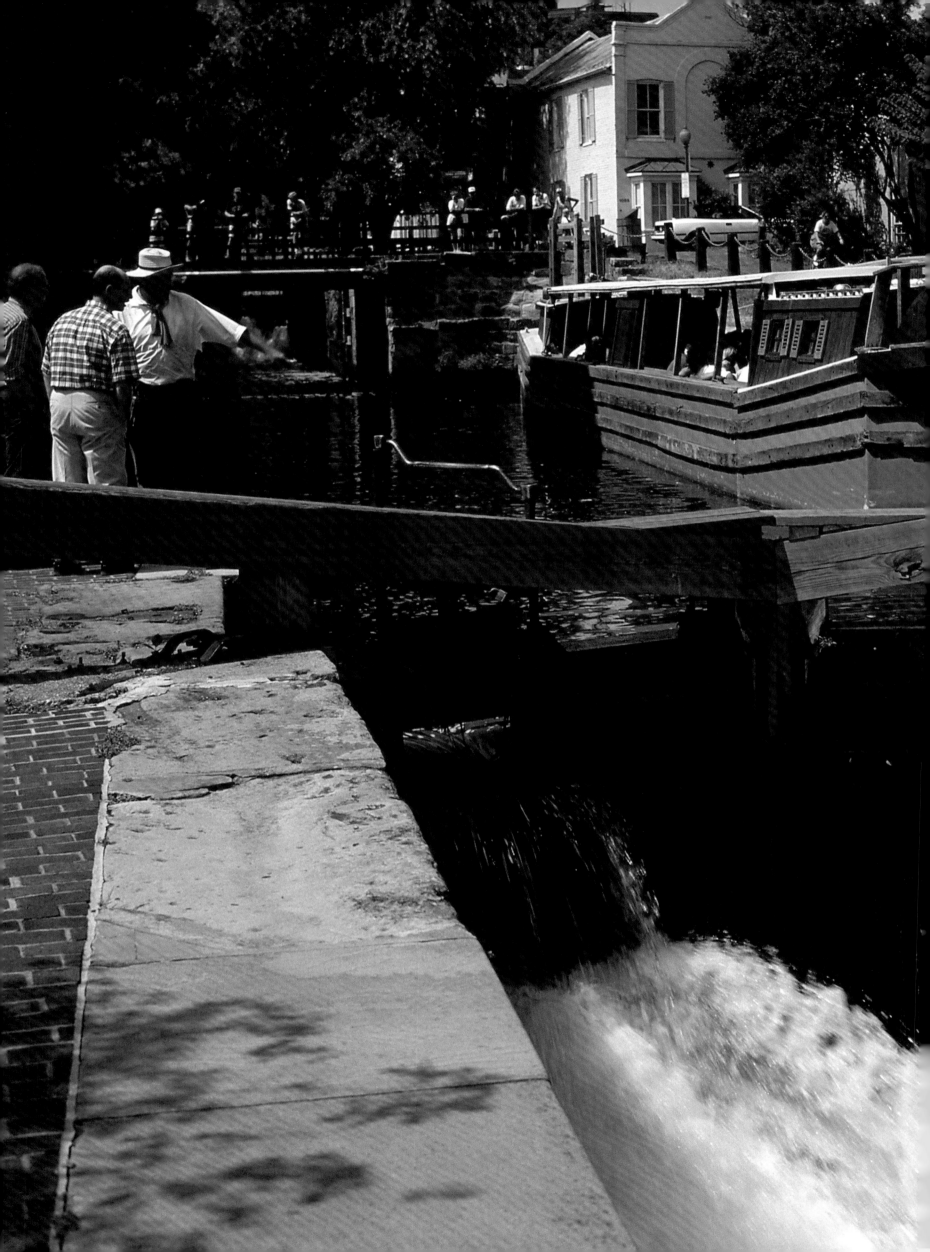

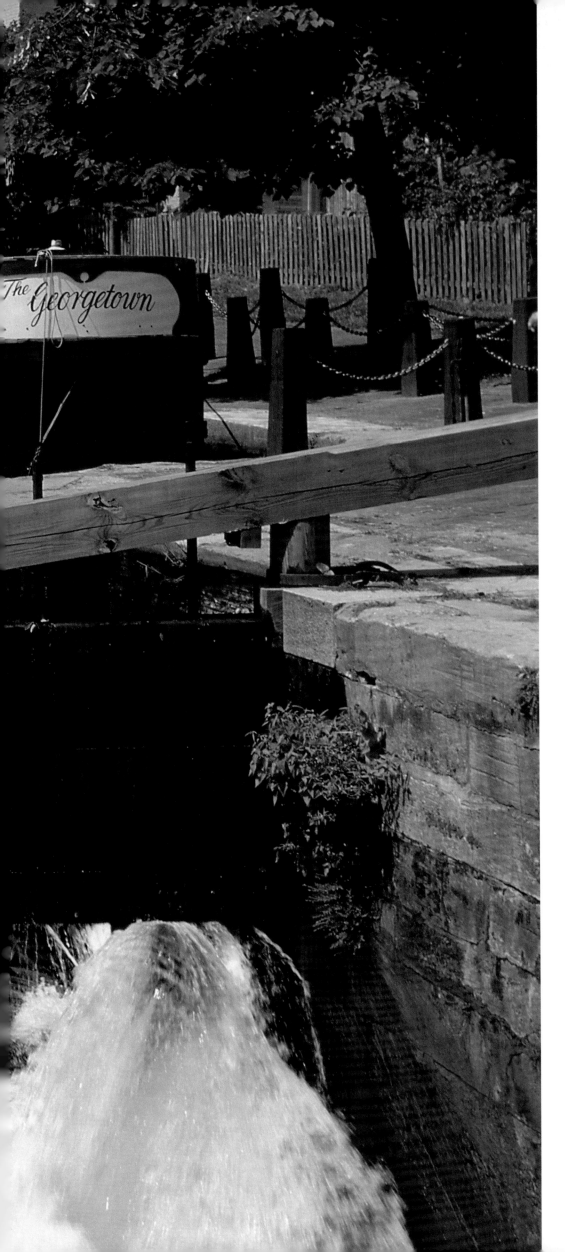

Boats still ply the Chesapeake & Ohio Canal, although now it is more for tourism than trade. Over 180 miles long and completed in 1850, the C&O Canal was once an important route for communities along the Potomac who used it to transport goods to markets. Today, boats pulled down the canal by mules recreate that chapter of transportation history.

The oldest Catholic university in the country, Georgetown University was called the Jesuit Georgetown College when it opened in 1789. From an initial roster of only 12 students, Georgetown College has grown into a vibrant school with thousands of students whose alumni include former President of the United States Bill Clinton and the President of the Philippines, Gloria Macapagal-Arroyo. With almost 60 buildings that include a performing arts center and athletic facilities, the university is an integral part of Washington's lively Georgetown district.

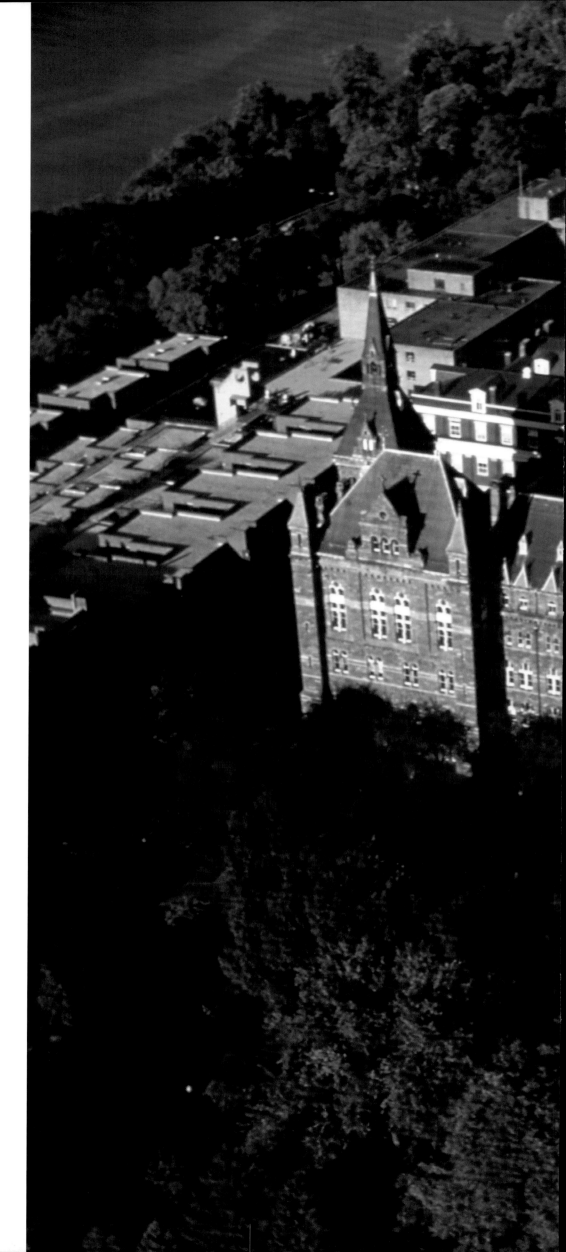

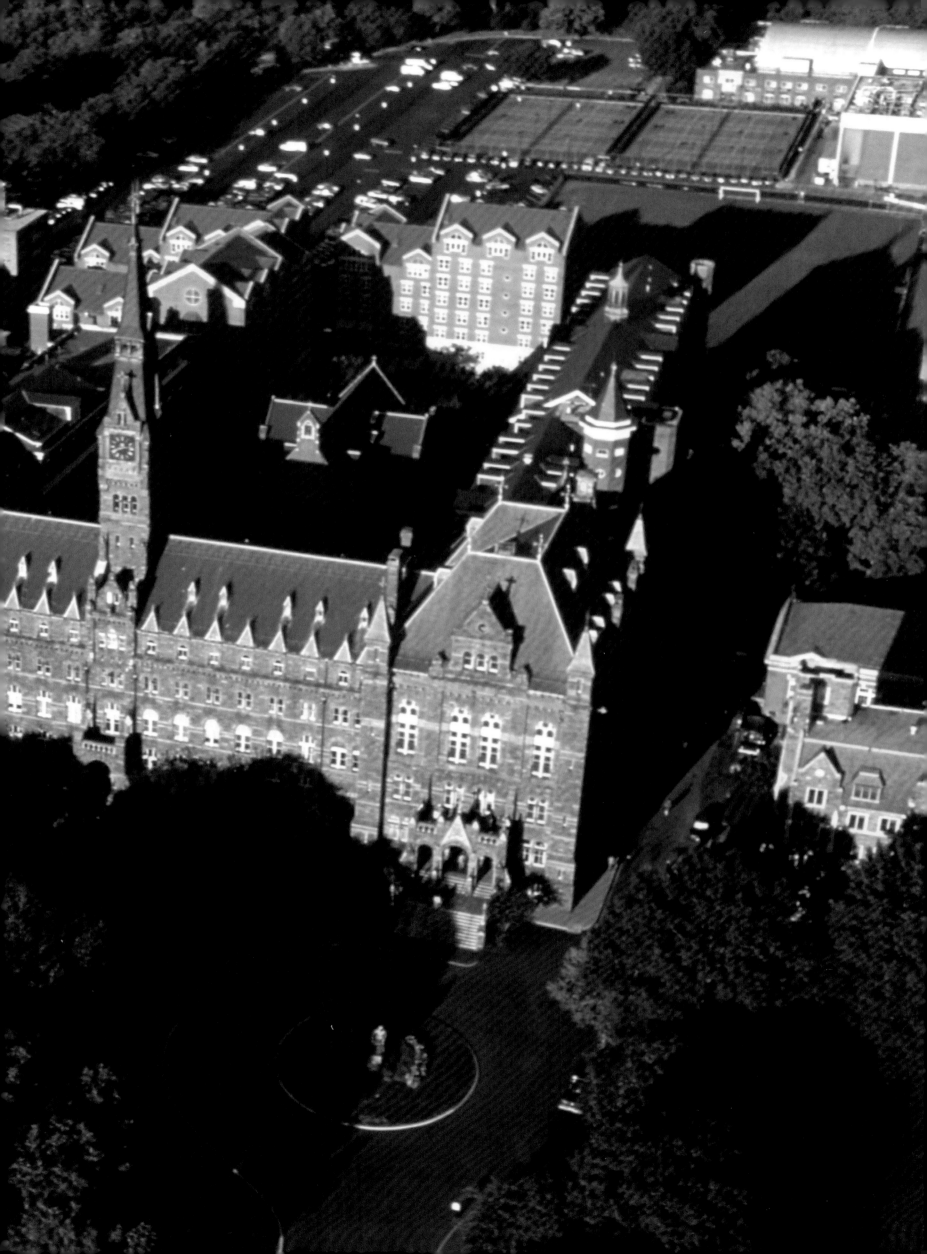

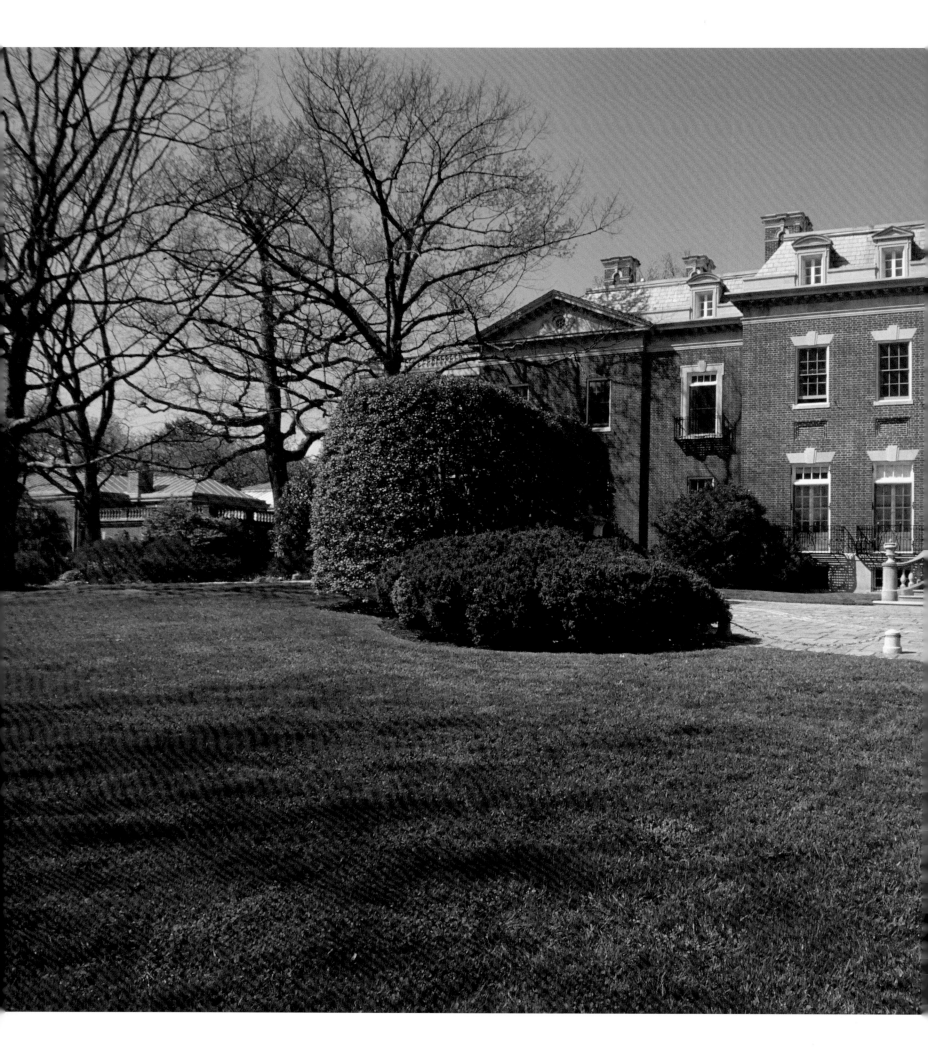

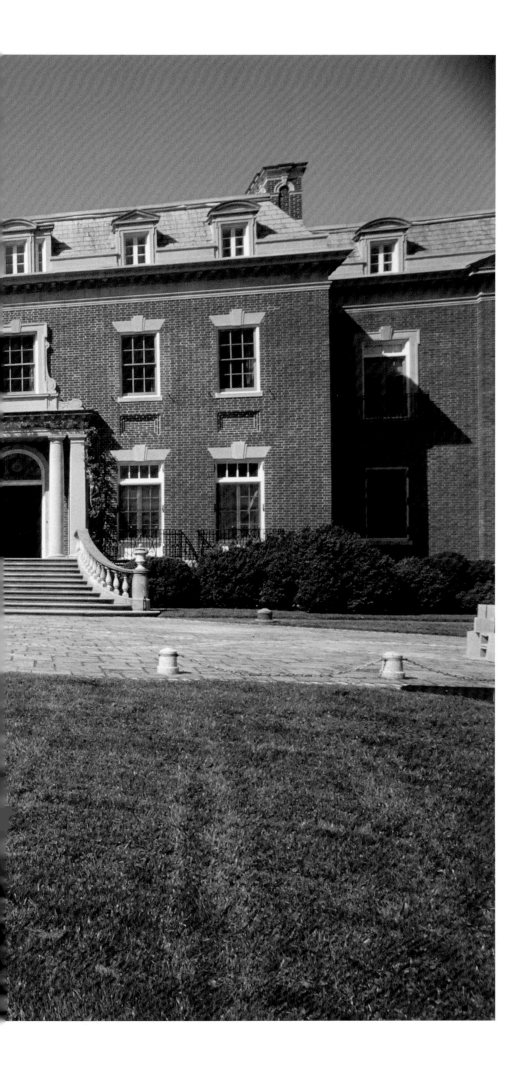

Surrounded by acres of garden, this Georgian mansion at Dumbarton Oaks was the home of diplomat Robert Woods Bliss before he bequeathed the estate to Harvard University in 1940. It was here in 1944 that delegates from the American, Chinese, Russian, and British governments met and agreed to form the United Nations. A portion of the mansion has been converted into a gallery to showcase former owners Robert and Mildred Woods Bliss' extensive art collection.

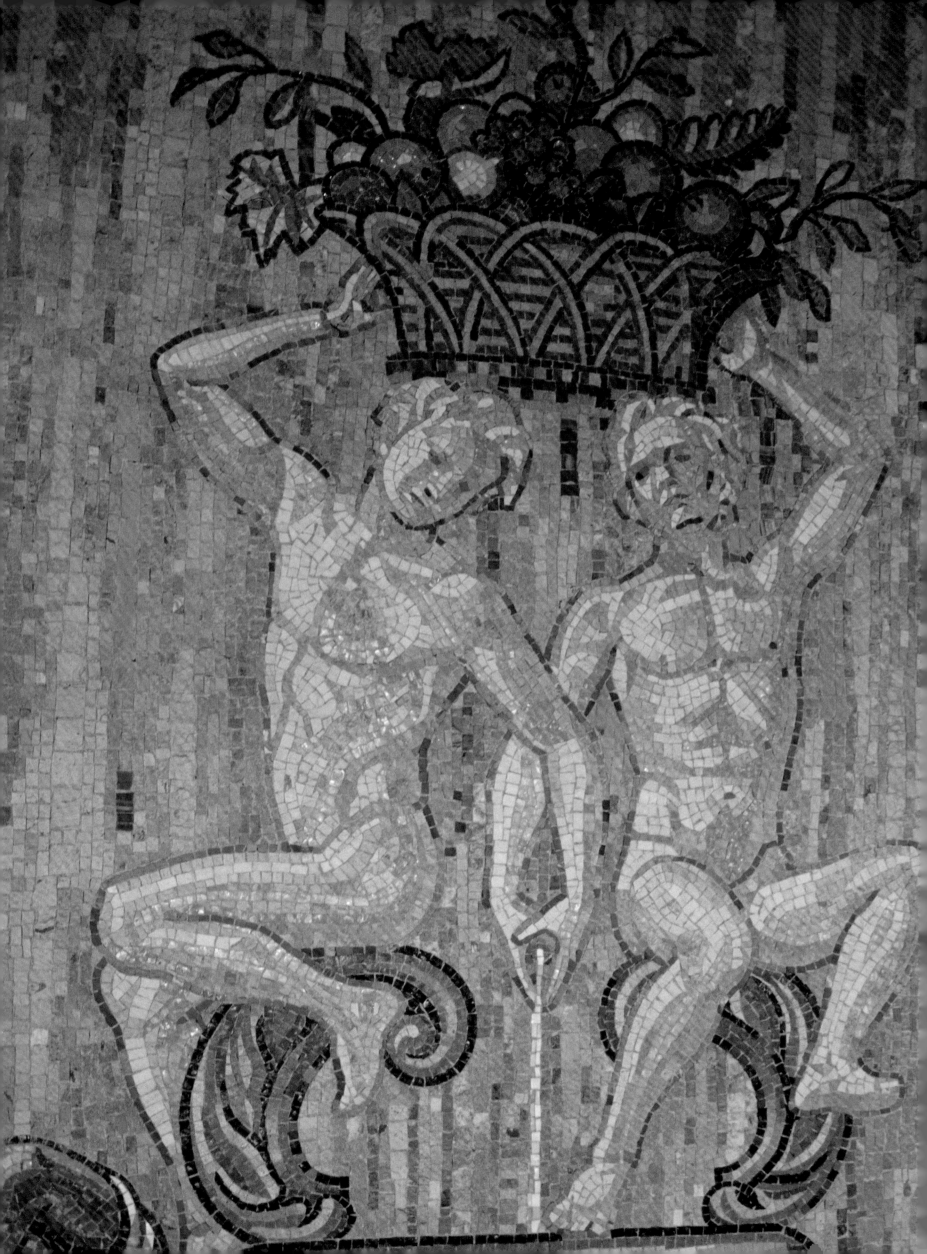

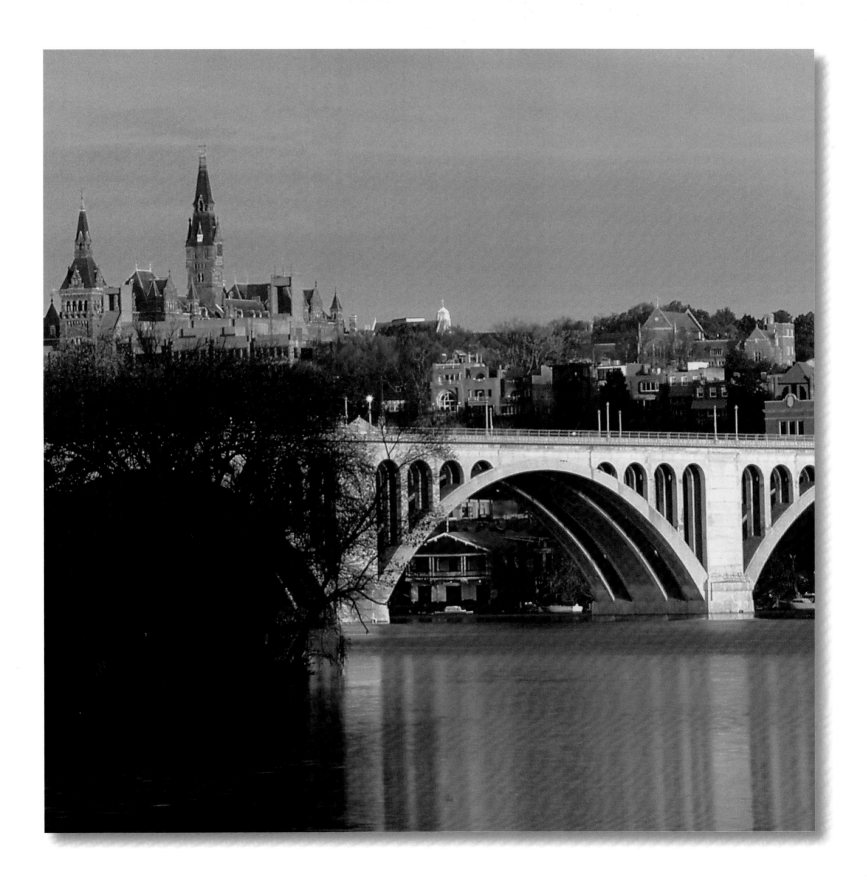

Named for the author of "The Star Spangled Banner," the Francis Scott Key Bridge connects Georgetown with Arlington, Virginia. A lawyer and author, Key was also responsible for prosecuting the man who attempted to assassinate seventh U.S. President Andrew Jackson.

Exquisite tile mosaics decorate the poolhouse at Dumbarton Oaks. Once a private home, the Dumbarton Oaks Research Library and Collection is now a resource center for scholarship in the fields of Byzantine, Pre-Columbian, and Garden and Landscape Studies. (*left*)

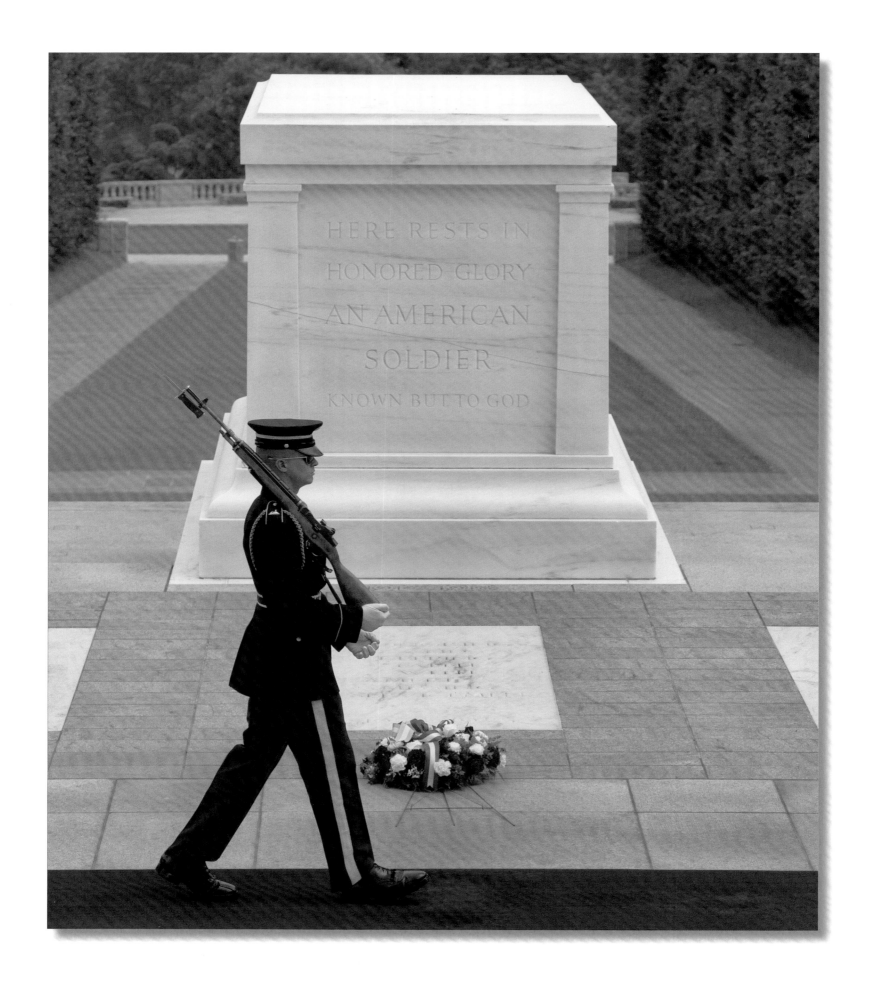

The changing of the guard is part of the commemorative Veteran's Day ceremony at the Arlington National Cemetery. Among the cemetery's many monuments and memorials dedicated to battles, soldiers, and wars is the Tomb of the Unknowns. Holding the unidentified remains of soldiers from World Wars I and II, the Korean War, and the Vietnam War, the tomb is a symbolic resting place for all the American soldiers whose bodies were never identified and a tribute to their bravery.

—ARLINGTON NATIONAL CEMETERY—

The many memorials and graves at the Arlington National Cemetery pay homage to the great figures of American history. The largest military cemetery in the nation is the final resting place for generations of soldiers — from those who fought in the American Revolution to the veterans of more recent wars in Afghanistan and Iraq.

Located across the Potomac River from D.C. in Arlington, Virginia, the cemetery is home to the gravesites of presidents William Howard Taft and John F. Kennedy, the Spanish-American War Memorial, the Space Shuttle Challenger Memorial, and the Pan Am Flight 103 Memorial Cairn. Perched on a hill overlooking the cemetery, the restored Arlington House is a memorial to its former resident, Confederate General Robert E. Lee.

Arlington House was built by Martha Washington's grandson by her first marriage, George Washington Parke Custis. Upon his death, the estate was bequeathed to his daughter Mary Anna Randolph Custis Lee, who was married to army lieutenant Robert E. Lee. A valued soldier for the Union and a descendent of a prominent Virginia family, Lee was opposed to his native state's decision to secede from the Union during the Civil War. When Virginia did withdraw, however, Lee chose to serve the Confederate Army, in spite of an offer from President Lincoln to lead the Union Army.

After Lee left his home at Arlington House to lead the Confederate Army, Union forces gained control of Washington, D.C., and Mary was forced to leave Arlington House. The government confiscated the estate and designated it a military cemetery. By the end of the Civil War in 1865, there were already 16,000 soldiers buried at the cemetery. After Lee died in 1870, his family fought to have the land returned to them, bringing their case all the way to the Supreme Court. The family did regain the rights to the estate in 1874, but were forced to sell it back to the government for financial reasons, and so the estate at Arlington remains a military cemetery.

Sprawling over 600 acres, the Arlington National Cemetery serves as the final resting place for thousands of people. Its rich past makes it an important part of American history. (overleaf)

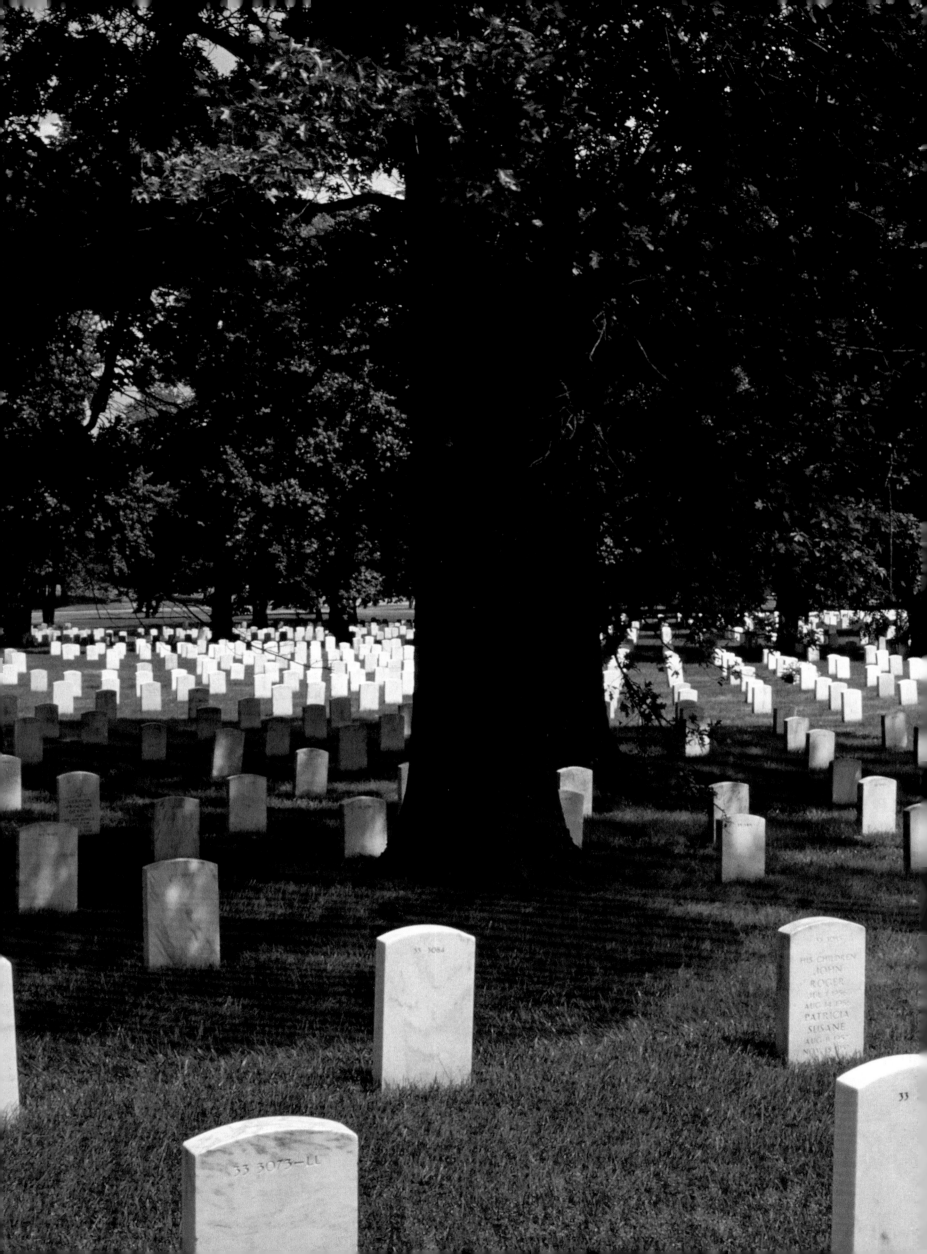

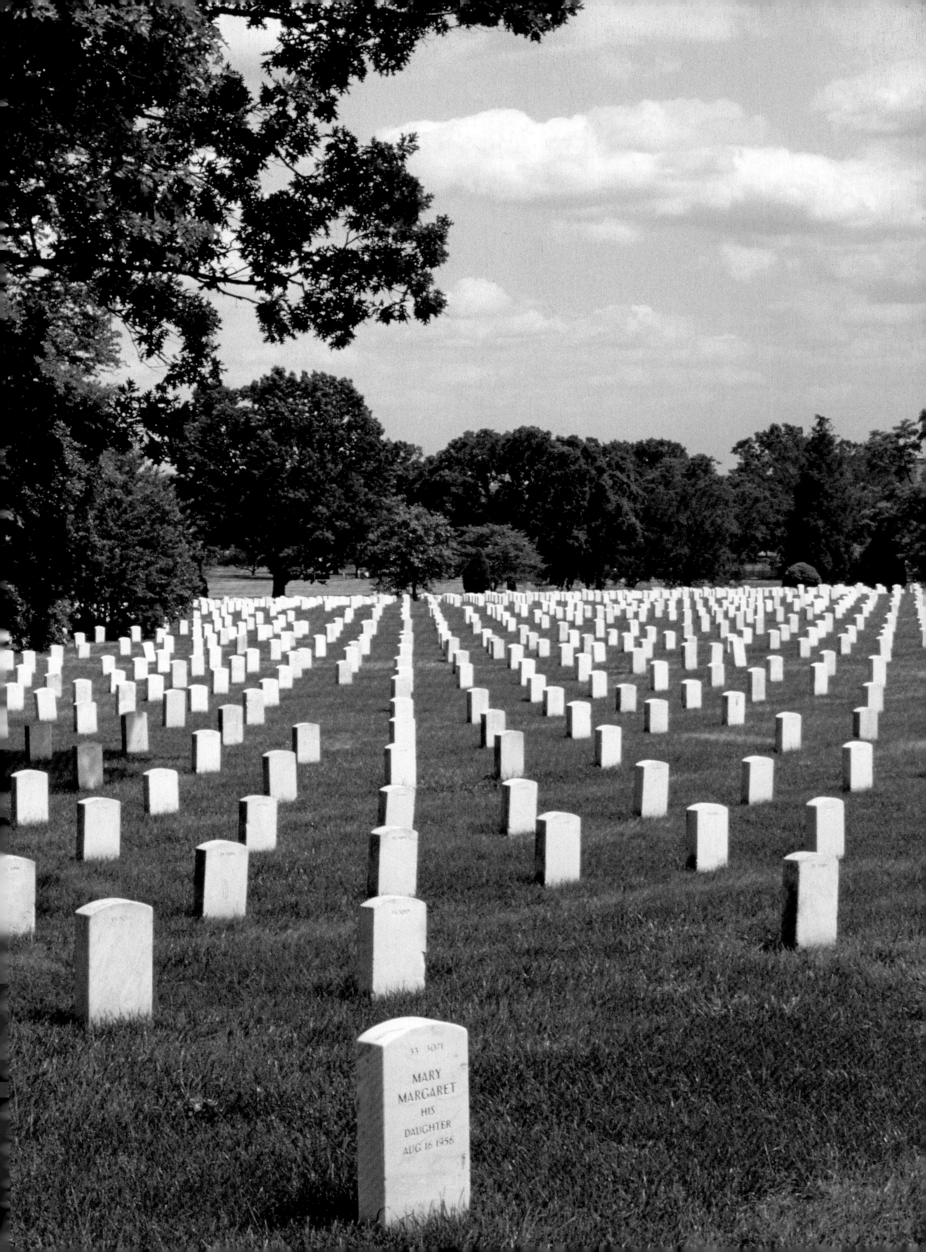

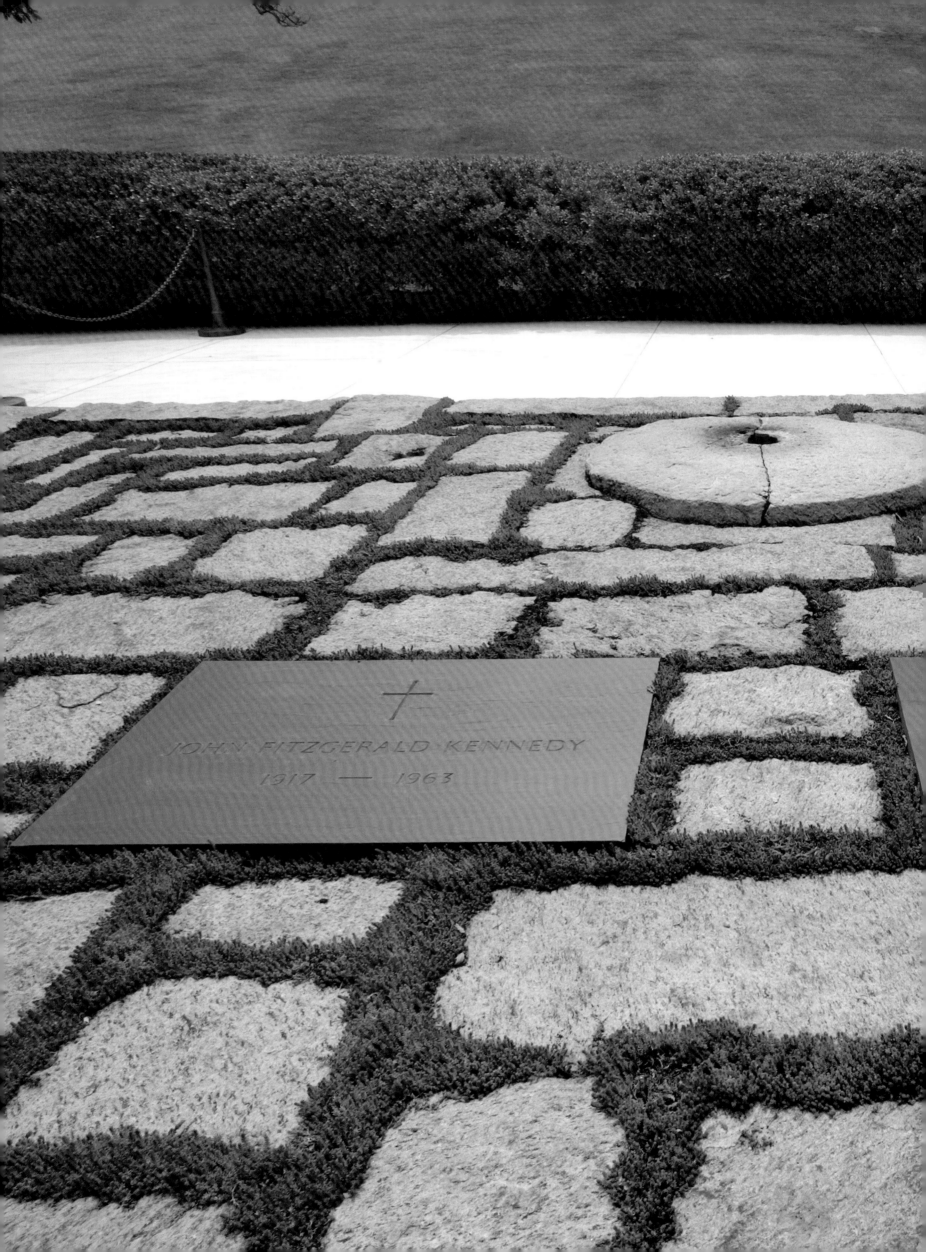

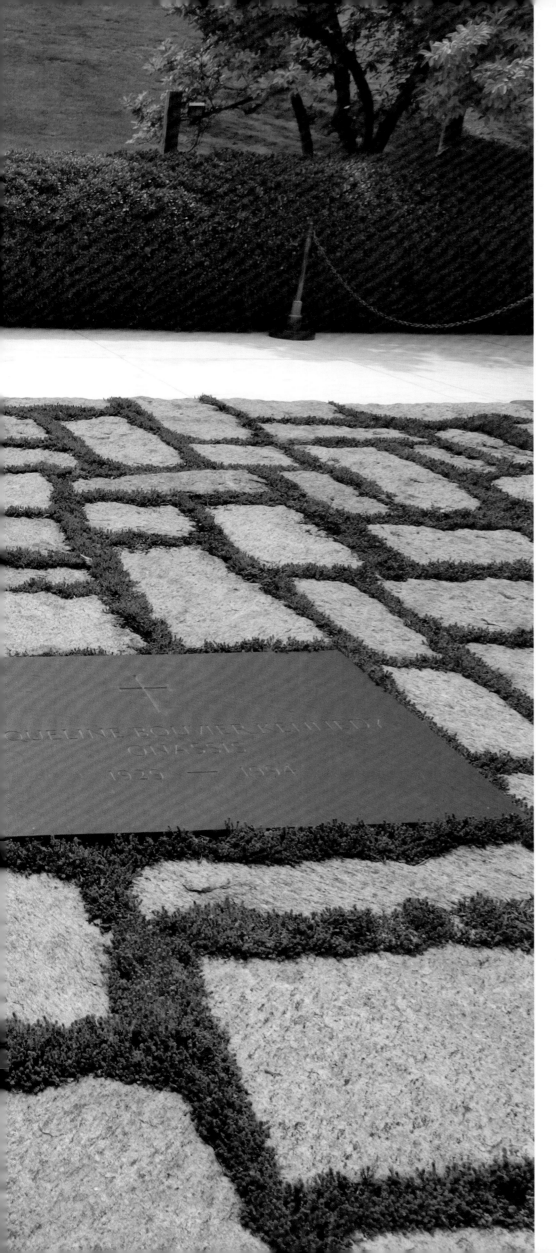

An eternal flame lit by Jackie Kennedy burns next to the gravesite of John F. Kennedy, the 35th President of the United States, who was interred here on March 25, 1963. Buried alongside Kennedy are his First Lady Jacqueline Bouvier Kennedy Onassis and two of their children. The youngest president to date, Kennedy had served the United States for almost three years when he was assassinated.

Modeled after a Pulitzer Prize-winning photograph by Joe Rosenthal, the United States Marine Corps Memorial depicts American soldiers raising their flag on Mt. Suribachi on the island of Iwo Jima. Dedicated to all of the United States Marine Corps personnel who lost their lives in battle, this monument is one of the few sites in the world that is officially entitled to fly the American flag all the time, an honor bestowed by President John F. Kennedy in 1961. (*overleaf*)

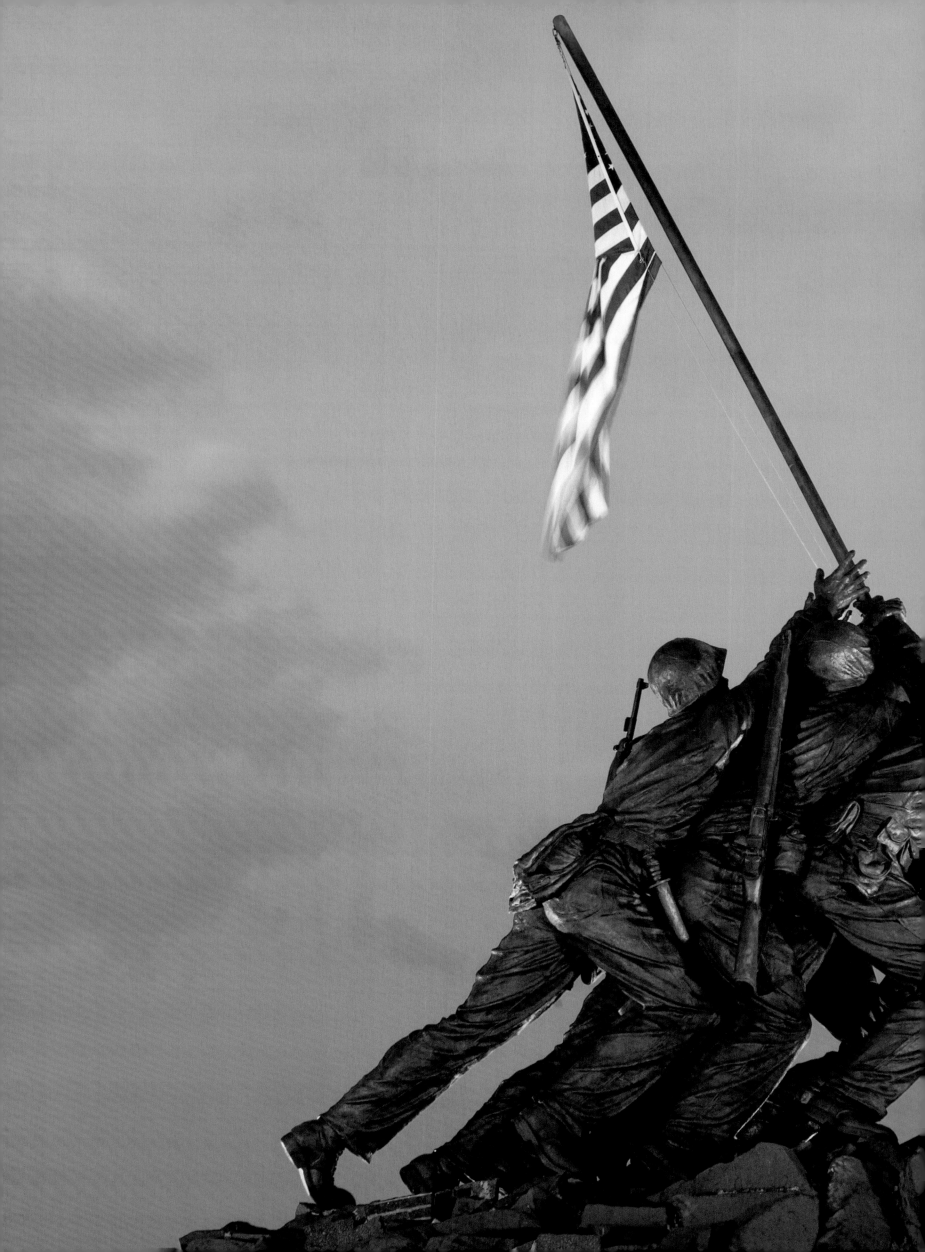

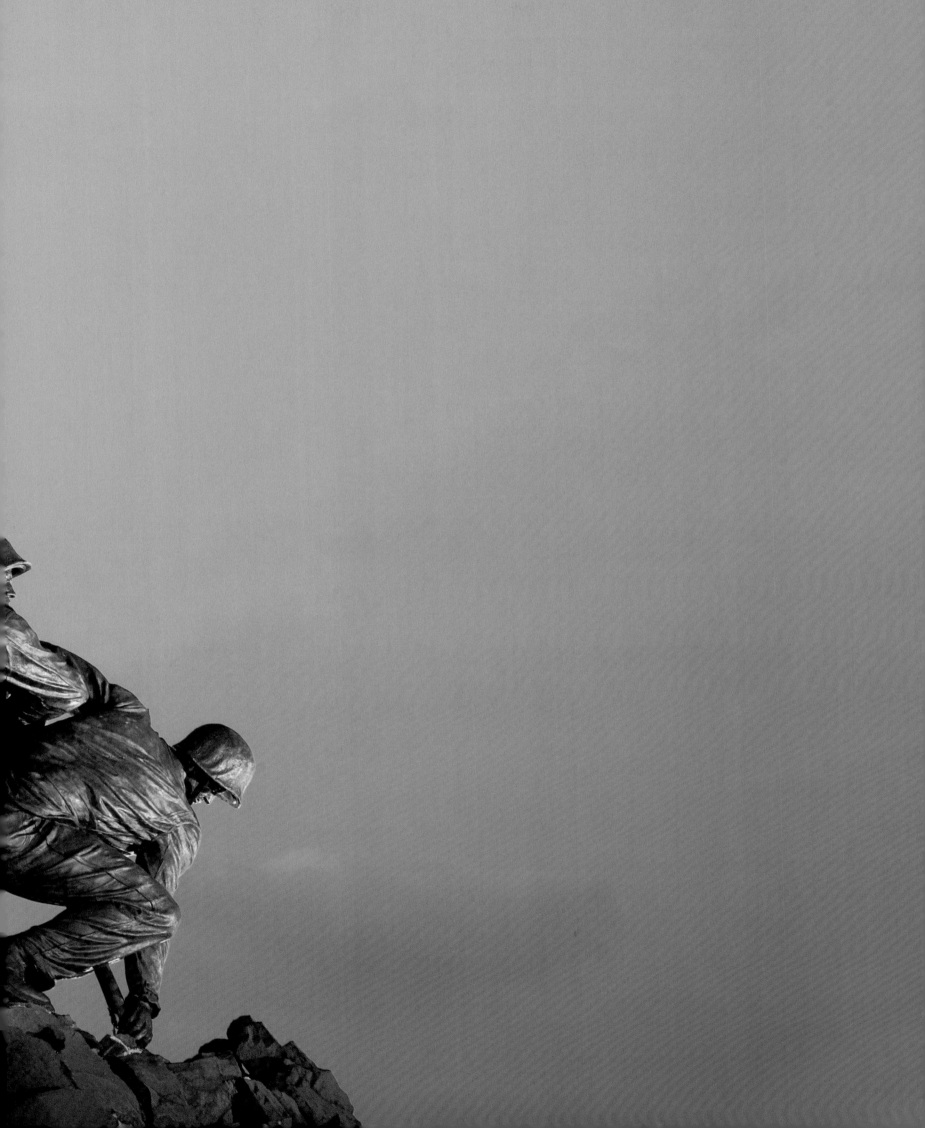

Along with its high concentration of buildings and monuments, Washington, D.C. has so many parks that it's one of the greenest cities in America. Winding through the capital city from the border of the Potomac to the border of Maryland, Rock Creek Park is the city's largest green space, providing a natural contrast to the ornate architecture of downtown Washington. Originally pegged as a possible site for the president's house, Rock Creek Historic District was established as a park in 1890.

—THE PENTAGON—

The imposing five-sided headquarters of the United States Department of Defense is such a recognizable monolith that the department itself is often referred to simply as the Pentagon. The world's largest office building, the Pentagon was intentionally designed as quick and easy to navigate: it takes only seven minutes to walk between any two places in the building.

During the Second World War the American army expanded at such a rate that it became difficult for the Department of War (renamed the Department of Defense in 1949) to provide office space for all its personnel, which was scattered among 17 offices all over Washington, D.C. When President Franklin Delano Roosevelt became aware of the urgency of the situation, he asked for Congressional approval to build the department more offices in and around D.C. The War Department's Chief of Construction, Brigadier General Brehon B. Sommervell, proposed housing the entire department in one building, and the Pentagon was born.

The unique design that gives the building its name was proposed to accommodate the site originally chosen for the Pentagon at the foot of the Arlington National Cemetery. When objections were raised about the Department of War headquarters blocking the view of Washington's core from the cemetery, the building's site was moved, but the design remained.

Army engineers started building the Pentagon on September 11, 1941, with gravel dredged from the Potomac River. Less than a year and a half later, on January 15, 1943, it was finished. At the height of construction, 15,000 people worked in shifts around the clock.

The result of this huge effort is a massive building sitting on almost 600 acres that accommodates over 25,000 employees. The Pentagon itself covers 29 acres, and its central courtyard occupies another five. The building has a total floor area of 6.5 million square feet and its five 900-foot-long sides create almost 20 miles of corridor. A feat of engineering that is one of the world's most powerful symbols, the Pentagon is the command center of the American army. (*right*)

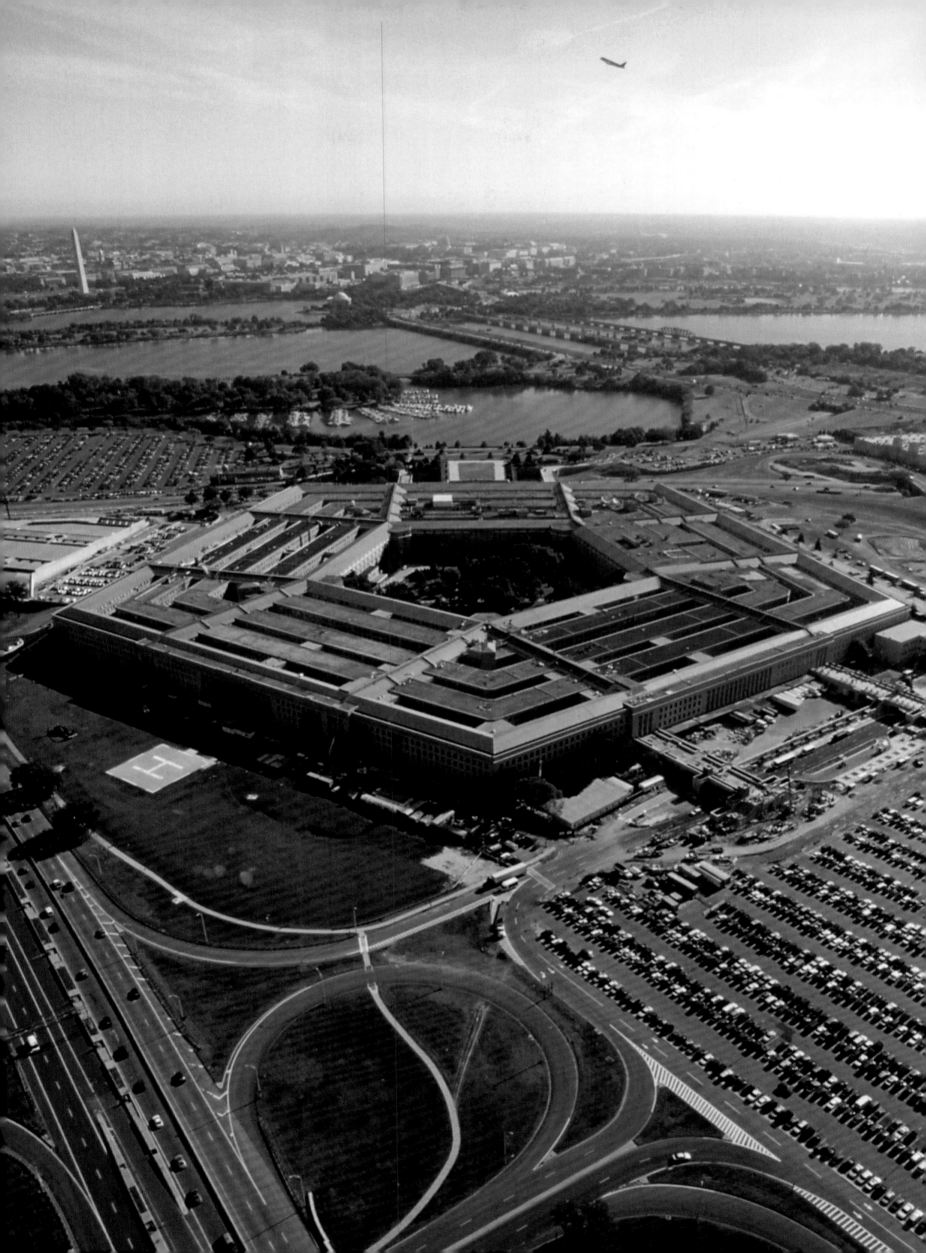

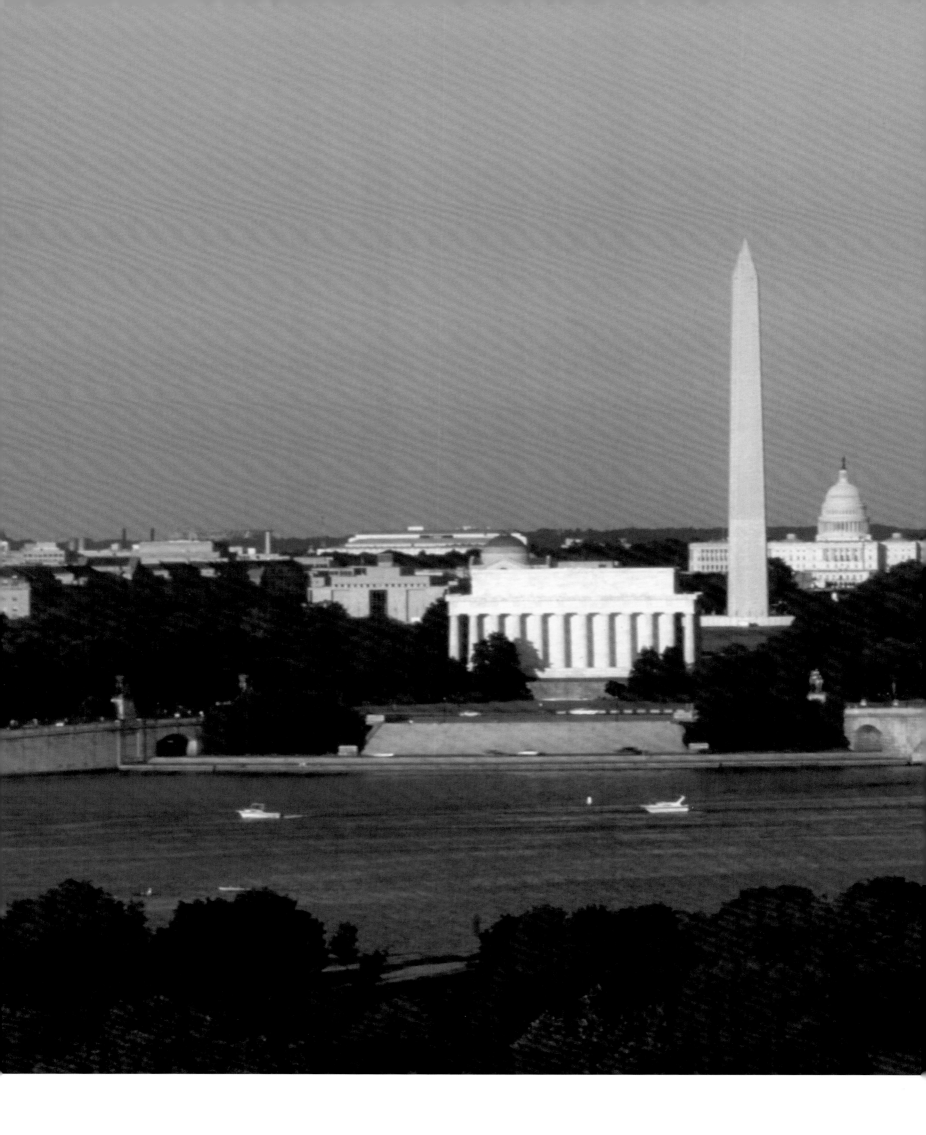

Flowing for about 285 miles from Cumberland, Maryland, to Chesapeake Bay, the Potomac is one of the longest rivers on the Atlantic coast. Some of Washington's most majestic monuments are reflected in the Potomac's waters, dubbed the "Nation's River" because it flows through America's capital.

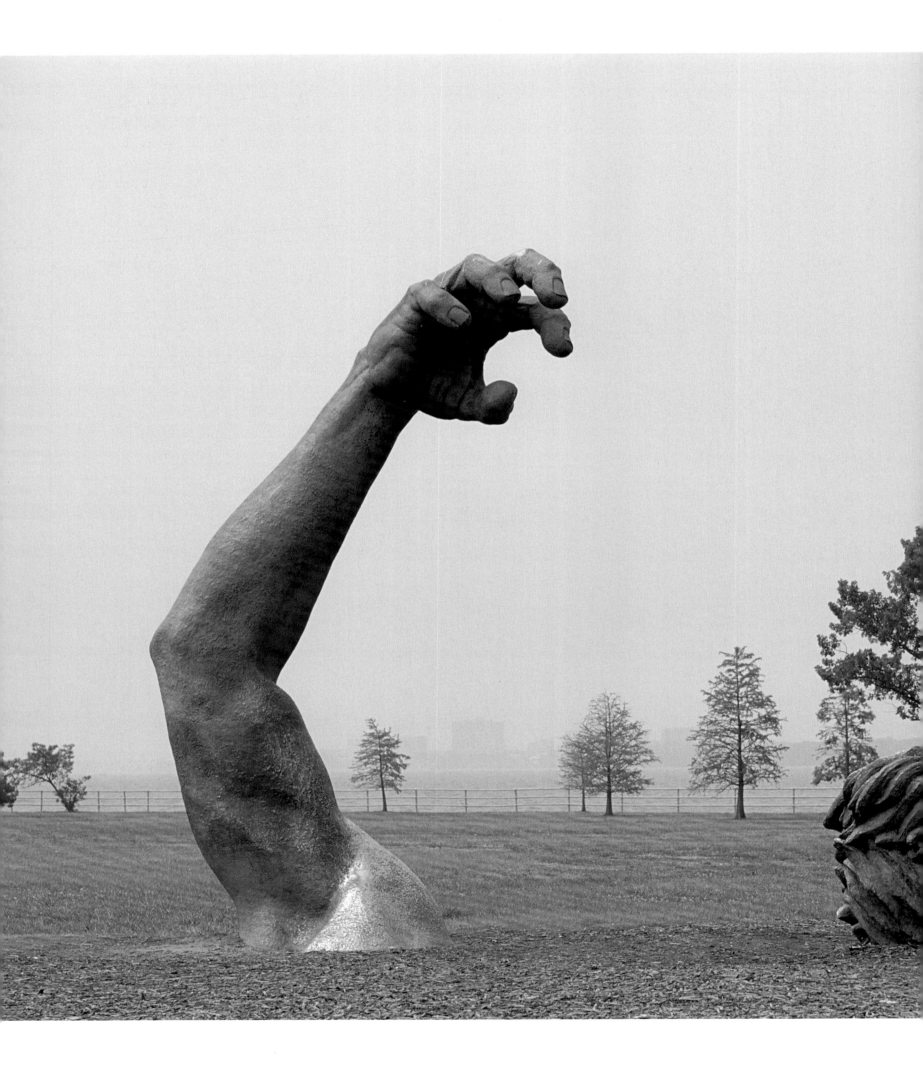

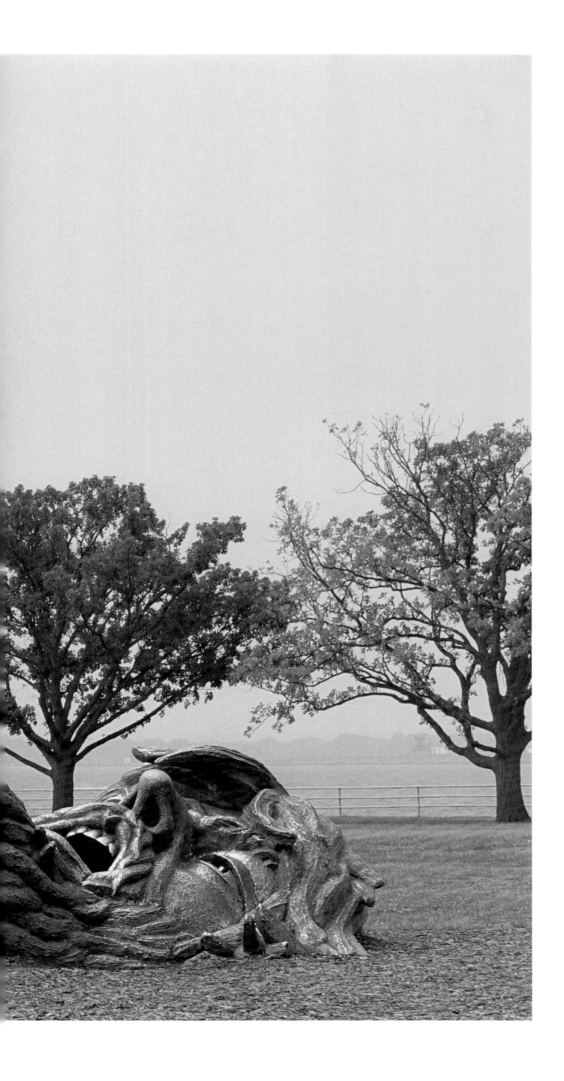

A distinct departure from most of the statues and memorials in Washington, D.C., *The Awakening* by J. Seward Johnson depicts a giant bursting out of the ground, his mouth open in what appears to be a primal scream. Composed of five different buried pieces this 100-foot sculpture was installed at Hains Point in East Potomac Park in 1980 for the International Sculpture Conference Exhibition.

PHOTO CREDITS

Adam Jones 1, 72–73, 74–75, 144, 148–49, 150–51

Scott T. Smith/Larry Ulrich Stock 2, 25

Michael Ventura/Folio 5, 6, 76–77, 85, 106–07, 120, 121

Jürgen Vogt 8–9, 12, 14, 16–17, 38–39, 40–41, 50–51, 54, 84–85, 86–87, 146–47

Richard Cummins 9, 10, 11, 13, 18, 20, 23, 26–27, 28, 29, 30–31, 44, 48, 52, 55, 60, 88, 108, 109, 118, 119, 123, 124, 140–41, 142

Scott T. Smith 19, 56–57, 58, 62–63, 64–65, 71, 78–79, 98

Tom Till 21, 61, 90–91, 96–97, 97, 130–31, 152–53

Fred Maroon/Folio 24

Michael Ventura 32–33, 102–03

Dennis Johnson/Folio 34–35

Bob Llewellyn/Folio 36

Lelia Hendren/Folio 42–43

Patti McConville/Unicorn 45, 70–71, 107

John Skowronski/Folio 46–47, 143

Mark E. Gibson/Unicorn 53

Jake McGuire 59

Michele Burgess/Unicorn 66–67

Rob Crandall/Folio 69

Florent Flipper/Unicorn 80–81

D. Degnan 83

Jean Higgins/Unicorn 89, 114–15

Jim Pickerell/Folio 92–93

Steve Bourgeois/Unicorn 94–95, 158–59

Paul Franklin/Folio 99

Richard Nowitz/Folio 100–01, 134

Hameed Gorani/Folio 104–05

Jeff Greenberg/Unicorn 110–11

NASA/Folio 112–113

Dennis Brack/Folio 116–17

L. Howe/Photri MicroStock™ 125

Cameron Davidson/Folio 126–27, 138–39

ChromoSohm/Unicorn 128–29

R. Simpson/Photri MicroStock™ 132

H.H. Thomas/Unicorn 133

L. Sardan/Photri MicroStock™ 136–37

Matthew Borkoski/Folio 155

Everett Johnson/Folio 156–57

WALTHAM FREE PUBLIC LIBRARY

3 3017 00918 1293

OCT 2000

WALTHAM FREE PUBLIC LIBRARY

3 3017 00918 1293

OCT 2000